PORTRAIT AND CANDID PHOTOGRAPHY
PHOTO WORKSHOP

SECOND EDITION

PORTRAIT AND CANDID PHOTOGRAPHY
PHOTO WORKSHOP

SECOND EDITION

Erin Manning

WILEY

John Wiley & Sons, Inc.

Portrait and Candid Photography Photo Workshop, 2nd Edition

Published by
John Wiley & Sons, Inc.
10475 Crosspoint Boulevard
Indianapolis, IN 46256
www.wiley.com

Published simultaneously in Canada

ISBN: 978-1-118-10005-9

Manufactured in the United States of America

10 9 8 7 6 5 4 3 2 1

For general information on our other products and services or to obtain technical support, please contact our Customer Care Department within the U.S. at (877) 762-2974, outside the U.S. at (317) 572-3993 or fax (317) 572-4002.

Wiley also publishes its books in a variety of electronic formats and by print-on-demand. Some content that appears in standard print versions of this book may not be available in other formats. For more information about Wiley products, visit us at www.wiley.com.

Library of Congress Control Number: 2011939644

About the Author

Erin Manning is a professional photographer, author, educator, and media personality. Television viewers know Erin best as the digital photography expert and host of DIY Network's Telly-award-winning TV series *The Whole Picture*. She helps people understand photography and technology by translating technical language into everyday words and by facilitating learning with a clear, friendly teaching style. She specializes in lifestyle imagery for clients such as AT&T, Bank of America, Disney, various lifestyle magazines, healthcare organizations, and individuals.

Erin serves on the board of directors for the Digital Imaging Marketing Association and is a member of the American Photographic Artists, Women in Photography International, and the Los Angeles Digital Imaging Group, whose purpose is dedicated to advancing the art and science of digital imaging.

In addition to *Portrait and Candid Photography*, Erin is also the author of *Make Money with Your Digital Photography*, published by John Wiley & Sons.

For more information on Erin and upcoming projects, visit her website at www.erinmanning.com.

Credits

Acquisitions Editor
Aaron Black

Project Editor
Kristin Vorce

Technical Editor
Haje Jan Kamps

Senior Copy Editor
Kim Heusel

Editorial Director
Robyn Siesky

Business Manager
Amy Knies

Senior Marketing Manager
Sandy Smith

Vice President and Executive Group Publisher
Richard Swadley

Vice President and Executive Publisher
Barry Pruett

Project Coordinator
Katherine Crocker

Graphics and Production Specialists
Andrea Hornberger
Heather Pope

Quality Control Technician
Dwight Ramsey

Proofreading and Indexing
Laura Bowman
Becky Hornyak

Acknowledgments

This book was written with the care and support of a few very important people. First, I must thank my mom, who has always supported my creativity and ideas, and has been instrumental in my growth as a writer. Thank you to my sister for her contagious wit that consistently lightens my day, and my father for capturing our early childhood on film and sparking my interest in photography. A special thanks goes out to Jack and Gianina, for being my sweet and beautiful models for years on end.

A big thank you to my contributing photographers Robert Holly and Stephen Poffenberger, and my attractive models who all kindly participated in this venture: Patricia Hunt, Lauren Shelley, Jack Kuller, Gianina Monroe, Maria Monroe, Karen Fowler, Olivia Tracy, Patricia Livinghouse, Rick Schuler, Janine Warner, Dylan Cavasos, David Palombo, Bryan Kent, Teresa O'Neill, Michael Welch, David Seyferth, Susan Kaminski, David Sullivan, Adam Bollinger, Raina and Maya Serota, Carm Goode, Courtney Kornegay, Tabitha Brown, Pavel Royz, Judy English, Bella Beckman, Nicolas Novobilski, Nyle Bilal, Matthew Knox, Alissa Clark, Dylan Goman, Suzie Benoit, Malik Ensley, Shelby Rae Bassman, Erin Dooley South, Bri Williams, Cooper Lovano, Loagan Thompson, Courtney Bowen, Michael Mulligan, Christopher Mulligan, the Killeens, the Wyatts, the Peternels, the Sammarcos, the Shahs, the Nakasones, the Georges, the Youngs, the Langsteins, the Tainters, the Friskes, the Rohmans and Watkins, the Poliquins, and the Stearns and Boldts.

Last but not least, my teachers over the years all deserve credit for sharing their knowledge and kindling my curiosity: Bobbie Leslie, Bobbi Lane, Charles O'Rear, Lee Varis, John Stewart, Carm Goode, Lawrence Manning, and Joyce Tenneson.

For my mother, who has inspired me and believed in me from the beginning.

Contents

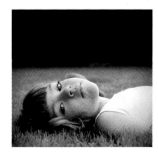

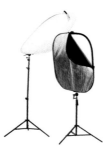

CHAPTER 3 Working with Light 50

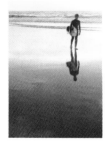

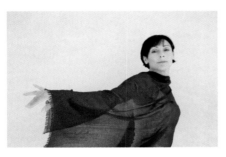

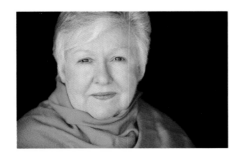

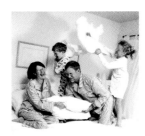

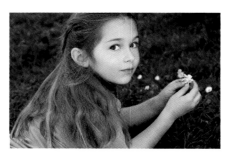

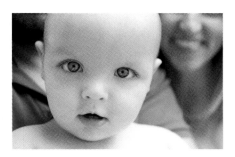

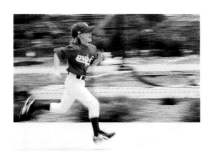

Introduction

Photography is a synthesis of so many things I care about — art, technology, creative expression, and connecting with people.

As a child, photography books like *The Family of Man* and pictures in the old family photo box mesmerized me. I didn't have an understanding of the mechanics of a camera and wasn't aware of basic composition, but I was drawn to the people in the photographs — their expressions, emotions, and relationships.

Inspired to create my own images, as an adult I began the journey toward becoming a photographer. The following image resonates with my sense of journey — reaching out to explore the world of creativity and expression and connecting with it on a personal level. Along the way I've educated my "eye" in design, learned to "see" light in a different way, and now use my camera and equipment as tools for creating photographs that capture part of people's lives.

This book is my effort to help you understand the technology and the basics for developing an artistic eye and to give you real-life techniques for connecting with, and photographing, people. Whether you are a beginning digital photographer with a compact camera or a more seasoned photo enthusiast with a dSLR, you will find the information you need to help advance your photography skills when photographing people in any situation, and those skills can take you far beyond just snapshots in any genre of photography!

My goal is to inform, inspire, and provide you with the skills and confidence to successfully use the digital camera as a tool to create and capture meaningful moments.

© Stephen Poffenberger

WHAT YOU MUST KNOW ABOUT PHOTOGRAPHING PEOPLE

OBSERVE AND CONNECT WITH PEOPLE

UNDERSTAND LIGHT

EXPRESS YOURSELF

Before you dive headlong into your pursuit of photographing people, it's a good idea to learn the basics about how to best approach your subject, identify and use the light to your advantage, and consider a few ideas for igniting your creativity. This chapter outlines these basics to help you get started as you begin to photograph people — whether in a candid shot or a posed portrait.

OBSERVE AND CONNECT WITH PEOPLE

A person's appearance, personality, and relationships are interesting and unique, but how do you capture any of this in a photograph? By taking the time to notice a person's special qualities, observing how a person reacts, and making an effort to authentically connect. People want to feel respected, appreciated, and comfortable, and if you show an interest and help them feel more comfortable, they will respond to you and your camera. When you photograph people, you are in a relationship, whether it lasts for a few minutes, a few hours, or a lifetime.

WHO ARE YOU PHOTOGRAPHING?

Decide what interests you about the person. Maybe the person has bright red hair and freckles, piercing green eyes, or a furrowed brow of experience. In addition to noting the unique physical attributes of your subject, ask yourself the following questions:

- What is the relationship I have with this person?
- What is the relationship between the people I am photographing?

- What message am I trying to convey?
- What is the intent of this image?

These are all questions to think about when you plan to take pictures of people. Everyone interprets the world a little differently; show the world what you see in this person. For example, in 1-1, Dylan was full of energy at the beginning of the shoot, but his serene and thoughtful side was revealed as he settled into a comfortable position on the tree branch.

CAPTURE A SPECIAL MOMENT

A moment in time — that is what a photograph captures. But what is a special moment? How do you find it, and how do you encourage it?

One of my favorite photographers, Henri Cartier-Bresson, defines the decisive moment in a photograph as "the simultaneous recognition, in a fraction of a second, of the significance of an event as well as the precise organization of forms which gives that event its proper expression." Whew! My translation — in a nanosecond, you must identify a special moment, have an intuitive sense of composition, and express what you see by capturing it with a camera.

As the photographer, you need to decide when that moment occurs, whether it's a glance, an emotion, or a gesture that you think is important, as shown in 1-2. You find that moment by observing what is going on around you and capturing it with technical confidence.

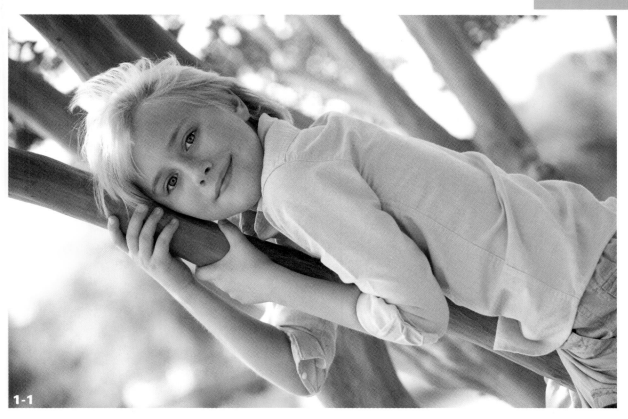

1-1

ABOUT THIS PHOTO *My intent was to capture an image of Dylan that revealed an authentic expression, his unique personality, and those beautiful, blue eyes. Taken at ISO 200, f/4.0, 1/500 sec. with a Canon EF 70-200mm f/2.8 lens.*

APPROACHES TO DIRECTING PEOPLE

There are two "directing" extremes when photographing people. One is to observe and be stealth-like in your approach; however, your subjects may never know you are photographing them and have no connection to you or the camera. The other extreme is to pose people and demand a certain look, which may result in an unnatural-looking photograph with no depth of

character or personality. I think there are many shades of gray between these two extremes, and choosing the best approach depends on what you intend to capture. Throughout this book I share some ideas, stories, and techniques that I have used to connect with people and encourage that special moment.

The following is a story about how I directed and connected with a four-year-old named Sophia, who initially was not too happy about having her photograph taken, as shown in 1-3.

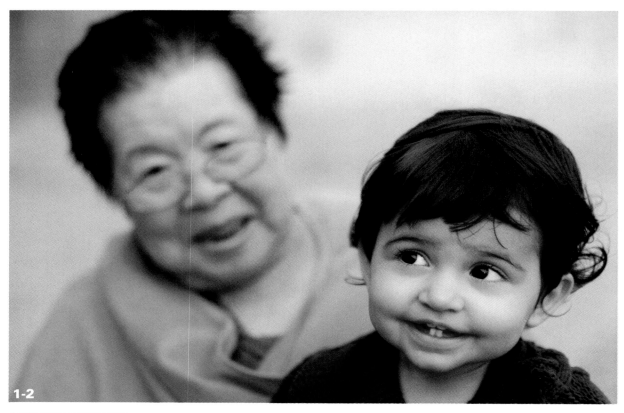

1-2

ABOUT THIS PHOTO *The interaction between this little girl and her grandmother was captured in a fraction of a second. Taken at ISO 200, f/2.0, 1/1600 sec. with a Canon EF 50mm f/1.4 lens.*

When I arrived at Sophia's house to photograph her family, she was intimidated by the activity, the photo equipment, and the presence of two people she didn't know: my assistant and me. She ran from us as we walked in the door. I had my camera, lenses, a tripod, diffuser, and reflectors along with some props: bubbles, a mirror, and long swaths of fabric netting. My goal was to create special family photographs depicting relationships and capturing special moments.

I began the shoot by talking with everyone and gathering them all together for various shots where they were casually positioned, both standing and sitting. We laughed and conversed between the shots. When I was shooting the pictures, I kept talking and gave them feedback about how they looked and direction on what to do.

I moved the family to the backyard, turned on some music, and helped Sophia blow bubbles in an effort to gain her confidence. I gave her some fabric netting to play with, and, still defiant, she gave a sourpuss look off-camera. It took a while to build the trust, but eventually I was able to capture some great action shots of Sophia running around in the backyard, oblivious to being photographed, as shown in 1-4 and 1-5, capturing the kind of special moments I'd hoped for.

When you're having your picture taken, you can't see how you look, which makes some people very self-conscious. People need feedback from their photographer. Encouraging comments and direction really help your subjects loosen up in front of the lens.

The poignant "decisive moment" occurred after all the activity waned and the photo shoot was officially over. I told Sophia I wanted to roll around in the grass, and asked if she would show me how. The beautiful resulting shot is 1-6.

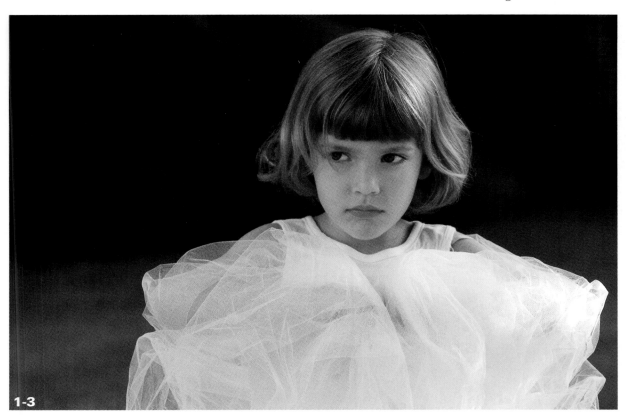

1-3

ABOUT THIS PHOTO *At first, Sophia felt I was an intruder. I like this picture, because she has a real expression on her face. Taken at ISO 200, f/4.0, 1/350 sec. with a Canon EF 70-200mm f/2.8L lens.*

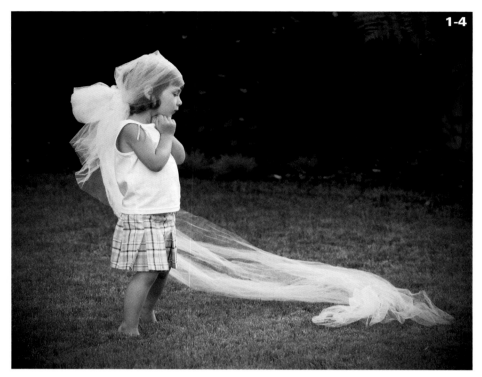

1-4

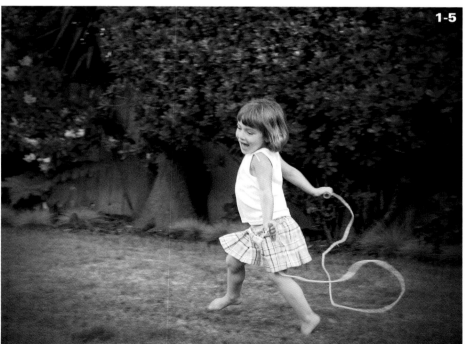

1-5

ABOUT THIS PHOTO
Here is the magical moment that was captured. Taken at ISO 200, f/4.0, 1/180 sec. with a Canon EF 17-35mm f/2.8L lens.

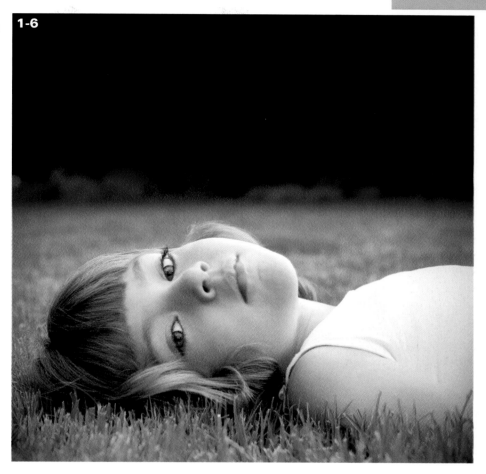

1-6

UNDERSTAND LIGHT

Over the centuries, artists have translated their visions and impressions of light with a brush on canvas; as the photographer, you have an opportunity to express yourself and capture light in a photograph. To understand and "see" light, it's important to know about the variations of light and how to identify those differences.

There are many types of light, both natural and artificial, but to see light as a photographer is to recognize the quality and direction of light and how it falls upon your subject. The source of light, the intensity, the angle, the color, the shadows and highlights that light creates, and where you place your subject all affect the look of your final image. Consider the following:

- Is your light source large (sun) or small (flashlight)?

- How intense is the light — bright or dim?

- How hard is the light — harsh or soft?

- What color is the light; is it a gray overcast day or a golden sunset?

- Is the light directly overhead or hitting your subject at an angle?
- How can you modify the light to enhance your subject?

Searching for and creating flattering light is possible when you know what to look for. Once you learn this new language of light, the world opens up with many more photographic opportunities, and your images dramatically improve.

 x-ref | In Chapter 3, I cover the subject of light in more detail, but these are the basic considerations.

FLATTERING LIGHT

One way to create flattering portraits is to shoot during the *golden hours,* generally the first hour and last hour of sun during the day. At these times, your subject can face the sun without squinting, because the light is diffuse and soft and it's easy to capture a sparkle in the eye. After just a few photographs, you begin to notice how the low angle of the sun and the soft intensity of the light make a big difference in the quality of your images — and everyone will love the photos. In 1-7, it was a late summer sunset at the beach and I knew that facing my subject toward the soft setting sun would illuminate her face with a beautiful golden glow.

If you don't have soft, afternoon light, another way to flatter your subject's features is to use a whiteboard or soft, gold reflector to reflect light back into the dark areas of the face, as demonstrated in 1-8. Given most people aren't thrilled to see pictures of themselves with under-eye shadows and wrinkles, reflecting soft, even light back into the face will make them much happier with the final resulting photograph, as you can see in 1-9.

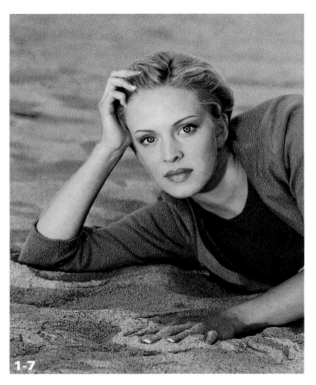

1-7

ABOUT THIS PHOTO *Photographing people during the golden hours is an easy way to capture a beautiful portrait. Taken at ISO 400, f/5.6, 1/90 sec. with a Canon EF 70-200mm f/2.8L lens.*

Now you can begin to search out flattering light in every situation. After learning that reflected light brightens my face, fills in shadows, and camouflages wrinkles, I have taken to standing near large white walls and understand the many benefits of restaurants with soft light and white tablecloths. As a result, I look better!

WHAT OUR EYES SEE

It's frustrating when your images don't convey what you intended to capture. If you've taken a high-contrast digital photograph and noticed that the shadows and highlights in the image have little to no detail, you are not alone. Many people don't realize that our eyes recognize a broader

ABOUT THIS PHOTO
A gray day required using a gold reflector to help brighten the faces in the family photo. Taken at ISO 200, f/4.5, 1/125 sec. with a Canon EF 24-105mm f/4L IS lens.

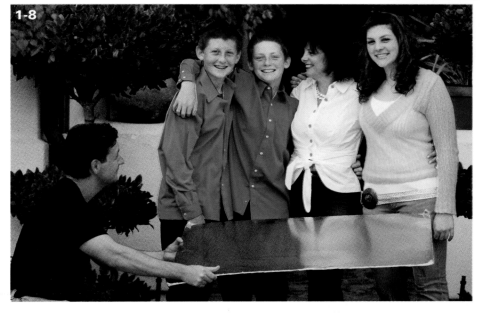

ABOUT THIS PHOTO
I zoomed in to capture the flattering light created by the gold reflector. Taken at ISO 200, f/4.5, 1/125 sec. with a Canon EF 24-105mm f/4L IS lens.

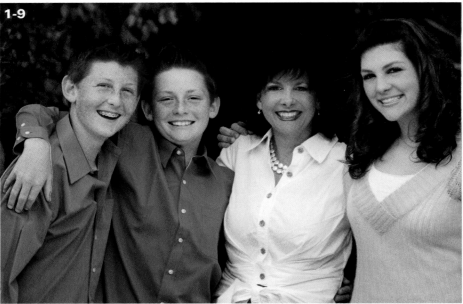

range of light than a camera is capable of recording. We can see the details in dark shadows and bright highlights that cameras cannot capture. Keeping this in mind when you compose your scene enables you to choose the best locations for a shot and gives you a better chance of correctly exposing your image.

x-ref

In Chapter 3, I provide more technical information to help you measure the difference between the light you see and the light the camera records.

EXPRESS YOURSELF

Photography is a synthesis of art and technology, a merging of the yin and the yang. Whether you're technically oriented, an artistic type, or an unusual mix of both, personal expression is a key aspect of creating unique and compelling images. Just as technology and art work together in photography, the techniques I'm sharing are only part of the picture; the rest is all about you and your personal history, observation, and unique "filter" on the world. Your personal photographic style communicates something; it's up to you to find out what that is.

FIND YOUR STYLE

Your personal style is developed when you explore, experiment, and discover things about yourself, and then allow your photography to be the extension of your personality. Knowing who you are, what you like and dislike, and what equipment to use are structural foundations upon which you can build a strong personal style. For example, if your penchant is for nature and a planned photographic process, you might consider photographing people in the landscape during the beautiful light of early morning or late afternoon. Or perhaps you like to follow the action and photograph people in a more documentary style, reacting to and capturing the decisive moments. Henri Cartier-Bresson built an entire career by being observant and moving around his subjects to capture just the right moment in time. Other things to consider are whether you prefer to create photographs that are clearly obvious in nature, such as a straightforward image of a person, or ambiguous "artsy" images that depict unusual shapes and designs. What motivates you? What is your personal history? What subjects do you enjoy photographing and why? Simple or complex? Conventional or challenging? These are all questions to consider as you ponder the intent of your next image.

My own personal style draws from a background in design, a love for people, and an interest in uncovering personal authenticity and revealing relationships, as shown in 1-10. I have always been drawn to capturing moments with and between people. I discovered a book entitled *The Family of Man* by Edward Steichen when I was a child, and I recall being mesmerized by the emotions, expressions, and interactions between the people in the images. That feeling remains with me today and I constantly seek interesting people

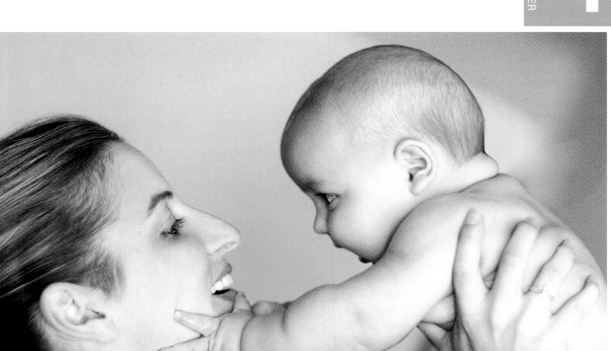

1-10

ABOUT THIS PHOTO *I like to capture unusual angles and authentic expressions in my images. Taken at ISO 500, f/2.0, 1/320 sec. with a Canon EF 85mm f/1.8 lens.*

to photograph. Perhaps you've had an experience in the past, whether long ago or recently, that has influenced you on an emotional level. Keep a journal and write these things down. It will help with your personal style process.

Keep in mind that a personal style isn't created overnight; it's something that begins to emerge as you learn, grow, and experiment. Don't be afraid to try new things, and, most importantly, don't be afraid to fail. Your personal style is a process and a journey. Be kind to yourself as you flail about, and if you shoot digital images, be thankful that you don't have to pay for the film and processing. You're free to make mistakes and learn from them!

13

TELL A STORY

Interesting and meaningful portraits are created by telling a story visually, as shown in 1-11 through 1-15. If you watch a great movie or TV show and notice how it's edited, you might see a wide shot of a room, then a medium shot of someone's face, and then a close-up of a foot or hand or other detail in the scene. A series of images like this, when presented together for the viewer, tells a story, creates interest, and draws you in. The same principle applies when telling a story with still images.

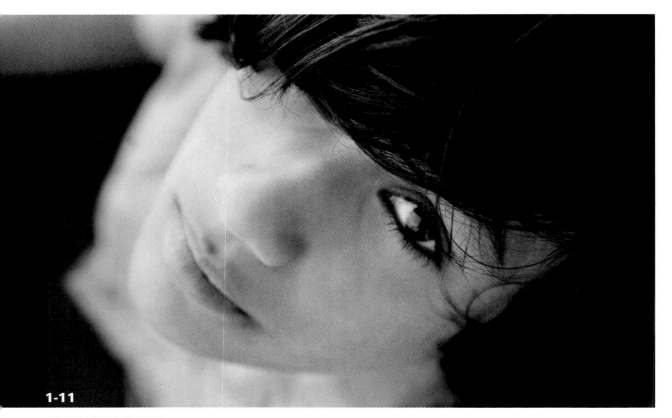

1-11

ABOUT THIS PHOTO *Each image in the series of 1-11 through 1-15 was captured from various angles and distances from the subject. Any one of these images might be interesting in its own right, but when you place them together they convey a story and create a visually compelling series of images. Taken at ISO 400, f/4.0, 1/125 sec. with a Lensbaby selective focus lens and a Canon EF 24-105mm lens.*

ABOUT THIS PHOTO *Give your subject something to do and get in close to capture the action. Taken at ISO 250, f/4.0, 1/125 sec. with a Canon EF 24-105mm lens.*

ABOUT THIS PHOTO *Close-up shots capture attention and help convey a story. Taken at ISO 250, f/2.0, 1/500 sec. with a Lensbaby selective focus lens.*

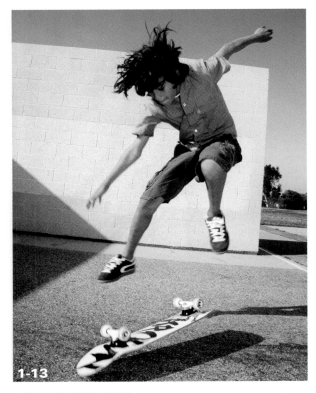

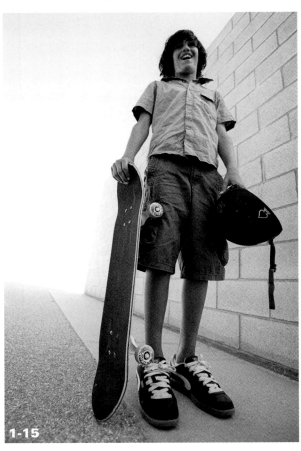

ABOUT THIS PHOTO *Stand back to capture the context of where your subject is located. Taken at ISO 400, f/16, 1/200 sec. with a Canon EF 24-105mm lens.*

ABOUT THIS PHOTO *Vary your angles. Positioning your camera below your subject makes him seem larger and implies importance. Taken at ISO 250, f/4.0, 1/320 sec. with a Canon EF 17-35mm f/2.8L lens.*

USE DEPTH OF FIELD (DOF)

Depth of field (DOF) refers to the zone of sharpness in your image. Your DOF is deep if most of your scene is in focus; it is shallow if a small area is in focus. The human eye is drawn to the part of an image that is sharp and in focus. As a photographer, you can creatively use DOF to direct the viewer's eyes to the important elements in your photograph. There are three ways you can control DOF:

- **Distance to your subject.** An image taken close to your subject produces a shallow DOF, as shown in 1-16. An image taken at a considerable distance from your subject will have a deeper DOF, as shown in 1-17.

- **Aperture selected.** The camera aperture affects how much light enters your camera and is recorded by the sensor. The aperture setting on your dSLR camera and lens is designated by f-stops, which are fractions of the lens focal length. A large aperture opening (such as f/1.8, f/2.8, or f/4.0) renders a shallow depth of field in your image, resulting in a blurred background or foreground. A small aperture opening (such as f/11, f/16, or f/22) renders a deep depth of field, resulting in an image with detail from near to far. Most people become confused when trying to remember which f-stop setting renders which effect.

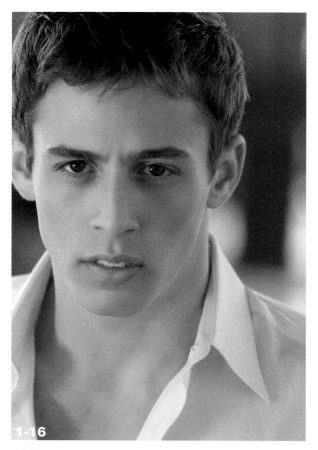

1-16

ABOUT THIS PHOTO *I blurred the background by standing close to my subject and using a wide aperture setting that created a shallow depth of field. Taken at ISO 200, f/4.5, 1/250 sec. with a Canon EF 70-200mm f/2.8L lens.*

A small aperture opening is represented by a larger number (f/22), while a large aperture opening is represented by a small number (f/1.8). It may be easier to think about it like this: ¼ piece of cake is larger than ¹⁄₁₆ piece of cake.

Using a large aperture (f/1.8, f/2.8, f/4.0) is a good way to isolate your subject from the background, rendering a shallow depth of field.

Using a small aperture (f/11, f/16, f/22) is a good way to ensure the environment surrounding your subject is in focus. Ansel Adams used a very small aperture in his images to capture sweeping vistas of the environment in minute detail.

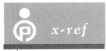

x-ref

Aperture and depth of field are also covered in Chapter 3.

■ **Lens focal length.** Short focal-length lenses (for example, 17-35mm) have a large field of view and, due to the lens optics, can render a deep depth of field. Long focal-length lenses (for example, 70-200mm) have a narrow field of view and, due to the lens optics, render a shallow depth of field.

1-17

ABOUT THIS PHOTO *Standing back at a distance from my subject helps create a deeper depth of field where more is in focus in the background. Taken at ISO 200, f/4.5, 1/250 sec. with a Canon EF 70-200mm f/2.8L lens.*

Assignment

Capture an Authentic Expression

Find a person you consider interesting and capture a series of portraits of this person, concentrating on capturing an authentic expression. Use your newfound techniques and intuition regarding directing your subject in front of the camera. Use some of my suggestions and then get creative. Your innate people skills are already there inside of you, you just need to build your confidence in bringing them out.

To complete this assignment, I photographed Ciaran, a delightful six-month-old boy who is constantly expressing himself. The challenge is to capture his expressions on-camera. In this instance, it helped having another child off-camera making faces and noises to attract Ciaran's attention. It's not always necessary to be the only director on a photo shoot; sometimes you can employ others to assist you. To avoid confusing your subject, be sure to only have one person directing him or her at a time. The photo was captured at ISO 400, f/4.0, 1/60 sec. with a Canon EF 24-105mm f/4L IS lens.

Remember to visit www.pwassignments.com after you complete this assignment and share your favorite photo! It's a community of enthusiastic photographers and a great place to view what other readers have created. You can also post comments, read encouraging suggestions, and get feedback.

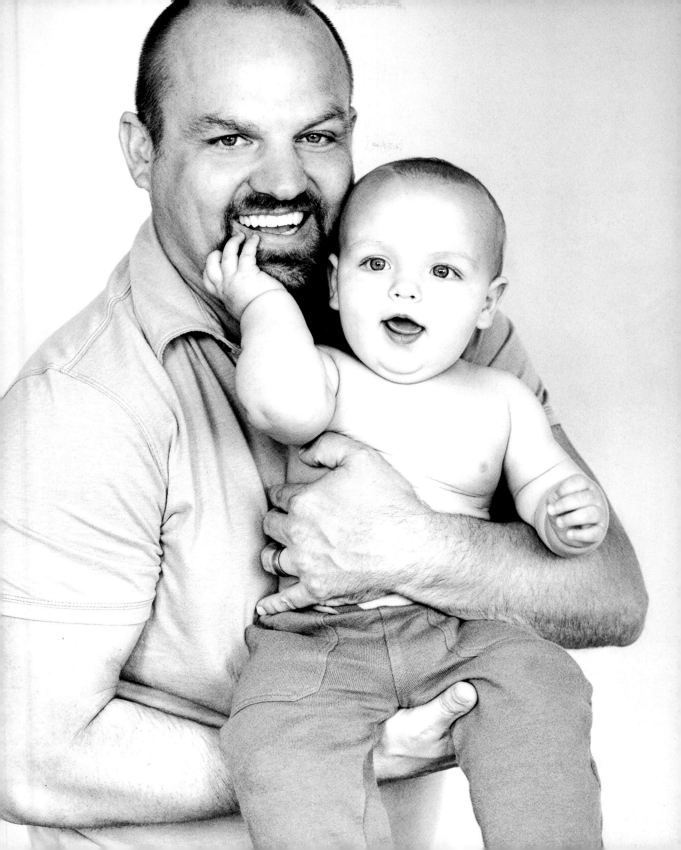

EQUIPMENT BASICS

After the photography bug bites, your life changes in many ways due to your new passion. You see the light in a different way, compositional elements are much more obvious, your direction skills are enhanced, and, last but not least, you begin researching and planning for camera accessory purchases. Although the quality of photographs depends more on the vision and creativity of the photographer than on the equipment, you need some basic accessories to begin, and you need to plan for other accessories as your photographic skills increase.

When I began photographing, I had very little money, but I did possess a lot of desire and passion to capture life moments and express my unique creativity in a photograph. I thought that if I only had the very best equipment, I could be a better photographer. I quizzed my instructors and my peers on what to purchase and was overwhelmed with the varying opinions and the astronomical costs associated with becoming a "good" photographer. I soon discovered that photography is an evolving process; your knowledge increases, your creative vision changes, technology transforms, and the world is constantly in flux. I could dream about, plan for, rent, or borrow what I could not afford and still take amazing photographs with minimal equipment.

Desire, dream, and diligently pursue your vision. Start with the basics and build your equipment cache. Get creative and use inexpensive items and tools to give your images a unique look. If you can afford to buy a good camera and many accessories, do so sparingly at first while you get used to your equipment. As your photographic experience grows, you can add more accessories.

After you begin building your accessory reserve, you may discover that what you once considered a techno-nerd equipment purchase is now something worth getting excited about, because it's a

means to help you create and interpret your vision. Every time you add something new to your photography accessory collection, the photographic possibilities increase: a lens, a reflector, a light — it's so exciting!

Reading this chapter should help you identify what basics you require on your photographic journey, what to improvise, and what to put on your wish list.

CAMERAS

Cameras have come a long way since George Eastman designed the first film camera for the general public in 1888, and they've come a long way since the first digital camera hit the scene in the early 1990s. Photography is no longer a prohibitively expensive endeavor, nor is it an exclusive one reserved for the technically proficient. Translation: Digital cameras are more accessible and easier to use, and photographic education is more accessible to everyone whether you plan on becoming a hobbyist or a professional. Now you can capture digital photographs and video via a compact camera, dSLR, or smartphone and choose multiple ways to easily share them with your friends and family.

COMPACT CAMERAS

Compact digital cameras (as shown in 2-1) are better than ever now with improved sensors, bigger LCD screens, and lots of features. Their main appeal is that you can carry them with you everywhere so you never miss a shot. In spite of their small size and lack of an interchangeable lens, it is possible to capture some fantastic images of people with these cameras just by learning a little about the basic functions. Given that there is not a standardized design for the functions and

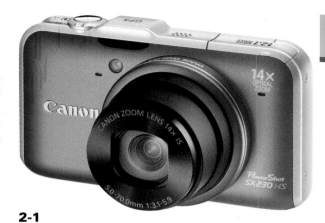

2-1

ABOUT THIS PHOTO *A compact camera is easier to carry around than a dSLR and offers more options than a smartphone. Photo courtesy of Canon.*

features on the cameras of different manufacturers, you may need to consult your camera manual to find the following modes:

- **Auto and P.** Automatic (Auto) and Program (P) modes are the most common modes people use when shooting with a compact digital camera. Automatic is fully automatic: the camera makes all the decisions. Program is an advanced automatic setting that allows you to make decisions about the flash, white balance, and drive mode. When it is in these auto modes, your camera makes its best guess in determining the exposure by focusing, reading the light in the scene, and automatically choosing a shutter speed, aperture, and white balance. If you're just starting out and still need to experiment to build your confidence with your camera, I suggest shooting in Program (P) mode. This setting gives you more control over your camera, but still makes all the exposure decisions for you.

note Using the automatic modes can result in acceptable images, and they are a good place to begin, but you won't have much control over the outcome unless you use some of the scene/creative modes, too.

- **Portrait mode.** This is likely represented as a head icon on your Mode dial, as shown in 2-2. When you select Portrait mode, the camera adjusts the aperture and shutter speed for you, softening hair and skin tones and minimizing the depth of field (DOF) for a soft background effect that isolates your subject from the background.

2-2

ABOUT THIS FIGURE *The Portrait mode icon on compact cameras typically looks like this.*

- **Sports mode or Kids & Pets mode.** By setting the camera to Sports or Kids & Pets mode, usually indicated with a runner icon, as shown in 2-3, your camera automatically chooses the fastest shutter speed possible, given the lighting situation. Some cameras also activate Continuous shooting mode (instead of Single Frame) and disable the flash. This setting also

works well for capturing active subjects and candid moments. To facilitate Continuous mode, just hold your finger down on the shutter button continuously and your camera will continue to fire the shutter for multiple consecutive shots.

2-3

ABOUT THIS FIGURE *A runner icon represents Sports mode while an icon with a child and pet represents Kids & Pets mode.*

■ **Macro mode.** Using the Macro mode, which is usually represented by a flower icon, as shown in 2-4, enables you to focus closer to your subject and capture details in your images that were previously too small or out of focus. Just because the Macro mode is represented by a flower doesn't mean that flowers are the only allowable subject. With Macro mode you can take close-up photos of people and capture every freckle, eyelash, or baby's fingers and toes in perfect detail.

2-4

ABOUT THIS FIGURE *A flower icon represents Macro mode.*

■ **Landscape mode.** Generally represented by an icon that looks like a mountain range, as shown in 2-5, Landscape mode (also known as Infinity mode) automatically uses a small lens aperture that provides maximum sharpness for distant and wide-vista scenes. This mode is also useful when photographing groups of people that are positioned at various distances from the camera. This deep depth of field allows you to capture detail in your image from near to far.

2-5

ABOUT THIS FIGURE *A mountain range icon represents Landscape mode.*

This section focuses on compact cameras, but dSLR cameras also include many of these functions. Here are a couple of ways to control the light on your subject:

■ **Flash mode.** A lightning bolt icon is located on the back of your camera representing the Flash mode. Set your Mode dial to P, which allows you to cycle through all your flash options. Some compact cameras require you to use the Manual mode to use the full features of your flash. Selecting the forced flash option, as shown in 2-6, enables you to use the flash outside in bright light, filling in harsh shadows on faces.

■ **Exposure compensation.** Compact and dSLR cameras have an additional feature that controls the amount of light hitting your camera's sensor; it's called exposure compensation.

2-6

ABOUT THIS FIGURE *A lightning bolt icon represents Flash mode.*

Adjusting your exposure compensation to add more light (+) or reduce light (−) is a quick, semiautomatic way to adjust how the camera records the light in your scene. By using exposure compensation, you still don't have total creative control over your camera, but you can make your image appear lighter or darker.

Have you wondered what zoom on a compact camera really means? Camera manufacturers often refer to digital zoom and optical zoom when marketing a compact digital camera. Optical zoom is the important feature because it refers to the lens optics and results in getting you closer to your subject without sacrificing image quality — a true zoom. The lens is not removable on a digital compact camera or a larger super-zoom variety, but both cameras refer to focal length as "X." For example: From your location, 3X optical zoom gets you three times closer to your subject, and 10X optical zoom gets you ten times closer to your subject. Digital zoom doesn't actually result in a closer shot; the camera is simply zooming and cropping so the image you are focused on appears larger, but the result is a lower-quality image than if you were using the optical zoom feature.

MICRO FOUR THIRDS

Also known as an Electronic Viewfinder Interchangeable Lens (EVIL) camera, a Micro Four Thirds camera incorporates compact camera features with dSLR benefits. It's essentially an advanced compact camera that's sized a little larger than a compact camera and much smaller than a dSLR, and it allows you to interchange lenses (see 2-7). The Micro Four Thirds camera does away with the traditional mirror and prism system to cut down on size and weight, and the optical glass viewfinder has been replaced with an electronic viewfinder. This means that you are seeing pixels instead of viewing your scene through the traditional glass viewfinder. Popular among traveling photo enthusiasts for its small size and advanced options, this camera may fit your needs until you're ready to invest in a full-fledged dSLR.

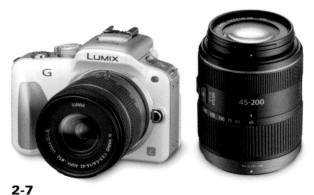

2-7

ABOUT THIS PHOTO *The Micro Four Thirds camera provides many advanced features in a compact camera body. Photo courtesy of Panasonic USA.*

DSLR CAMERAS

In the term *dSLR*, the *d* stands for digital and the *SLR* for single lens reflex. The camera's reflex mechanism is a series of mirrors and prisms inside the body that reflect the image coming through the lens to your optical viewfinder. Digital SLR cameras (as shown in 2-8) are similar to traditional film SLR cameras, except that an image sensor captures your images and records them onto a media card instead of film.

In addition to the scene modes listed in the compact camera section, a dSLR also includes a few more modes that are helpful when capturing pictures of people:

- **Shutter Priority.** This mode is referred to as Tv on Canon cameras and S on Nikon cameras. You set the desired shutter speed, and the camera automatically adjusts for the proper aperture exposure. This is a good setting to use when you need control over movement in your image. You can choose to freeze the action or blur it, depending on your shutter speed selection.

- **Aperture Priority.** This mode is referred to as A or Av on most cameras. You set the desired aperture, and the camera automatically adjusts for the proper shutter speed exposure. Use this setting to control your depth of field. This is great for isolating your subject and blurring out the background with a wide aperture, such as f/2.8 or f/3.5. Or you can capture a deep depth of field (everything is in focus from near to far) by using a small aperture, such as f/16 or f/22.

- **Manual.** Shooting in the Manual setting allows you to select your aperture and shutter speed independently, and therefore gives you the most creative control when photographing. To successfully use the Manual setting, it's important to understand how aperture and

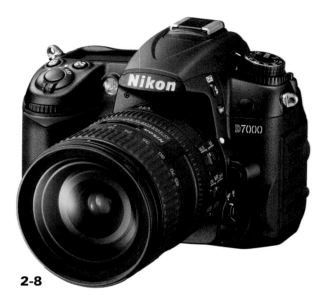

2-8

ABOUT THIS PHOTO *dSLR cameras look similar to SLR film cameras, but are quite different on the inside. Photo courtesy of Nikon Inc. USA.*

shutter speed each affect the depth of field and movement in an image, and also how they work together to create a proper exposure.

x-ref | Learn more about shutter speed, aperture, and exposure in Chapter 3.

While compact digital cameras and smartphones have some great uses, dSLRs have several big advantages:

- **Image quality.** A larger image sensor provides larger pixels, and more of them, for greater detail in your images. Enhanced ISO capability leads to faster shutter speeds and less noise (a grainy appearance at higher ISOs, usually 800 or higher) in your images.

- **Speed.** You experience faster start-up and focusing, less shutter delay, and more frames per second for shooting images in sequence; dSLRs are great for taking pictures of kids, animals, sports, or anything else that moves.

■ **Creativity.** Manual modes and semiautomatic modes allow for greater control. Manual mode is what most professional photographers use.

■ **RAW format capability.** RAW files are uncompressed and therefore offer more options and control over your final image.

■ **Lenses.** You have the ability to swap lenses for different perspectives and effects.

 x-ref

For more information on file formats and how to choose the best one for you, see Chapter 10.

If you're still shopping for a dSLR, determining which one is right for you may require a little research. Although budget is always a consideration when determining which camera to choose, you should also evaluate which features you are going to need. For example, if you plan to photograph people in challenging lighting situations, having a camera with a spot meter is important. This helps you create the proper exposure in backlit or high-contrast lighting situations. If you're interested in sports photography, then you'll want a camera that can shoot more frames per second to ensure you don't miss your shot. And of course, one of the best ways to evaluate a camera is to hold it in your hand to make sure it's easy to handle.

 tip

A good independent source for unbiased detailed camera reviews is the Digital Photography Review website (www.dpreview.com).

SMARTPHONE CAMERAS

As you're probably already aware, capturing images with a smartphone is a little different from capturing images with a compact camera or dSLR. The major benefit is that a smartphone (shown in 2-9) is probably always with you, so you won't miss documenting life's moments, and you can immediately share them online via the smartphone's e-mail or Wi-Fi option. The downside is that most smartphones still don't possess the features or give you the control necessary to produce quality images. Either way, smartphone photography has changed the way many people capture and share photographs.

2-9

ABOUT THIS PHOTO *The iPhone is a popular smartphone and it provides an easy way to capture everyday moments. Photo courtesy of Apple.*

New mobile applications such as Hipstamatic and Instagram have created a movement of amateur and professional photographers capturing digital images that look as if they were collected from a shoebox in the 1970s. These mobile apps use the smartphone's camera and transform your images with artistic filters and borders that are intended to look just like old pictures. The result has been a movement of faux-nostalgic picture taking, a sort of hipster renaissance that has filled social networks with quirky and often beautiful photos of everyday activities.

Have you heard the expression "the best camera to have is the one you have with you?" Sometimes it's better to capture the shot with something rather than miss the moment. But if you're planning to learn about photography and produce the best images possible, then it's best to use a dSLR or, at minimum, a good compact camera. I'd recommend using your smartphone camera as a documenting device for social media and, with the help of a mobile app or two, as an artistic addition to your photographic arsenal. I would not suggest using a smartphone as your only camera, unless it's all you can afford for now.

IMAGE STORAGE

When you use your digital camera to capture images, they are stored on a memory card until you transfer them to your computer or to another medium or device for backup. From your memory card to storage and backup, you should consider a few options when planning your digital workflow.

MEMORY CARDS

Various types of memory cards are available depending on the camera you select. CompactFlash (CF) cards, as shown in 2-10, are used by most professional-level dSLR cameras.

Secure Digital (SD) cards, as shown in 2-11, are probably the most popular and are used in many compact cameras and some entry-level dSLR camera models. Memory Stick (MS) cards are proprietary to Sony still and video cameras. Your camera box and camera manual should reference which memory card your camera accepts.

2-10

ABOUT THIS PHOTO *A CompactFlash (CF) memory card. Photo courtesy of SanDisk.*

tip Memory cards are small and very sensitive electronic devices that you should handle with care. Do not place them near strong magnetic sources, drop them, or mangle them — you could lose all your images. Make sure you label your card with your name and contact information, just in case you misplace it.

2-11

ABOUT THIS PHOTO *A Secure Digital (SD) memory card. Photo courtesy of SanDisk.*

Higher megapixel cameras create larger files and need more image storage space. Your digital camera probably came with a small capacity memory card that holds a few images to get you started, but it's always a good idea to purchase a memory card with enough capacity to hold a lot of photos and video, plus additional cards. When shooting an important event, spread your images over multiple memory cards due to possible memory card failure. Memory cards can become corrupted, and although there is software you can use to try to retrieve your images if this terrible incident occurs, it's always better to be safe than sorry.

Memory cards are available in gigabyte (GB) capacities, and they hold from hundreds to thousands of images, depending on the image quality setting you choose on your camera. Some digital camera LCD viewfinders even display the approximate number of images you can shoot once you insert the memory card and set the image quality. I often use a 16GB card in my dSLR. Unlike conventional film, high-speed memory cards are not more sensitive to light; they just record or write and transfer data faster. However, that's an advantage only if your camera reads and writes data quickly. Without getting into all the differences in speeds and classes, keep in mind that dSLRs work faster with high-speed cards such as 150x or class 6–10, while compact camera models will accept lower speed cards. Here are a few important tips for working with your memory cards:

■ *Do* have a fully charged battery before transferring images to another location.

■ *Don't* remove the memory card while files are still being transferred.

■ *Do* format your memory card in-camera and not in-computer.

■ *Don't* use a memory card from another camera without formatting it first.

Some memory cards have Wi-Fi capabilities, enabling you to transfer images from the card to your computer via a wireless network. Image 2-12 shows a wireless SD Eye-Fi memory card; with it, you specify where you want your photos sent, select a Wi-Fi network, and then turn on your camera to make the transfer.

2-12

ABOUT THIS PHOTO *A wireless memory card enables you to transfer photos from your camera to your computer via a Wi-Fi connection. Photo courtesy of Eye-Fi.*

tip Before you begin taking pictures, it's a good idea to format your memory card. This prepares and optimizes the card for use with your specific camera. Formatting is also the best way to clear images from your card after transferring them to a hard drive or portable storage device or burning them onto a CD or DVD. Formatting your memory card after safely saving your images elsewhere ensures that your card is clean, restructured, and ready to go. Check your camera's manual for details.

EXTERNAL HARD DRIVES

Your digital photography workflow includes transferring photos from your camera's memory card to your computer. In addition to storing

photos on your computer, you should also store them on an external hard drive. That way, if disaster strikes and your computer is lost, stolen, or broken, or your hard drive fails, your precious images are not all lost. I use full-sized G-Technology hard drives in my studio (see 2-13) and small, travel-sized G-Technology and LaCie hard drives when traveling.

2-13

ABOUT THIS PHOTO *In addition to storing your images on your computer's hard drive, you should keep copies on an external hard drive. Photo courtesy of G-Technology by Hitachi.*

LENSES AND FILTERS

When your photography skills begin to mature, you also become more aware of the creative and technical accomplishments of other photographers. Learning about the tools others use when creating their masterpieces and researching the online reviews about these photo accessories can help you make informed decisions when you decide to add more equipment to your own photo accessory cache.

Interchanging lenses on your dSLR is a great way to exercise your creative options and technical abilities. If you want your weekend soccer-match images of the kids to look more like *Sports Illustrated* as opposed to a regular snapshot, you need to change your lens (which is one of the major benefits of using a dSLR — the option to change your lens).

LENS SPEED

A lens with an aperture of f/2.8 is considered a *fast* lens because it allows for a wider aperture setting and it allows more light to pass through the lens, which results in a faster shutter speed. A lens with a smaller maximum aperture (for example, f/5.6) is *slow* because less light can pass through the lens, and this results in a slower shutter speed.

Most basic, inexpensive zoom lenses have a varying lens speed of approximately f/3.5 to f/5.6. The lens speed changes as you zoom closer or farther away from your subject with the wide or telephoto capability of your lens. These lenses are wonderful to use when you're beginning your photographic journey. They are constantly improving and produce excellent images, but they do have limitations. For example, you can't shoot handheld in most low-light situations — you can capture the action in only bright light or by using a flash, and rendering a very shallow depth of field is not attainable.

A fast lens is considered a high-quality lens; it contains more glass so it's heavier, and it has an enhanced lens coating to reduce flare. A fast lens is more expensive, but the image results can be

amazing. With a high-quality lens, you can capture more action because you don't need as much light in your scene for a proper exposure, and you can use a faster shutter speed. A fast lens also enables you to open up your aperture to f/1.4 or f/2.8 and create images with a very shallow depth of field — perfect for beautiful portraits and transforming your weekend soccer snapshots into professional-looking images.

TYPES OF LENSES

Professional photographers use various types of lenses to achieve different effects in their images. You can build your lens collection over time to include the basic options and perhaps add other unusual lenses for a completely unique effect in your images. It's important to understand that different types of lenses affect how you approach your subject and the resulting image:

- **Zoom lenses.** Zoom lenses have a range of focal lengths (for example, 24-70mm) and allow you to quickly increase or decrease your lens focal length, including more or less of your scene, in seconds, without changing your physical distance to your subject.

- **Prime lenses.** Prime lenses have a single focal length (for example, 50mm), are generally less expensive than zoom lenses, and produce sharper images, but you miss the convenience of quickly changing your focal length with one lens.

note

35mm film focal-length measurements are standard and familiar to most photographers. The millimeter (mm) measurement is also used to describe digital focal length.

LENS FOCAL LENGTHS

Lenses are available in a multitude of focal lengths with varying levels of quality. Technically, the *focal length* of a lens is defined as the distance from the middle of the lens element to the digital camera's imaging sensor, and it is measured in millimeters. The focal length of a lens is usually displayed on the side of the lens barrel.

You may have lenses that you used on your prior film camera and now you want to use them with a compatible digital camera body. That works out very well when you switch from shooting with film to shooting with digital, except for one little thing: a cropped-sensor camera, also known as an *APS-C sensor camera.* Many dSLR cameras have an APS-C sensor that is smaller than the 35mm photographic film frame equivalent and only captures part of the information projected by a lens. Depending on which camera and lens combination you use, this phenomenon can affect the perceived focal length in your images. For example, if you attach a 28-80mm zoom lens to a dSLR with a 1.5 crop factor, it captures images as a 42-120mm lens (28mm × 1.5 = 42mm). This alteration may work out just fine, especially if you prefer longer focal lengths. However, if you intend to capture a 28mm wide-angle appearance in your image, you have to upgrade to a full-size sensor digital camera, purchase a lens with a significantly increased wide-angle capability, or purchase a lens designed exclusively for digital cameras that lack a full-size sensor. These lenses are sold with digital camera lens specifications noted in the lens description.

The Canon lens in 2-14 has a focal length of 50mm with a maximum aperture of f/1.8. This lens is called a *standard* or *normal lens* because 50mm approximates the perspective of the human eye, maintaining the spatial relationship of objects in your image very closely to the way you see the world. Keep in mind that I am using these focal lengths as general examples — to be completely technically correct, a 50mm lens approximates the perspective of the human eye when used with a full-frame sensor camera. If you are using a cropped-frame APS-C sensor camera, you need to use a 30-35mm lens to achieve this effect.

A *telephoto lens* technically can range from 60 to 1000mm, but a common telephoto zoom lens example is 70-300mm. A telephoto lens is similar to a telescope; it magnifies your subject and narrows your field of view. Capturing candid shots is easier with this lens because you can zoom in and photograph your subject from quite a distance. This is also a great lens for shooting sports, wildlife, and people.

A telephoto lens is great for portraits because it provides a flattering perspective and allows you to isolate your subject from the background. The spatial relationship in the scene is flattened, so noses don't look larger than normal (as with wide-angle lenses), and a long focal length combined with a wide aperture enables you to blur out everything behind the subject. The Canon telephoto lens in 2-15 has a zoom capability of 70-200mm.

2-14

ABOUT THIS PHOTO *A 50mm normal lens approximates the perspective of the human eye. Photo courtesy of Canon.*

2-15

ABOUT THIS PHOTO *A 70-200mm telephoto zoom lens allows you to shoot from farther distances. Photo courtesy of Canon.*

A *wide-angle lens* exaggerates the spatial relationship of objects in your image. Typically denoted by any measurement less than 50mm, a common wide-angle lens is 16-35mm. This lens perspective is fantastic for capturing the interior of a room or large, expansive environmental portraits. Besides including a wider field of vision, a wide-angle lens is shorter than a telephoto lens and can render a deeper depth of field. This lens is a favorite with landscape photographers who intend to capture detail from the foreground to the background of their images.

Be aware that anything close to the wide-angle lens appears a good deal larger than life. Although this is often not a flattering perspective for portrait photography, you can create some very interesting effects by shooting with a wide-angle lens close to your subject.

An example of a wide-angle lens is shown in 2-16.

Macro lenses are available in various focal lengths (for example, 50mm, 65mm, and 100mm) and, unlike other lenses, allow you to photograph your subject at shorter focal distances than other lenses. Shooting with this lens not only produces images with a different scale, but it also focuses your viewer's attention on details that might otherwise go unnoticed and gives your images a close-up, intimate feel. For example, you can use a macro lens when photographing babies and kids. Soft little features on babies can go unnoticed in portraits taken at a typical distance, and close-up images can create a more intimate connection with your viewer.

Compact digital cameras have a Macro mode that enables the camera lens to capture images up close. Although the results are not as magnified

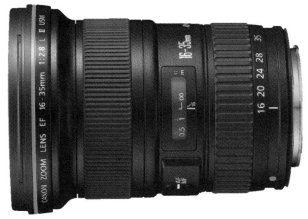

2-16

ABOUT THIS PHOTO *A 16-35mm wide-angle lens can capture a wider field of view and increase your depth of field. Photo courtesy of Canon.*

as a dSLR lens, this setting can help you produce beautiful close-up images. An example of a macro lens for a dSLR camera is shown in 2-17.

Selective focus lenses are used to correct the converging lines of buildings as you compose your shot from the ground, providing a solution to the unnatural perspective problem. These lenses and other selective focus lens variations are also used for a contemporary effect. You can manually control the lens to find a sweet spot of focus in your image and artfully blur other elements, producing a dream-like aesthetic. An example of a selective focus lens is shown in 2-18.

 note A *lens mount* is the point of connection between the lens and your dSLR, and these connections are proprietary to the camera's manufacturer. Before you purchase a lens, ensure that it works with your particular camera brand.

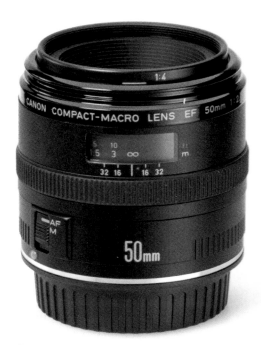

2-17

ABOUT THIS PHOTO *A 50mm macro lens allows you to capture close-up images without distortion. Photo courtesy of Canon.*

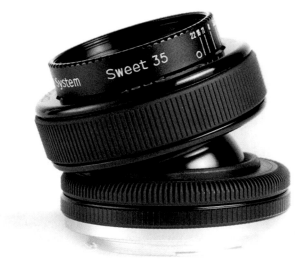

2-18

ABOUT THIS PHOTO *Selective focus lenses can help you create an image with a dream-like aesthetic. Photo courtesy of Lensbaby.*

LENS FILTERS

A digital camera's white balance now replaces the need for most color-balancing optical filters that were required for film images. Computer software also reduces the need for effect filters, such as the softening filter or a starburst filter. Now, a well-stocked camera bag includes just a few essential filters for your lens.

A *UV filter* is a clear, glass filter that attaches to the front of your lens and helps cut down on atmospheric haze, producing a clearer shot. This filter also serves as a protective shield against scratches and dings on the front of your lens glass. The logic behind using this protection is that a $20 filter is easier to replace than an $800 lens. Another school of thought states this filter interferes with your focusing sensors and results in a blurry image. (I have personally never experienced this focusing issue with filters and believe that protecting your lens glass against scratches and nicks is very important.)

A *polarizing filter*, as shown in 2-19, is a dark glass filter that is used to darken blue skies, enhance color contrast, and reduce glare and reflections on water and glass. Linear and circular polarizers are available, but you should use the circular polarizer on a digital camera — a linear polarizer can confuse your camera's metering and autofocus systems. Because they are darker glass, polarizing filters reduce the amount of light entering your lens, and, therefore, require a slower shutter speed or wider aperture setting. The polarizing effect achieved in your images depends upon the time of day, the reflective qualities in your scene, and the angle of light in your scene.

A *neutral density (ND) filter* does not affect the color in your scene, but it does reduce the amount of light entering your lens. These filters are available in varying degrees of strength, and

2-19

ABOUT THIS PHOTO *A circular polarizing filter reduces the glare from water and other reflective surfaces, and saturates colors in your images. Photo courtesy of Tiffen.*

you use them when you want to achieve a certain effect but the light is too bright to allow the exposure effect you want; for example, you would use them to blur action in your scene by using a slow shutter speed, or to produce a very shallow depth of field by using a wide-open aperture.

Graduated neutral density filters are dark on one end and then gradually fade to clear in the middle of the filter. This filter is typically used in land-scape portraits in which the sky is much brighter than the land beneath the horizon. With a graduated ND filter, a more balanced exposure is possible.

TRIPODS

If you are shooting in low light or at night, your exposure requires a slow shutter speed, and you need a tripod. Using a slow shutter speed makes your camera sensitive to the slightest camera movement caused by wind, unsteady hands, or

even depressing the shutter button — which often results in out-of-focus images. If you aren't concerned about traveling light, and you have a few extra minutes to set up your shot, using a tri-pod is a good way to improve the sharpness of your images. Trying to handhold a camera using a shutter speed below 1/60 sec. is risky, and using a long focal length lens further increases your chances for image blur.

You also need a tripod for environmental por-traits in which the foreground requires sharp focus through the background. Deep depth of field requires a small aperture, and a small aper-ture, in turn, requires a slower shutter speed to maintain the correct exposure in your scene.

Tripods come in all shapes and sizes, and it's important to choose one that stabilizes your cam-era and is easy to use. A dSLR camera and a long lens can be heavy, so a heavier tripod is necessary to balance the weight and ensure a stable plat-form. A lighter tripod may work well for smaller, lightweight camera and lens combinations. You can stabilize compact cameras with very small, lightweight tripods.

TRIPOD FEATURES

A tripod consists of two major parts: three legs that you can collapse and extend as necessary, and a center shaft that you use to raise or lower the camera. This center shaft ends at a flat platform through which projects a threaded screw. It's on this platform that you mount a tripod head.

■ **Tripod heads.** Tripods are available with dif-ferent types and qualities of heads. These heads are the part of the tripod that supports the camera and allows you to pivot it into position for your shot. Some tripods are con-trolled by a series of knobs; some have a *ball-head* (see 2-20). Tripod heads with a series of

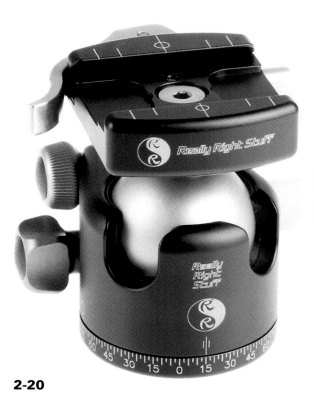

2-20

ABOUT THIS PHOTO *With a ball-style tripod head, you can easily position your camera at any angle. Photo courtesy of Really Right Stuff.*

knobs require independent adjustments for directional camera movement; tripods with ballheads enable you to smoothly adjust your camera in multiple directions with one knob. Both types allow you to move the camera into different positions and keep it stabilized while you compose and capture your image. Whichever tripod you choose, make sure that after you connect your camera to it, your camera's memory card slot is accessible.

■ **Quick releases.** A must-have for photographing with a tripod, a quick release allows you to quickly release the camera from the tripod. It consists of two parts: a plate that mounts on the bottom of the camera and a clamp on top of the tripod head that enables you to quickly attach and detach the camera to the tripod plate. Without a quick release, you are left to unscrew your camera from the tripod head, which can become cumbersome and impractical. If your tripod does not include a quick release, there are quick release adapters available.

> **tip** When using your tripod, position the third leg away from you and not between your legs. This way, you won't trip and accidentally knock over the tripod and your camera.

MINI-TRIPODS

Mini-tripods are smaller, lighter versions of a standard-sized tripod. Often used for stabilizing small, compact cameras on various surfaces, some mini-tripods are designed to hold a dSLR camera with a zoom lens. These mini-tripods are easy to carry and less obtrusive than their larger counterparts. The Gorillapod, as shown in 2-21, is a unique solution because you can easily mold it into various positions and even attach it to objects such as tree branches, poles, or anything that helps stabilize your camera.

MONOPODS

A monopod, shown in 2-22, consists of only one leg and requires you to hold it upright. Monopods are generally used by sports photographers who need to move around on the fly but don't want the burden of holding their cameras all day long. However, a monopod isn't just for professional photographers. You can use monopods in any low-light situation, such as a kid's basketball game or other sporting events where a steady hand and mobility are needed. You can also use a monopod to elevate the camera above a crowd.

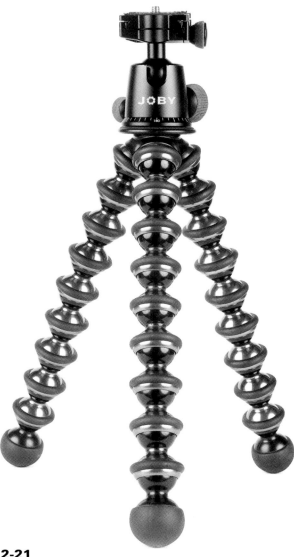

2-21

ABOUT THIS PHOTO *This mini-tripod can stabilize a dSLR camera, even with a large telephoto lens. You can easily fold it up and place it inside a purse or backpack. Photo courtesy of Joby.*

Tripods are constructed with different materials, at different weights, for a range of prices. Visit your local camera store and do some hands-on research to see which tripod feels right for you.

2-22

ABOUT THIS PHOTO
A monopod helps you stabilize your camera when a tripod isn't convenient. Photo courtesy of Gitzo.

REFLECTORS AND DIFFUSERS

One of the secrets to taking flattering portraits is learning how to see and manipulate the light falling upon your subject. Outdoor locations provide plenty of natural light, but if you don't have the tools to modify the available light, your photographs may not turn out as well as you had hoped. Using reflectors and diffusers is fundamental to controlling and manipulating this light.

> *tip* I like to use a collapsible, soft, gold reflector that, when positioned correctly, fills in shadows, brightens faces, and puts a twinkle in the eye of everyone I photograph.

A common mistake when you begin to photograph people outdoors is placing them in harsh, direct sunlight. Harsh light can be very unflattering, cast harsh shadows under your subjects' eyes, and result in squinting faces. The quality of light changes throughout the day. In the morning, the light is soft; by midday, it's directly overhead and very harsh; and then in the late afternoon or early evening, the sunlight softens as the sun sets below the horizon. Be aware of this difference in light quality and plan your photo shoot during the early morning or late afternoon. If shooting midday is necessary, you can soften the harsh light by positioning your subject in a shaded area, or you can place a diffuser between the harsh light source and your subject to soften the light falling upon your subject.

> *x-ref* Find out more about reflecting and diffusing light in Chapter 3.

After you learn the principal of reflecting and diffusing light, you have much more control over the scene and can take advantage of potential lighting challenges instead of avoiding them when composing your photograph.

PROFESSIONAL

If you can afford to buy a professional reflector and diffuser, they will be a practical investment for your photography cache. I bring them on every photo shoot.

Professional reflectors come in various shapes and sizes and are essential for bouncing light back into areas of shadow to reduce contrast and fill in shadows. They're available in white, silver, and gold (see 2-23).

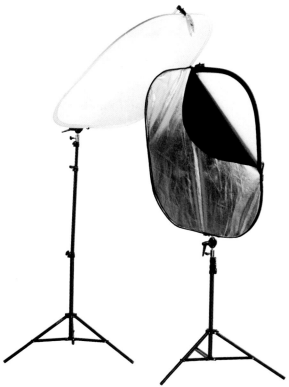

2-23

ABOUT THIS PHOTO *You can use reflectors and diffusers to manipulate light. In this image the diffuser is located on the left and the reflector is on the right. I never go on a photo shoot without them. Photo courtesy of F.J.Westcott Company.*

A professional diffuser is made of translucent material (sometimes called a silk) that is stretched over a collapsible wire disc, as shown in 2-23. When placed between the harsh light and your subject, it softens and diffuses the light falling upon your subject.

HOMEMADE

Whether you're on a budget or you just like to be creative, there are many ways you can make your own unique reflector or diffuser:

- **A reflector is anything that reflects light into your scene.** A mirror, a white tablecloth, a cookie sheet covered in tinfoil, or even a car dashboard reflector can do the trick. Keep the sources of reflection in the white or silver category, otherwise you may end up with some strange colorcasts in your images.

- **A diffuser is anything that diffuses the harsh light falling upon your subject.** Everyday household objects such as a white umbrella, a translucent white shower curtain, or sheer white material can help diffuse harsh light and make your subjects look far more appealing. Get creative! Stick to white or off-white for diffusion fabrics.

LIGHTS AND ACCESSORIES

You create a compelling image by seeing, controlling, and capturing the light that falls upon your subject in the scene. Sometimes natural light is not enough, and you need to light up the scene with artificial light. Most digital cameras have a built-in flash to cover the basic lighting needs, but the light they emit can result in images that look flat and lack subtle gradations of tone. Use your on-camera flash as a last resort to fill in shadows in bright light or to capture images at parties or events where bringing an external flash isn't convenient. If you are determined to take better pictures using artificial light sources, prepare to make some extra room in your camera bag.

Lights for photography can be classified into two categories: strobes or flashes and continuous lights. *Strobes* and *flashes* emit a burst of light for a fraction of a second. *Continuous lights* are consistent light sources that you can easily adjust and manipulate because you can see how the light affects your subject in the scene and then compose your image.

EXTERNAL FLASH

You attach an external flash to your camera (see 2-24) by connecting it on the camera's *hot shoe* — a mounting bracket located on the top of your camera. The main benefit to using an external flash is that it's elevated well above the camera's lens. This extended elevation solves the red-eye problem that occurs due to the proximity of the on-camera flash to the camera lens.

If the flash is designed to work with your camera, you can use the TTL (Through-the-Lens) metering on your camera to create well-lit scenes. You can also swivel the flash head so the light can be reflected off other surfaces, softening the light and extending the coverage over a greater area.

> **note** Red-eye occurs in low-light situations — when an on-camera flash reflects light from the back of the retina into the camera.

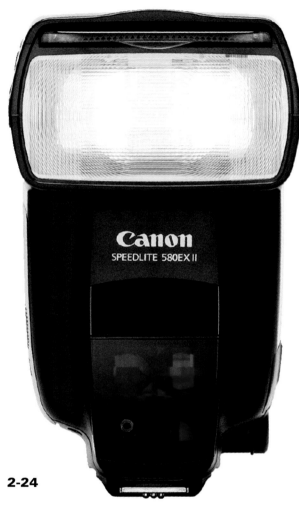

external hot-shoe flash unit designed to replicate the lighting effect produced by traditional, expensive, and heavy powered studio ring light units.

Another type of diffuser is a *bounce card* that attaches to the head of your flash. You can also use a white business card attached with a rubber band. Most new flash units have a white bounce card that pulls out of a slot next to the flash head, creating a nice white bounce of light on your subject.

2-24

FLASH MODIFIERS

You can purchase *flash modifiers* at a camera store or online, and they generally consist of a white, translucent plastic or fabric softbox cover that slips over the head of your flash unit. A popular version is made of molded white plastic, giving a directional but more attractive light. The flashed light passes through the translucent cover and is diffused and softened by the time it reaches your subject. There are many innovative light modifiers available on the market; one variation includes a unique ring flash adapter, as shown in 2-25, for an

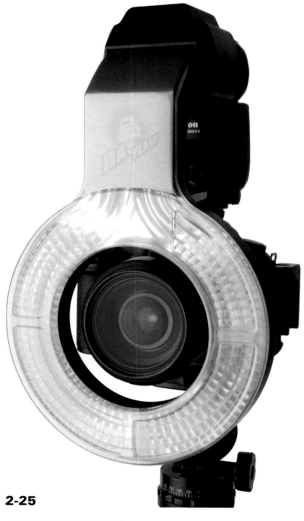

2-25

TRANSMITTERS

There are a few ways to trigger flash units wire-lessly: via an infrared transmitter on your external flash that is attached to your camera, via an infra-red transmitter attached to your camera, as shown in 2-26 and 2-27, or via a radio transmitter, as shown in 2-28. The infrared system works very

2-28

ABOUT THIS PHOTO
A radio transmitter is very reliable and works every-where under all conditions and does not require a line-of-sight to your external flash. Photo courtesy of PocketWizard.

2-26

ABOUT THIS PHOTO *An infrared transmitter triggers other exter-nal flash units to light your scene. Photo courtesy of Canon.*

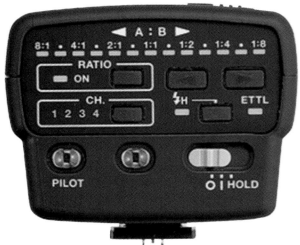

2-27

ABOUT THIS PHOTO *The infrared transmitter controls are featured here. Photo courtesy of Canon.*

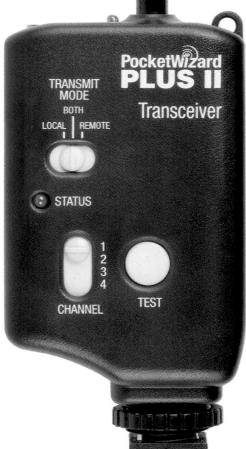

similarly to your TV remote at home — if you are not in direct line of sight or there is an object in between, the signal will not reach the destination. A radio transmitter has no line of sight limitations, can work over long ranges of 1,500 feet or more, and is extremely reliable, but can be more costly.

> **note** A slave flash is an external flash unit that can be used to provide extra lighting. When your camera's flash fires, it triggers the slave flash to fire as well, often within milliseconds. You might use a slave flash to fill in the shadows created by another light source or to even out the light in your scene.

CONTINUOUS STUDIO LIGHTS

Each light source has advantages and disadvantages. A continuous light source is on all the time; this makes it easy to see the light falling upon your subject. The disadvantage is that some continuous light sources can generate a lot of heat and can possibly make your subjects hot and uncomfortable. Fortunately, there are different types of continuous light sources available:

■ **Fluorescent lights.** Fluorescent lights have traditionally been used in offices and public buildings because they are efficient and inexpensive. Unfortunately, they used to emit a sickening, flickering green colorcast. But things have changed! Now professional fluorescent photo lights are very popular because they operate at cooler temperatures, are energy efficient, and daylight balanced. Daylight-balanced bulbs emit a clean, white light, similar to daylight. They can be a very inexpensive and creative light source for your portrait sessions. Check out this Home Studio Lighting Kit that includes an educational DVD (see 2-29).

■ **Photo floods.** You can find photo floods at your local hardware store, and they are very inexpensive. They are similar to household lights in that they emit a golden colorcast, and they are often used as construction or utility work lights. They produce a generous amount of light, but the bulbs have a fairly short life span and put out a lot of heat. Photo floods are not considered a professional studio light source, but I have used them for lighting up backyard party shoots and I have seen them used on many video productions.

When working with hot lights, it's necessary to exercise caution. Read the fine print, determine the allowable bulb wattage, and never clip something over a hot light that could burn. If you are photographing people, avoid pointing the light directly at them. Instead bounce the light onto a white wall, or large whiteboard, and let it cast a softer light upon your subject. Experiment with the white balance settings on your camera for different bulb temperatures.

■ **Household lights.** Yes, those household lights you purchased at your local hardware store can help you illuminate your subject. You can use 200-watt bulbs with inexpensive metal clamp-ons inside Chinese lanterns. A Chinese lantern produces a soft, even light similar to a softbox in a professional photo studio. This is a rather weak light source, so don't expect to light up an entire room, but when it's used creatively, it can be very effective.

■ **Tungsten lights.** Tungsten lights provide a broader range of light and cast a semigolden glow upon your subjects. This continuous light source is affordable, but can be very hot and uncomfortable for your subjects. You also need to be very careful when shooting inside the home with these lights.

Another factor that affects your image is the shape of the light you are using. The shape of the light source creates a reflection, or *catch-light*, in

ABOUT THIS PHOTO *The Home Studio Lighting Kit includes softboxes, stands, and daylight-balanced bulbs, plus an educational DVD hosted by yours truly. Photo courtesy of F.J. Westcott Company.*

2-29

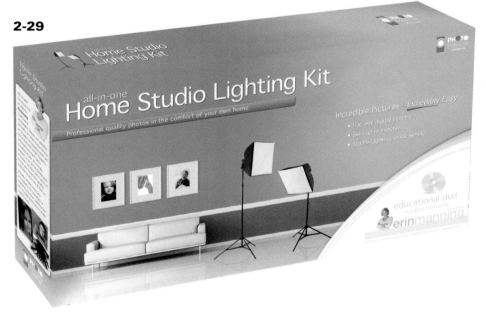

your subject's eyes. Fluorescent bulbs are long and thin, creating a unique light reflection. These lights have been used in many music videos and fashion photographs. The next time you flip through a magazine or watch a music video, look for the light reflections in the model or actor's eyes and see whether you can detect the shape of the light source.

> **tip** Umbrellas are a great tool for spreading and softening light. For example, you might place a white transparent umbrella on a stand between your light source and your subject to soften the light or point your light toward the inside of an umbrella with a reflective surface to redirect it.

ODDS 'N' ENDS

There are so many accessories designed to enhance your photographic adventure, giving you endless options for a safer, easier, more prepared, and more creative experience. Rest assured, you

may never have another boring day in your life after you discover how many photo accessories exist to assist you in this venture.

BACKDROPS

You should always consider the background in your portrait photo. Sometimes the backdrop is the great outdoors or the interior of a home; this is considered an environmental portrait. A classic backdrop is seamless paper or muslin cloth draped behind subjects in a photo studio. Seamless paper backdrops are sold in large rolls and are available in a variety of colors. You can purchase a professional backdrop setup with two stands and a pole that holds the role of paper, or you can fashion your own homemade backdrop by hanging a pipe or wooden pole from the ceiling. Fabric backdrops are also available from a photo supply store, and you can drape them almost anywhere that accepts clamps. Inside or outside, a solid colored backdrop can provide a clutter-free background so your subject is the focus.

CAMERA BAGS

After you start acquiring accessory equipment, you need a place to safely store and transport your camera and accessories. Camera bags come in all shapes, colors, and sizes, so look for one that handles your gear and fits your lifestyle (see 2-30 for an example). Make sure you have enough room for your necessary items: camera, lenses, filters, batteries, media cards, flash, and flash accessories, with some spare room for future purchases. When you visit your local camera store, bring your camera and a few lenses and try the camera bags. Check to see whether the bag is comfortable on your shoulder and your equipment is easily accessible.

When traveling on an airplane, do not check your camera bag at the airport; keep it with you at all times. Check the airline's size and weight limitations for carry-on baggage via its website, well in advance of your trip. When traveling, I prefer to use a durable, well-designed, carry-on-size roller bag, as shown in 2-31.

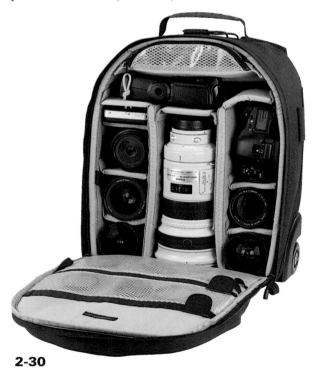

2-30

ABOUT THIS PHOTO *A sturdy, comfortable camera bag is an essential for storing and transporting your camera and accessories. Photo courtesy of Lowepro.*

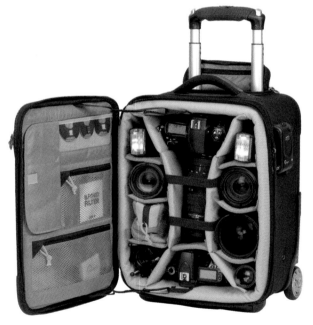

2-31

ABOUT THIS PHOTO *A travel-sized roller bag makes airline travel a little easier. Photo courtesy of Lowepro.*

idea

> Be creative with your backdrop choices — a textured wood fence, a brightly colored wall, and a colorful fabric create different effects in your images. Visit a fabric store and purchase large remnants of fabric to experiment with. Leopard spots, velvet, fur, flowers — use your imagination and play.

DIOPTRIC ADJUSTMENT LENSES

To ensure that images and focusing points in your viewfinder are adjusted for your vision, you can adjust the diopter setting. The little diopter dial is typically located just to the right of the optical viewfinder on a dSLR. The built-in diopter setting handles minimal vision correction and is very handy for photographers who are burdened by eyeglasses. If you require stronger correction than your camera offers, an additional dioptric adjustment lens is available for purchase, and it fits right over the camera's existing optical viewfinder (see 2-32).

2-32

ABOUT THIS PHOTO *A dioptric adjustment lens provides enhanced vision correction, increasing your ability to see through the optical viewfinder. Photo courtesy of Canon.*

PHOTOGRAPHY VEST

These handy vests have a multitude of pockets, enabling you to become a walking camera bag. Sometimes shooting on location or on the go precludes you from setting down your camera bag every ten feet to retrieve a different lens, a battery, or a filter. When you wear one of these vests, your accessories are at your fingertips. Typically made of heavy khaki or olive-colored cotton, they aren't the most fashionable addition to your wardrobe, but they're very practical (see 2-33). If you have trouble finding a vest made specifically for photography, you could wear a fishing vest instead.

2-33

ABOUT THIS PHOTO *A photography vest holds many photo accessories so they're ready at your fingertips. Photo courtesy of Tamrac.*

UNDERWATER CAMERA HOUSING

If you've used the disposable underwater cameras and want more professional-looking images, try using an airtight camera housing made specifically for underwater photography (see 2-34). Housing accessories exist for most camera models, and, depending on the model, they allow you to submerge underwater from 15 to 300 feet. They're great for vacation photos where you plan on spending a lot of time in, and under, the water.

LCD VIEWFINDER HOOD

With digital photography, the ability to view images on the LCD viewfinder immediately after capturing them is a wonderful feature; however, problems can arise when bright, outdoor light makes it difficult to see your images on the LCD screen. Using a small rubber or plastic hood (see 2-35) can help shield the glare, allowing you to see what you're capturing.

2-34

ABOUT THIS PHOTO *An airtight camera housing gives you underwater mobility. Photo courtesy of Canon.*

ABOUT THIS PHOTO *The HoodLoupe is a perfect device for easily viewing your LCD screen in bright sunlight. It also magnifies the image for closer inspection. Photo courtesy of Hoodman Corporation.*

REMOTE SHUTTER RELEASE

When you photograph large groups, using a tripod and a remote shutter release in unison enables you to interact with the group and easily provide direction. This remote release connects to the camera and replicates the functions of the camera's shutter release (see 2-36).

2-36

ABOUT THIS PHOTO *A remote shutter release is handy for taking pictures of subjects that are difficult to approach or for minimizing vibration for close-ups and time exposure. Photo courtesy of Canon.*

LENS CLOTH, PENS, AND TISSUE

A microfiber lens cloth, lens pen, or lens tissue is an essential item in every photographer's bag. By always keeping your lens clean, you can save yourself hours in the postproduction phase of image editing, and it helps preserve the life of your gear.

MULTITOOL KNIFE

Also known as a Swiss Army knife, this is your versatile tool kit for any emergency. The world of photography is full of surprises, and you never know which tool you might need for the unexpected. When traveling, don't pack it in your carry-on luggage, or it's going to be confiscated by airport security. Pack your multitool knife in your checked luggage.

POWDER

Most people have a slightly oily nose and forehead, and the flash of a photographic light can exaggerate this shine. You've probably looked through photo albums and noticed the sheen on people's foreheads; it's rarely attractive and can distract your eye when you view an image. That is why you should keep a bag with colorless, loose face powder and multiple powder brushes on hand when photographing people. Lightly powdering your shiny subjects before a photo shoot pays off. You may hear a few objections from Uncle Gus when he claims that he's never worn makeup before, but if you apply it lightly, the powder reduces the shine, and your pictures look fabulous. On the next family photo shoot, Uncle Gus may holler out "makeup!" and insist on powder for his close-up.

Assignment

Experiment with Backdrops

Use a fabric backdrop as a design element in your portrait. Choose a favorite patterned shirt or dress, bring it to the fabric store, and find a fabric that echoes or contrasts the pattern in your outfit. One or two yards of fabric should be enough for a portrait background. Don't be afraid to try something unusual; go with what feels right to you and experiment.

To complete this assignment, I used one of my favorite black and white psychedelic-patterned shirts on my subject, Gianina, to complement the black and white polka-dotted fabric I found at the fabric store. We played around with props and a fan to enhance the look. Taken at ISO 400, f/5.6, 1/100 sec. with a Canon EF 24-105mm f/4L IS lens.

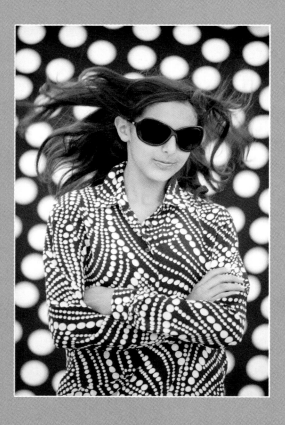

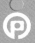 Remember to visit www.pwassignments.com after you complete this assignment and share your favorite photo! It's a community of enthusiastic photographers and a great place to view what other readers have created. You can also post comments, read encouraging suggestions, and get feedback.

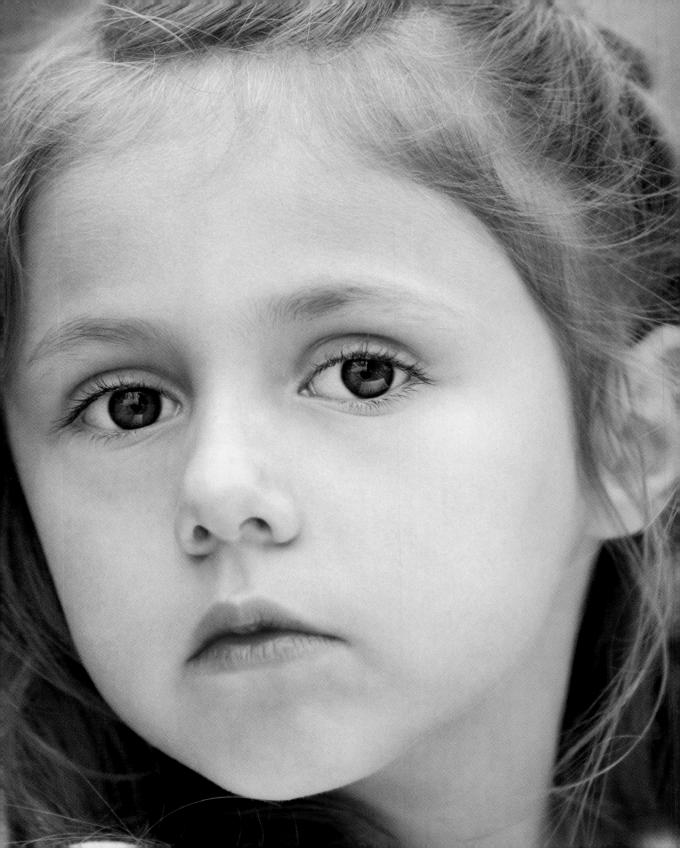

When I initially learned to recognize the different qualities of light, it was equivalent to learning a new language. This new spark of understanding inspired me to develop my creative eye and explore the world of photography more confidently. My goal is to assist you in identifying the characteristics of light so you understand this language and can use it to improve your photographs. Light can speak to you and influence every image you create if you know how to identify the basics.

RECOGNIZE THE CHARACTERISTICS OF LIGHT

Great images are a synthesis of content, composition, technical ability, and timing, but these components are secondary to the presence of light. The quality, direction, intensity, and color of light all have an effect on your image.

QUALITY

Millions of years of evolution have conditioned the human eye to judge all light in terms of natural sunlight. The sun's position in the sky and various atmospheric conditions alter the quality of light visible in our natural world. To develop your awareness of light, look at the world around you at different times of the day and observe how the light falls upon a tree in your backyard or a building in your neighborhood. Think of the soft, warm light of sunrise; the harsh overhead light of midday; or the warm, golden light of late afternoon and sunset, as shown in 3-1.

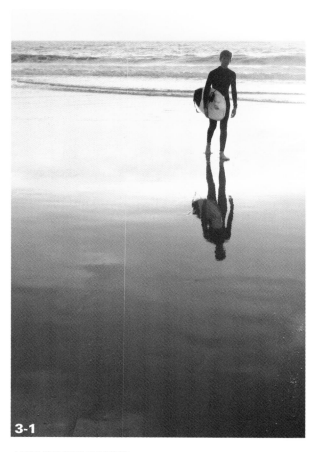

3-1

ABOUT THIS PHOTO *Late afternoon light on a winter day in California creates a magical glow in the sky and a reflection on the sand that captures my surfer subject in silhouette. Taken at ISO 200, f/5.6, 1/250 sec. with a Canon EF 17-35mm f/2.8 lens.*

Learn to read where the light is coming from by looking at shadows. Long shadows occur when the sun is lower in the sky (as shown in 3-2) during sunrise and sunset; short shadows occur when the sun is high in the sky. Notice if the shadows are hard-edged or soft-edged. A general rule for beautiful images is to plan your photo

3-2

ABOUT THIS PHOTO *These hard-edged, long shadows indicate bright, late afternoon light. Taken at ISO 200, f/8.0, 1/800 sec. with a Canon EF 70-200mm f/2.8 lens.*

shoot for early morning or late afternoon because the sun is lower in the sky and equates to softer shadows and less contrast in your scene. This produces a flattering light for your subject.

DIRECTION

The angle of light falling upon your subject is an important concern in portrait photography. Whether the light is natural or artificially created in a studio, its direction dictates the outcome of your image. The four angles of light discussed in

the following list — sidelight, front light, backlight, and top light — are the basic light directions that you need to understand.

- **Sidelight.** Light from the side accentuates facial features and emphasizes texture, revealing shape and form, and providing dimension to the face.

In 3-3, an early morning scene outdoors shows long shadows accentuating my subject's facial characteristics and adding dimension to the rock formations in the background.

ABOUT THIS PHOTO *The texture of Bryan's face and sweater are enhanced by directional, early morning light. Taken at ISO 100, f/6.7, 1/350 sec. with a Canon EF 17-35mm f/2.8 lens.*

 x-ref

Review Chapter 2 for more information about the lighting accessories used in this chapter.

In 3-4, I used a backdrop and homemade studio lights to create an example of sidelight, illustrating the way early morning or late afternoon sunlight might fall upon your subject's face. Image 3-5 illustrates how I achieved this result by positioning a lantern next to my subject to create the sidelight.

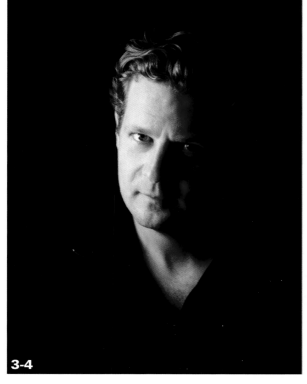

ABOUT THIS PHOTO *Using a Chinese lantern and a 200-watt household bulb, I placed my subject in front of a black backdrop and positioned the lantern off-camera and to the side of his face. Taken at ISO 800, f/4.0, 1/100 sec. with a Canon EF 24-105mm f/4L IS lens.*

ABOUT THIS PHOTO
This is the simple setup I used to illuminate the side of my subject's face. Taken at ISO 800, f/4.0, 1/100 sec. with a Canon EF 24-105mm f/4L IS lens.

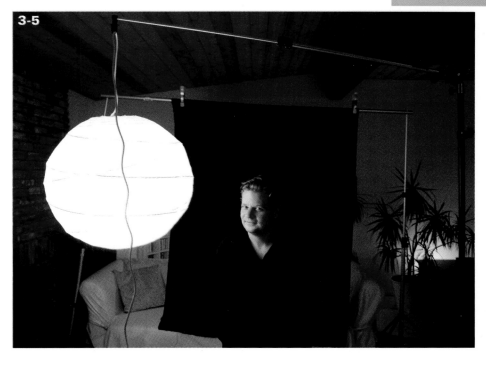

3-5

Front light. When your subject faces the light, it illuminates the entire face. In 3-6, the soft front light of my Chinese lantern illuminates all of my subject's face, yet allows for some tonal subtleties as the light falls away. This is different from the hard light of a camera flash, which creates an image lacking in the gradual tones that help add dimension.

Another example of front light is soft, early morning or early evening light when the sun is very low in the sky. Soft light enables your subjects to face the light without squinting and allows for some gradation in tone, as shown in 3-7.

Backlight. Backlight comes from behind your subject (you are shooting into the light) and can be used to create a rim light, a silhouette, or lens flare. It can also reveal transparency of an object in your image. This can be the trickiest lighting to expose for, but depending on the desired effect, you can master it by metering correctly, reflecting light into the shadows, or simply allowing the backlight to create a lens flare in your image. Following are the ways backlight can affect your portrait images:

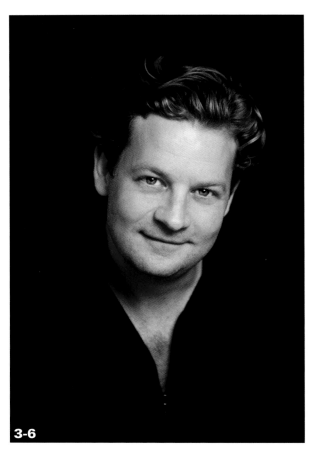

3-6

ABOUT THIS PHOTO *A soft, front light allows for a subtle dimensional quality to my subject's face. Taken at ISO 500, f/4.0, 1/40 sec. with a Canon EF 24-105mm f/4L IS lens.*

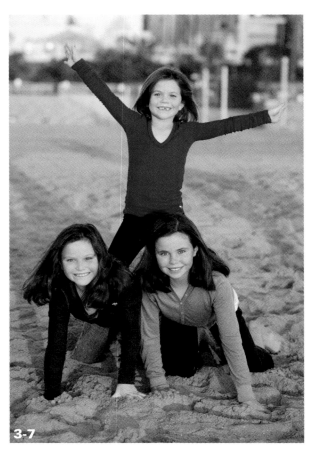

3-7

ABOUT THIS PHOTO *Captured in a playful pose as they faced the light, my subjects were enveloped in the golden glow from the soft rays of the setting sun. The most attractive natural front light occurs at sunrise and sunset. Taken at ISO 200, f/3.5, 1/250 sec. with a Canon EF 24-105mm f/4L IS lens.*

> **Rim light.** Watch how the light falls upon your subject. Create a rim light around your subject by shooting outdoors when the sun is lower in the sky, either early morning or late afternoon. The goal is to shoot into the light while avoiding the sun's direct rays on your lens. Both 3-8 and 3-9

were shot late in the afternoon when the sun was low in the sky. My camera was not pointed directly into the sun, but slightly off to the side to avoid lens flare. A lens hood is also helpful in blocking these rays.

ABOUT THIS PHOTO
The late afternoon light illumi-
nates Pavel's hair, creating a
rim light that helps isolate him
from the background. I use a
gold reflector to bounce light
back onto his face. Taken at
ISO 200, f/3.5, 1/200 sec. with a
Canon EF 70-200mm f/2.8 lens.

3-8

> **Silhouette.** A silhouette occurs when your subject is placed against a brighter background, like a bright sky in the early morning or late afternoon, or right after sunset. If your camera's flash is turned off, its internal light meter will read all the light in your scene and expose for the brightest areas, rendering the shadows black, as shown in 3-10.

ABOUT THIS PHOTO *The backlight in this image illuminates my subject's hair and creates a late afternoon mood. Taken at ISO 400, f/3.5, 1/125 sec. with a Canon EF 70-200mm f/2.8 lens.*

> **Lens flare.** Lens flare is caused by strong rays of light directly hitting your lens and causing a slight haze or veil across the image, reducing contrast and saturation, as shown in 3-11. You might also see a sunburst or

polygonal shapes in your images. Sometimes it happens by accident, but you can create it on purpose for a cool contemporary effect in your images.

caution

Do not look through your optical viewfinder directly into the sun with a telephoto lens. The magnified light can damage your eyes.

tip

When using backlight without a flash or a reflector, make sure your camera is metering the exposure from the subject's face and not from the light source.

■ **Top light.** Harsh overhead sunlight or studio light creates deep shadows under eyes and chins. Unless you fill in the shadows with a flash or a reflector, this is a very unattractive lighting scenario, as shown in 3-12.

There are 360 degrees of possibilities. If the light isn't working for you, change your position, your subject's position, or, if possible, the light source.

INTENSITY

A light's intensity, or brightness, determines your camera's ability to interpret the light and make an exposure. This intensity affects your camera's capacity to capture action and depth of field (DOF). Less intense light creates the need for a slower shutter speed and a wide aperture, which can result in motion blur and a shallow DOF.

ABOUT THIS PHOTO
These guitar players were captured in a silhouette against the after-sunset sky. The long shutter speed allowed for a blurred effect denoting movement. Taken at ISO 1600, f/14, 1 sec. with a Canon EF 24-105mm f/4L IS lens.

3-10

ABOUT THIS PHOTO
By shooting into the sun I created an artistic lens flare effect that envelopes Gianina and her horse with a hazy veil of light and polygonal shapes. Taken at ISO 100, f/4.5, 1/320 sec. with a Canon EF 70-200mm f/2.8 lens.

3-11

3-12

ABOUT THIS PHOTO *Direct overhead lighting is similar to sunlight at high noon — usually not attractive. Try to avoid this direction of light unless you are using it for a particular effect. Taken at ISO 500, f/4.0, 1/40 sec. with a Canon EF 24-105mm f/4L IS lens.*

More intense light helps you capture action with a faster shutter speed and a smaller aperture, resulting in a deeper DOF. The size of your light source and your subject's distance from the light also affect the intensity of the light. For example, if your subject is positioned very close to a bright light, your camera settings would be different from a scene where your subject is positioned far away from the light source. The correct exposure

depends on your lighting conditions, your artistic interpretation of the scene, and the camera settings you use to achieve your desired results.

COLOR

Looking at the world through your eyes, you'd probably never notice it, but light varies in color depending on the source, the time of day, the weather, and a lot of other factors. The human eye automatically compensates for these variations in color and our eyes adjust to always see light as a neutral white. Unfortunately, camera sensors are not as advanced as the human visual system, so your digital camera may produce images with a colorcast.

The color of light is expressed as *color temperature,* measured in degrees Kelvin (K), as shown in 3-13. There are many sources of light, and each source has its own color temperature. For example, photos taken inside your home may have a golden cast, images taken at an office using fluorescent lighting often have a greenish cast, and pictures taken outside in the shade might look a bit blue. Fortunately, digital cameras have a white balance (WB) setting. This control is used to compensate for any difference in color temperature and allows the camera's sensor to record the image as you see it with your eyes. Some colorcasts can be beautiful and evoke a mood, such as the warm glow of a sunset, or they can negatively affect the aesthetic quality of your image, such as a pink or green glow from indoor basketball court lighting. It all depends on your creative vision and intent.

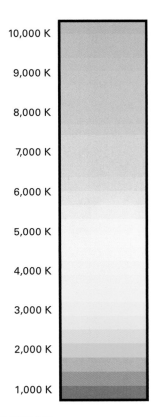

10,000 K

9,000 K

8,000 K

7,000 K

6,000 K

5,000 K

4,000 K

3,000 K

2,000 K

1,000 K

3-13

ABOUT THIS FIGURE *The Kelvin scale represents the color temperature of various light sources, which can translate to a colorcast in your images.*

When your camera is set to the automatic white balance (AWB) setting, it adjusts for the color temperature in your scene and makes its best guess for the proper white balance exposure, rendering the whites in your image a true white, without any strange colorcasts. In some situations the AWB works well, and other times you may end up with a colorcast, as shown in 3-14. Because this default AWB setting doesn't always make the best guess regarding your particular conditions, you need to take control and select one

WB setting for each specific lighting scenario. Digital camera settings vary from manufacturer to manufacturer, so consult the user's manual and find your camera's WB setting. Scroll to the white balance options — daylight, cloudy, incandescent/tungsten, and so on — and pick the one that matches your specific light condition.

Some digital cameras have a manual adjustment setting that allows you to dial in a specific Kelvin temperature. The most accurate method of setting WB is to use the custom WB setting your camera offers. Using custom WB amounts to shooting a white or gray object as a reference and then shooting remaining shots normally. It helps to carry a white piece of paper, white card, or gray card, but other objects can be used as well, such as white shirts, a white door, or a concrete driveway. It's only necessary to have the white or gray object cover the center metering circle in the camera's viewfinder, not the entire frame. It may sound impractical, but this method can improve your photos.

tip By choosing one WB setting for a particular lighting scenario, you're assured of the same colorcast in all the images. This saves time later when adjusting multiple images together in an image-editing software application.

note Color temperature is measured in Kelvin (K). It may sound counterintuitive, but the Kelvin scale describes the intensity of lower-temperature light as red, midrange temperatures as neutral, and the higher readings as blue. Temperatures range from 1,000K to 10,000K.

FIND THE LIGHT

Now that you've learned about the direction and quality of light, where do you find the best light for capturing a beautiful photograph?

THE GOLDEN HOUR

Images captured in the harsh light of the midday sun can look flat and boring, lacking dimension, depth, and warmth, but images captured in early morning or late afternoon light reveal textures, shadows, and depth in warm and vivid tones. Whether you're shooting landscapes or people, this quality of light offers a greater chance of capturing a beautiful and interesting image.

I captured this quintessential California surfer image in 3-15 right before sunset. The light was low in the sky, creating a golden glow, and the sidelight provided dimension to his face. It's almost impossible to capture a bad photo when shooting at this time of day.

3-15

ABOUT THIS PHOTO *The late afternoon light casts a golden glow upon this surfer. Taken at ISO 200, f/5.6, 1/250 sec. with a Canon EF 24-105mm f/4L IS lens.*

What if you don't have the time or luxury of shooting at the most beautiful time of day? Are your chances of capturing a beautiful image… shot? Not at all! It's still possible to capture great images in the middle of the day; you just have to know what to look for.

OPEN SHADE

Open shade can be found almost anywhere on a sunny day: beneath a tree (as shown in 3-16), under the porch of a house, in a doorway, under an umbrella, in the shade of a building, or any other location where the sunlight is not directly

falling upon your subject. This is one of my favorite light sources for shooting pictures of people. It produces beautiful soft light, often mimicking studio lighting, and it's one of the easiest light sources to shoot with.

Placing your subject in harsh direct sunlight often results in hard-edged shadows and squinty eyes, as shown in 3-17. If you place your subject relatively close to the edge of open shade, looking toward the light, you'll be able to see a catch-light in your subject's eye and the person's face will be evenly lit, as shown in 3-18. As the photographer, you can be standing in full sun to get the shot, if necessary, as long as the subject is not in direct sunlight, as shown in 3-19. This means that you can photograph at almost any time of day and not have to worry about the timing of the early morning or late afternoon light.

3-16

ABOUT THIS PHOTO *The open shade found under a tree on a bright afternoon creates a soft, even light for illuminating faces. Taken at ISO 400, f/5.0, 1/320 sec. with a Canon EF 70-200mm f/2.8 lens.*

3-17

ABOUT THIS PHOTO *This photo was taken in midafternoon in direct sunlight. Look at how the harsh light creates shadows across my subject's face, and he can't even fully open his eyes. Taken at ISO 200, f/8.0, 1/320 sec. with a Canon EF 24-105mm f/4L IS lens.*

WINDOW LIGHT

Window light has been a source of inspiration for traditional artists for centuries when they paint portraits of people, still-life images, and the interiors of magnificent works of architecture.

The quality of window light I'm referring to is the soft, indirect light that comes in through a window during the middle of the day. This is different from the hard, direct light that can also come through a window. Direct light can be just as unflattering indoors as outdoors.

3-18

ABOUT THIS PHOTO *I moved my subject into the shade near his house. See how nice and even the indirect lighting is on his face? There are no harsh shadows and he isn't squinting. Now you can see his beautiful blue eyes. Taken at ISO 200, f/4.0, 1/250 sec. with a Canon EF 24-105mm f/4L IS lens.*

Similar to open shade, window light can be a very convenient light to shoot in, especially when the weather outdoors is not comfortable and perhaps your subject wants to stay inside.

Here's how I took a great headshot for a Hollywood actor using window light, a gold reflector, and a gray paper backdrop. We shot the picture in a living room with a couch that faced a big sliding glass door (see 3-20). It was a bright overcast day, so no direct light entered the room, only bright, indirect light. I positioned Adam a couple of feet from the backdrop on a chair facing the window with a gold reflector placed in front

of him, on the floor (see 3-21). I stood out on the balcony and, using a long focal-length lens, zoomed in to fill the frame with Adam's face. The image I captured is shown in 3-22. It looks like a professional studio shot, and you'd never know how easy it was unless I revealed the setup. You can do this, too!

ABOUT THIS PHOTO *I zoomed in to frame Adam's face and eliminate the background distractions. Taken at ISO 400, f/7.0, 1/250 sec. with a Canon EF 24-105mm f/4L IS lens.*

OVERCAST DAYS

You might think that a gray, overcast day would be a good reason to cancel a photo shoot, but an overcast sky can result in great photos. Instead of a direct light source coming from a small spot in the sky, the clouds on an overcast day create a huge softbox in the sky, resulting in even, diffused light falling upon your subjects and less contrast in your images. Overcast skies also allow you to capture more saturated images during the middle of the day.

3-21

ABOUT THIS PHOTO *Here is the setup shot where I placed Adam in front of a backdrop on a chair. He's illuminated by indirect window light and the gold reflector is on the floor in front of him. Taken at ISO 400, f/7.0, 1/250 sec. with a Canon EF 24-105mm f/4L IS lens.*

And if you're lucky enough to have some weather roll in, this can be a great time to take advantage of the different moods weather can evoke in a photograph. For example, I scheduled a photo shoot with a surfer, hoping to capture a golden sunset shot, but the fog rolled in that afternoon. We decided to shoot anyway and instead of the typical "golden sunset" surfer shot most people are used to seeing, I captured a unique image of a surfer walking in the fog, evoking a lonely, moody feeling from the viewer, as shown in 3-23.

3-23

ABOUT THIS PHOTO *Weather helps create an interesting mood in this foggy surfer image. Taken at ISO 200, f/1.4, 1/1600 sec. with a Canon EF 50mm f/1.4 lens.*

EXPOSE FOR THE LIGHT

The word *exposure* refers to the amount of light hitting your camera's sensor and being recorded by the camera's memory card. Your camera gives you a little help with this situation by providing an internal reflective light meter that (once activated by pressing the shutter button halfway) measures the light and dark in your scene and then tells the camera what it thinks the proper exposure should be. You can let the internal light meter do all the thinking for you and see what results, or gain a little more control by adjusting it with your camera's metering settings, or, depending on the light in your scene and your artistic intent, disregard it completely. In any case, it's good to know how to control the light entering your camera with the three *photographic triangle* elements. There is no guaranteed formula for capturing the perfect exposure. The correct exposure is whatever helps create the result you've intended. In other words, you have the ultimate control over your camera's exposure settings to create the image you desire — that's why it's important to learn the details about these elements.

THE PHOTOGRAPHIC TRIANGLE

An exposure is a simple combination of three important elements: aperture, shutter speed, and ISO. It's often referred to as the *photographic triangle*, and it's shown in 3-24.

■ **Aperture.** The aperture is an adjustable opening within the camera lens that controls the amount of light passing through the lens and into the camera. This opening is measured in *f-stops*, which are numeric names that indicate the size of the aperture, such as f/2.8, f/4.0, and f/5.6.

ABOUT THIS FIGURE
An exposure is a combination
of shutter speed, aperture, and
ISO, also known as the photo-
graphic triangle.

3-24

The
Photographic
Triangle

- **Shutter speed.** The shutter is a mechanism that controls the amount of light entering the camera. The shutter speed is the length of time the shutter is open.

- **ISO.** The ISO is the light sensitivity of your camera's sensor or film.

The following sections discuss these three elements of exposure in more detail — they are the essence of controlling and creating your personal vision in a photograph.

WHAT IS A STOP OF LIGHT? The incremental doubling or halving of the quantity of light (aperture) or duration of light (shutter speed) is represented as 1 stop. For example, if you adjust the shutter speed from 1/125 sec. to 1/250 sec. you're reducing (halving) the light by 1 stop, because you're reducing the length of time the shutter is open. If you adjust the size of the lens aperture from f/8.0 to f/5.6 you are increasing (doubling) the quantity of light entering the camera by 1 stop.

Aperture can be the most confusing area for beginning photographers, so don't feel bad if you need to read and reread this section more than a few times. For all lenses, the smallest aperture number, f/1.4, f/1.8, f/2.0, f/2.8, or f/4.0, depending on the lens, provides the widest opening and allows the greatest amount of light to pass through the lens and record an exposure onto your camera's memory card. As you read in Chapter 2, the lens aperture limits your ability to choose various aperture settings on your camera for the desired exposure. For example, this is why you can't select an aperture setting of f/2.8 on your camera if your lens's aperture is only f/3.5. (Keep going here, and it will begin to make sense!)

APERTURE

Shooting with a wide aperture is referred to as *shooting wide open*. The largest aperture numbers are typically f/16, f/22, or f/32. These large numbers represent a smaller opening and let in less light. Switching from a wide aperture opening to a small aperture opening is referred to as *stopping down*. See 3-25 for a visual representation of aperture numbers and sizes.

Along with controlling the amount of light that passes through the lens and into the camera, the aperture has one very important function and creative photographic effect: the size of the aperture determines the depth of field for the photograph. *Depth of field* (DOF) can be described as the area of sharpness (from near to far) within an image. Because the human eye is drawn to the part of an image that is sharp and in focus, it's fun to play with your aperture settings and experiment with isolating your subject and creating a blurred-out background, or capturing a crisp, sharp image from near to far. Think about what you want to creatively convey in your images. Are you more interested in telling the whole story or focusing on just one subject in your scene? I suggest setting your camera to Aperture Priority mode when conducting this experiment. Shooting in Aperture Priority mode allows you to choose the aperture setting and the camera handles the rest of the exposure settings for you.

Use a wide aperture that lets in more light, such as f/2.8, and your subject is isolated from the background due to the shallow DOF, as in 3-26.

Use a small aperture that lets in less light, such as f/16 or f/22, and your subject and the background are in focus from near to far, as in 3-27.

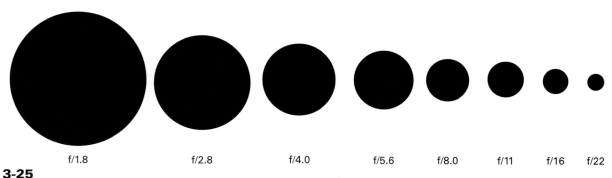

| f/1.8 | f/2.8 | f/4.0 | f/5.6 | f/8.0 | f/11 | f/16 | f/22 |

3-25

ABOUT THIS FIGURE *Camera aperture settings are directly related to the aperture on your lens. Check to see what your lens aperture is. The standard lens apertures are f/1.4, f/1.8, f/2.0, f/4.0, f/5.6, f/8.0, f/11, f/16, and f/22.*

ABOUT THIS PHOTO
An example of shallow depth of field captured at a wide-open aperture. Taken at ISO 200, f/4.0, 1/1250 sec. with a Canon EF 24-105mm f/4L IS lens.

3-26

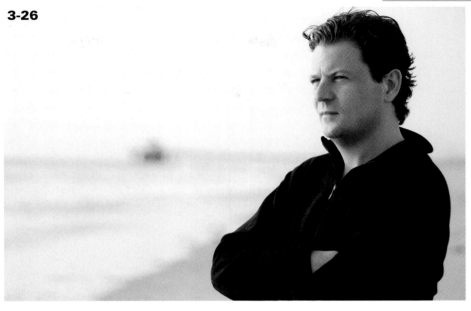

ABOUT THIS PHOTO
An example of deep depth of field using a small aperture. Taken at ISO 200, f/22, 1/60 sec. with a Canon EF 24-105mm f/4L IS lens.

3-27

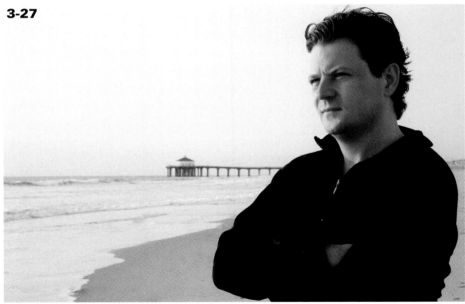

As I mentioned in Chapter 1, DOF is influenced by three things: the focal length of the lens, the distance between you and your subject, and your aperture setting. Out of these three factors, aperture is the most important.

> **tip**
>
> If the aperture concept seems confusing, it helps to think of aperture values (f-stops) in terms of fractions. 1/16 (f/16) is smaller than 1/8 (f/8.0) and therefore lets in less light.

SHUTTER SPEED

Shutter speed is all about time and motion. It's a measurement of how long the shutter remains open and how motion appears in your final image.

Here's how it's measured: The shutter speed numbers displayed by your camera represent seconds, or fractions of a second. The standard speeds are 30, 15, 8, 4, 2, 1, 1/2, 1/4, 1/8, 1/16, 1/30, 1/60, 1/125, 1/250, and 1/500 sec. For example, when the shutter speed is set to 1/250, the shutter is open for 1/250 sec. Cameras vary and some of the newer models offer faster shutter speeds and additional speed increments.

Here's how shutter speed affects your image: A fast shutter speed freezes motion, stops the action, and reveals detail. If you want to stop a hummingbird's wings in flight, use a fast shutter speed of 1/4000 sec. Or to freeze a cyclist in action, use a fast shutter speed of 1/500 sec. I captured a friend in action at 1/1250 sec. as she swung her hair around, as shown in 3-28.

A slow shutter speed blurs the appearance of motion and produces images with a sense of visual energy and movement. When you use a shutter speed slower than 1/60 sec. it's a good idea to stabilize your camera on a tripod or solid surface to avoid camera shake and image blur, unless that's the effect you're intending to achieve, as I did in 3-29, with a shutter speed of 1/50 sec.

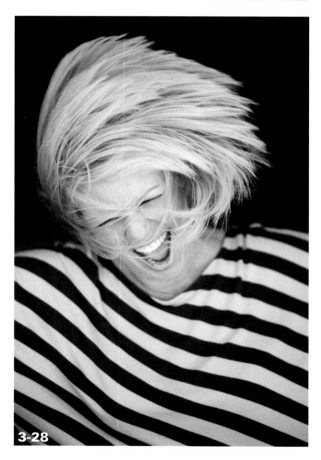

3-28

ABOUT THIS PHOTO *My friend, Karen, is uncomfortable in front of the camera so I gave her direction to swing her hair around and show off her natural energy — and great hair! Taken at ISO 1600, f/1.8, 1/1250 sec. with a Canon EF 85mm f/1.8 lens.*

Check your camera manual to find out which dial or button you need to press to cycle through the aperture and shutter speed choices on your camera.

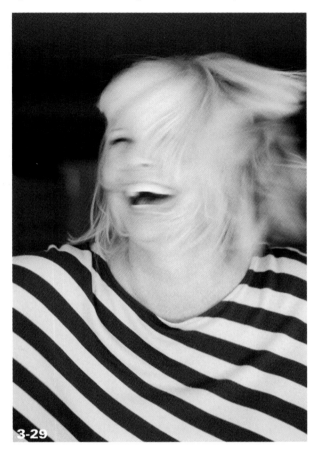

ABOUT THIS PHOTO *The light was fading in this location so I had to use a slow shutter speed to capture the shot, which resulted in motion blur when Karen swung her hair around. The movement created an interesting effect. Taken at ISO 200, f/3.2, 1/50 sec. with a Canon EF 85mm f/1.8 lens.*

ISO

Another way to control the light is to adjust your camera's ISO, as shown in 3-30. ISO is your camera sensor's sensitivity to the light. If you're in a low-light situation, like a party, museum, or school play, and you can't use your flash to light up the scene, to reduce the blur and still capture the shot, raise your ISO to 400, 800, or as high as it goes. There is one catch to raising the ISO: You may see noise in your images. Noise is similar to film grain; it appears as discolored pixels in parts of your image. Some of the high-end cameras like the Nikon D3 or the Canon 5D Mark II allow you to use a high ISO setting without experiencing major image degradation, but many cameras produce images with too much noise when you set the ISO above 400. Raising your ISO can solve the problem of low light, but it's not an ideal solution. You'll have to make an assessment at the time, and decide whether you want a blurry image, due to low light and a slow shutter speed, or a little noise in your image. To capture sharp images, you need to do the following:

- Increase the ISO.

- Open the lens aperture.

- Use a tripod.

If all else fails and you still end up with image degradation, it's possible to make some adjustments in an image-editing software program such as Adobe Photoshop Elements.

| AUTO |
| 100 |
| 200 |
| ISO 400 |
| 800 |
| 1600 |

3-30

ABOUT THIS FIGURE
An example of an ISO camera display.

An ISO (International Organization for Standardization) rating measures the light sensitivity for film or a digital imaging sensor.

METER THE LIGHT

Human eyes can see a greater dynamic range of light than cameras are capable of recording. If your scene is high contrast, with dark shadows and bright highlights, your camera has difficulty capturing all the detail. You have probably experienced the result of this camera limitation if you've taken a photograph of someone positioned in front of a bright background. Although your eyes can see the detail in your subject's face, in the image, your subject is in the dark.

In addition, by positioning your subject in front of a bright background, the sharp contrast between the lights and darks in your image can confuse a camera's internal reflective light meter. When you press the shutter button, the reflective light meter analyzes the light in your scene, selects an aperture and shutter speed combination, and produces an exposure. Understanding how your camera's metering system works is

necessary to control the light entering your camera. You do have options. Take out your camera manual and find the section on metering. Locate your metering mode button and learn about these three ways to control your image:

■ **Evaluative metering.** Depending on your camera, this mode may be called Pattern or Matrix (see 3-31). This is a good default mode because it divides the image into sections, analyzes the light, and calculates for the optimal exposure. The downside is this setting can be fooled by heavily backlit scenes.

■ **Average or Center-weighted metering.** This is the original metering mode used in cameras for years (see 3-32). It meters (reads) the light in the entire frame but gives greater emphasis to the center area of the frame. A work-around for quickly reading the light in a specific area in your scene is to center the frame over the area in the scene you want the meter to read (ensure sharp focus by metering on a focal plane near your subject), press the shutter button halfway, and then recompose your shot.

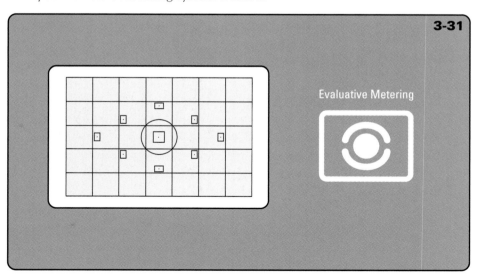

3-31

Evaluative Metering

ABOUT THIS FIGURE
Evaluative metering looks like the image on the left when viewed through your camera's viewfinder. Most digital cameras use the icon image on the right to represent Evaluative metering.

■ **Spot, or partial, metering.** In-camera spot meters, as shown in 3-33, measure the light from a very selective portion of the image (typically about 2 to 10 percent) and give the photographer the greatest level of control over the light reading. Spot metering is especially useful when the scene includes several areas of varying brightness levels, such as a landscape or a backlit subject.

In 3-34, I incorporated a glowing yellow background with a well-exposed face and body in the foreground by using the camera's spot metering feature.

ABOUT THIS FIGURE
Center-weighted metering looks like the image on the left when viewed through your camera's viewfinder. Most digital cameras use the icon image on the right to represent Center-weighted metering.

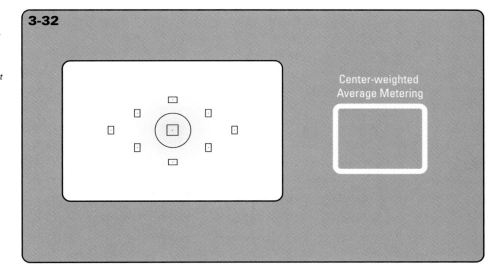

3-32

Center-weighted
Average Metering

ABOUT THIS FIGURE
Spot metering looks like the image on the left when viewed through your camera's viewfinder. Most digital cameras use the icon image on the right to represent Spot metering.

3-33

Spot Metering

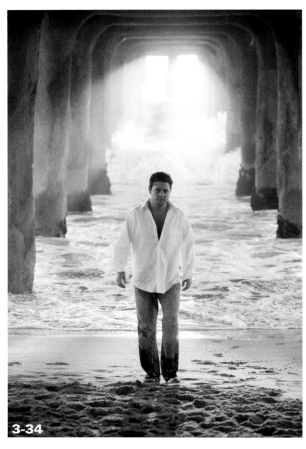

ABOUT THIS PHOTO *Backlight gives Michael a golden rim light to his hair and creates a dynamic image. I exposed for his face and let the background highlights overexpose. Taken at ISO 400, f/4.0, 1/160 sec. with a Canon EF 70-200mm f/2.8 lens.*

On a digital camera, the internal reflective light meter measures the luminance of your scene. The reflected light is averaged into medium-tone 18 percent gray. This is great for rendering good exposures of medium-toned scenes, but may cause problems when you're photographing white or black surfaces. Using exposure compensation is recommended in those instances.

Exposure compensation is a feature that allows you to quickly let more or less light into the camera without manually adjusting your shutter speed and

aperture. You can access it by pressing a button located on the back or top of your camera. It's a quick, semiautomatic way to adjust how the camera records light in your scene. Consult your camera user guide to locate the Exposure Compensation button on your camera. Photographers often use it to override the camera's reflective light meter when shooting a bright, white scene or black surfaces.

In 3-35, my camera metered for the brighter light in the background, rendering my subject a silhouette. In 3-36, I used a flash to illuminate my subject yet still captured the sunset in the background.

ABOUT THIS PHOTO *Metering for the backlight created a silhouette against the setting sun. Taken at ISO 400, f/9.0, 1/200 sec. with a Canon EF 24-105mm f/4L IS lens.*

3-36

ABOUT THIS PHOTO *Michael's jump is captured and illuminated in midair with an on-camera flash. The backlit scene still registers in the background. Taken at ISO 400, f/8.0, 1/200 sec. with a Canon EF 24-105mm f/4L IS lens and Canon 580EX Speedlite flash.*

EXPERIMENT WITH EXPOSURE

Remember the photographic triangle I mentioned earlier? This is where shutter speed, aperture, and ISO all come together with your exposure setting. Every light situation will vary and your creative intent will differ, but here is one example of a standard sunny daylight exposure:

- Set your Mode dial to Manual mode.
- Set your shutter speed to 1/125 sec.
- Set your aperture to f/11.
- Set your ISO to 100.

Take a few pictures and see how the exposure looks. Experiment with adjusting your shutter speed and aperture for different effects.

CONTROL THE LIGHT

Light comes from many sources and directions with varying degrees of intensity. That's why it's important to understand how to identify the light so you can begin to modify it to your liking. Reflecting and diffusing the light creates so many more possibilities for capturing a beautiful image, because you're in control.

HOW TO REFLECT LIGHT

Light is reflected around you every day — mirrors, glass, white walls, and even white tablecloths reflect light. You can buy professional reflectors of gold, silver, and white from camera stores, but you can also use common household items to reflect light back onto your subject. A white foam core board from an art store and a car dashboard reflector are both handy, ready-made reflectors.

To reflect light, find your light source and bounce the light from your main light source with a reflector back onto your subject; this fills in shadows and livens up the catch-light in the eyes. In 3-37, a diagram illustrates a setup for a backlit portrait with a handheld reflector. It helps if you have a willing assistant hold the reflector for you. If you are shooting solo, you can prop the reflector on something or use a stand and reflector "arm" to position and hold your reflector or diffuser.

3-37

ABOUT THIS FIGURE *This is one example of how you might position your subject and your reflector to capture a beautiful portrait.*

 x-ref

Chapter 2 illustrates the use of a reflector and stand.

As you read about earlier in the chapter, shooting portraits on an overcast day results in an even, diffused light falling upon your subjects and less contrast in your images. The same effect occurs when you shoot portraits in open shade. Either way, your subject's face may still need a little brightening. A reflector helps diminish shadows, wrinkles, and many other imperfections, so why not use it? In 3-38, I asked Alissa to hold a soft gold/silver reflector near her face to reflect the ambient light, eliminating undereye shadows, imperfections, and brightening her eyes. You can see the results in 3-39 when I zoomed in for a close-up. This is a great solution for soft shadows on an overcast day or in the open shade, but I don't recommended positioning the reflector this way in direct sunlight because the reflected light coming from beneath your subject's face would result in a horror-film-lighting look!

ABOUT THIS PHOTO
The closer the reflector is to your subject, the brighter the light. Alissa is holding this reflector close to her face to enhance the brightening effect. Taken at ISO 100, f/4.0, 1/320 sec. with a Canon EF 85mm f/1.8 lens.

3-38

3-39

ABOUT THIS PHOTO *I filled the frame with Alissa to crop out the reflector. Taken at ISO 100, f/4.0, 1/320 sec. with a Canon EF 85mm f/1.8 lens.*

HOW TO DIFFUSE LIGHT

You can soften harsh light by placing sheer-white fabric, paper, or a professional diffuser between your subject and the harsh light source. In 3-40, my assistant is holding a professional

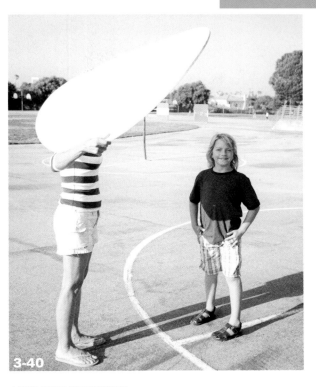

3-40

ABOUT THIS PHOTO *A diffusion disc placed between the light source and Matthew softens the directional afternoon light and evens out his skin tone. Taken at ISO 250, f/4.0, 1/320 sec. with a Canon EF 24-105mm f/4L IS lens.*

sheer-white diffusion disc between the sunlight and my subject, Matthew, to soften the harsh afternoon light.

Figure 3-41 illustrates what harsh light looks like on Matthew's face without a diffuser to soften the light. Figure 3-42 shows the result of using a diffuser to soften the harsh light falling upon my subject's face.

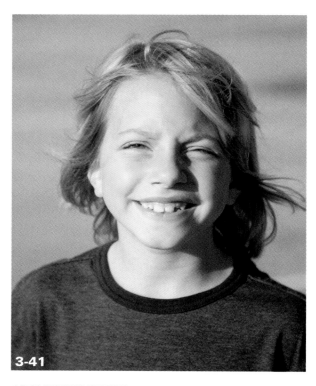

3-41

ABOUT THIS PHOTO *Harsh afternoon sunlight creates shadows across Matthew's face. Taken at ISO 250, f/4.0, 1/800 sec. with a Canon EF 24-105mm f/4L IS lens.*

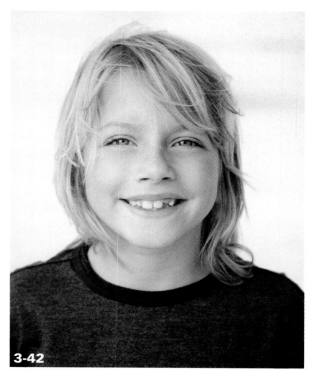

3-42

ABOUT THIS PHOTO *Using a diffuser to soften the light results in beautiful, even lighting across Matthew's face. Taken at ISO 250, f/4.0, 1/320 sec. with a Canon EF 24-105mm f/4L IS lens.*

LIGHTING TECHNIQUES FOR ARTIFICIAL LIGHT

This book deals mainly with photographing in natural light, which is the best place to begin when you're learning about photography because it's readily available and offers so many possibilities for photographs, and it doesn't cost anything. I personally love the authentic quality and beautiful nuances of natural light. Of course, your unique style, subjects, photographic intent, and content will affect your choices. Sometimes, natural light is not enough, meaning you need to illuminate your scene with artificial light. As a very brief overview, photographic artificial light can be classified in two categories:

- **Flashes and strobes.** These emit a burst of light for a fraction of a second.

- **Continuous lights.** These create a consistent and continuous light in your scene.

Whether you're using natural light, an on-camera flash, an external flash, a set of continuous light softboxes, or any other type of lighting, there are a few basic techniques you should know about lighting your subjects.

The following sections on lighting ratios and lighting patterns may sound somewhat technical, and if your eyes are glazing over about now, don't worry. It's really all about how the light falls upon your subject and various ways for you to control it. At this point, I'm not going to advocate using any other equipment (such as a professional incident light meter) to measure the light, other than your eyes and your camera's internal light meter.

LIGHTING RATIOS

When you photograph people, think about how you want the image to appear: bright and happy, dark and moody, or somewhere in between. You can control the appearance by adjusting the amount of contrast in your scene. Contrast is created with highlights and shadows. The relationship between the highlight and shadow in your scene is called a *lighting ratio*. A lighting ratio is measured in numbers —1:1, 2:1, and 4:1 are just a few examples.

It's easiest to start with one or two lights — a main light and possibly a fill light — depending on how light or serious you want the image to appear. The *main light* is the brightest light falling upon your subject and has the most influence in your scene. It's placed close to the subject and off to an angle, positioned slightly above the eye line. The *fill light* is placed at an angle on the opposite side a little farther away from the subject, and used to fill in any shadows. See 3-43 for an example of this simple setup.

The portraits of my mom in 3-44, 3-45, and 3-46 illustrate the difference between the various lighting ratios. I used two lights in this setup — the main light and the fill light. The fill light is the only light I moved.

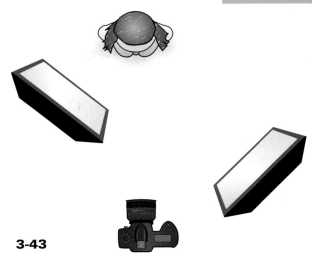

3-43

ABOUT THIS FIGURE *This is one example of how you can position your subject and two lights to achieve various levels of contrast in your image.*

■ **1:1.** This lighting ratio is created by placing the main light and fill light at an angle to your subject and an equal distance away. In this case, each light is approximately 2 feet away from my mom. Because these lights are daylight-balanced florescent bulbs, they're cool to the touch, so you can place them pretty close. The effect is bright and somewhat flat, but this high-key look does tend to diminish imperfections and even out skin tone.

■ **2:1.** This lighting ratio is created by leaving the main light where it is, and backing the fill light away about another 6 inches. Observe the brighter side of the face; it should appear twice as bright as the shadow side of the face. Now you can begin to see how light and dark can create dimension and form in your image.

■ **4:1.** This lighting ratio has more contrast and looks more dramatic because I've backed the fill light even farther away — now it's almost 4 feet away from my mom. You should see approximately four times more light in the highlight areas than in the shadow areas of the face.

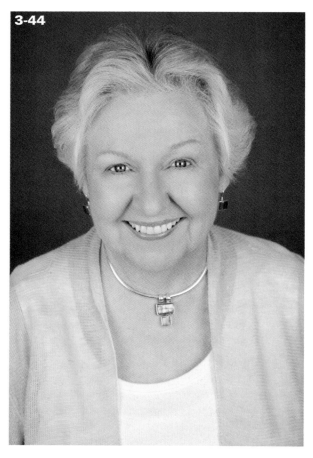

3-44

3-45

Here's a good starting point with your exposure settings:

- Set the Mode dial to Manual mode.
- Set the shutter speed to 1/100 sec.
- Set the aperture to f/5.6.
- Set the ISO to 400.

Take a few shots; if things look too dark, you can adjust the shutter speed and aperture to allow for more light. Just remember that if you use a shutter speed less than 1/60 sec., you'll need a tripod so your images aren't blurry from camera shake.

ABOUT THIS PHOTO *This is an example of a 4:1 lighting ratio.*

3-46

LIGHTING PATTERNS

Lighting patterns have been around for centuries. Take a look at any of the masterpieces from Leonardo da Vinci, Rembrandt, or Michelangelo and you'll begin to notice similar lighting techniques in photography. Whether you prefer to capture candid images or thoughtfully posed portraits, applying a basic knowledge of lighting patterns to your images can significantly help improve your photographs. Following are the four classic lighting styles:

- **Short light.** The main light illuminates the side of the face that is farthest (turned away) from the camera, so the part of the face that is closest to the camera is mostly in shadow, as shown in 3-47. It tends to emphasize the contours of the face and has a slimming effect.

- **Broad light.** The main light illuminates the side of the face that is closest to the camera (turned toward), as shown in 3-48. It tends to reveal more of the face and can add volume to a thin face.

- **Split light.** Only half of the face is illuminated, hence the split. This is a very dramatic light and tends to have a more serious look, as shown in 3-49.

- **Rembrandt light.** Made famous by the Dutch painter, Rembrandt, this lighting style is obtained by positioning the main light high and on the side of the face. It's identified by a small, triangular patch of light on the shadow side of the face, as shown in 3-50. This lighting pattern tends to imply a solid, regal feel in an image.

Learning how to recognize the different types of light is an integral part of creating beautiful images. By studying these basics and applying the principles individually or simultaneously in your shots, you can develop your own unique photographic sensibility.

3-47

ABOUT THIS PHOTO *Short lighting has a narrowing effect and works well for low-key light portraits. Taken at ISO 400, f/2.8, 1/100 sec. with a Canon EF 70-200mm f/2.8 lens.*

3-48

ABOUT THIS PHOTO *Broad lighting deemphasizes facial features and can make narrow faces appear wider. Taken at ISO 400, f/2.8, 1/160 sec. with a Canon EF 70-200mm f/2.8 lens.*

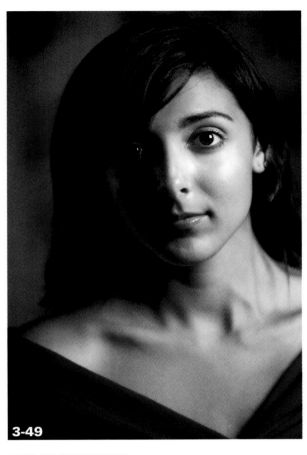

3-49

ABOUT THIS PHOTO *Split lighting has a very dramatic effect. Taken at ISO 400, f/2.8, 1/125 sec. with a Canon EF 70-200mm f/2.8 lens.*

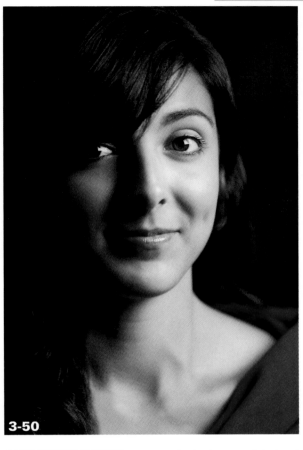

3-50

ABOUT THIS PHOTO *Rembrandt lighting has a classic look and feel. Taken at ISO 400, f/2.8, 1/100 sec. with a Canon EF 70-200mm f/2.8 lens.*

Assignment

Use Sidelight in a Portrait

Sidelight introduces dimension and form in your image. Get creative and use sidelight to create a flattering portrait.

I created the sidelight in this image with 100 percent natural light. I positioned the model outdoors on my patio balcony about an hour before sunset. She was facing the light yet one side of her face was darker because it was pointed toward the interior of my house, which was darker. This dark side helped emphasize the contours of her face and created dimension in the image. This photo was taken at ISO 400, f/2.4, 1/160 sec. with a Canon EF 85mm f/1.8 lens.

 Remember to visit www.pwassignments.com after you complete this assignment and share your favorite photo! It's a community of enthusiastic photographers and a great place to view what other readers have created. You can also post comments, read encouraging suggestions, and get feedback.

COMPOSING YOUR PORTRAITS

Composition Basics

Point of View and Focus

Have you ever wondered why some portraits are more interesting or better than others? What is the mysterious formula? Must you attend art school to understand? Although there is no guaranteed formula, you can shoot better portraits by understanding some basic principles, regardless of whether you have an intuitive eye for design. Let me explain my understanding of intuition: To some extent your ability to intuit and perceive are governed by sensory and intellectual wiring. However, as you develop your understanding and learn about photography, what you learn over time becomes a part of you and your intuitive response. Once you learn to see the design elements all around you, your ability to read an image and create your own compelling photograph greatly improves.

COMPOSITION BASICS

The rules of composition are proven design principles you can use to create compelling images. After you learn these guidelines, your world opens up, giving you infinite creative opportunities because you know the basics. You might think of them as building blocks in your portfolio of creative possibilities. Having honed your intuition, you can then take risks, break the rules, and create your own unique style. Learning the basics can also assist you in critiquing your images and allow you to evolve and become a better photographer.

SIMPLICITY

Less is more. As Leonardo da Vinci said, "Simplicity is the ultimate sophistication." In other words, edit everything out of your image that does not contribute to the story you want to convey. Pay attention to your background when you compose your shot. Is there a plant coming

out of anyone's head? Are toys scattered about? Is there an unknown or unwanted lurker in the scene? An image with elements and objects that compete with your subject is busy and confusing. Your viewer's eyes may dart around the photograph and never rest, and may not even focus on the subject at all.

Da Vinci created his works of art with a blank canvas and painted only what he wanted viewers to see. You, as the photographer, have to create your image amid the clutter of reality and selectively omit anything that is not important. However, you have control over the composition of the shot and how you choose to portray your subject: By using creative framing, you can exclude elements you don't want in the picture. Don't dilute the focus of your image with a busy background. Take the time to move unwanted objects, reposition the camera, and stand back from your subject, or use your camera's lens to zoom in and exclude any distracting elements.

In 4-1, I positioned my subject on an uncluttered, evenly lit stairway to give her the attention she deserved in the photograph. The stairway provided a repetitive pattern with a receding diagonal line that draws your eye through the image. The overhead skylight provided soft, even lighting, and the white walls reflected the soft light onto my subject. I used a gold reflector positioned near my subject's feet, just out of frame, to fill in any shadows on her face.

RULE OF THIRDS

Placing your subject right in the middle of an image is great for the perfunctory passport and driver's license photo, but unless other interesting compositional elements are present, it's not an exciting image. When composing your image, use the Rule of Thirds and think of the scene in your

4-1

ABOUT THIS PHOTO *The light was perfect in this stairwell. Taken at ISO 200, f/11.0, 1/125 sec. with a Canon EF 70-200mm f/2.8 lens.*

viewfinder or on your LCD as a tic-tac-toe board, and mentally divide the image into thirds. Try not to place people or things right in the middle of the frame, but instead place something of interest at one or more of the tic-tac-toe intersections. In 4-2, I positioned my friend, Maria, slightly off-center and shot the image in the vertical format from a distance. It's not a very interesting image because it doesn't convey any particular message. Her casual pants and shoes

don't work in combination with the sophisticated scarf, and there is no reason for the shelf on the wall near her knees. I decided to simplify the image by changing my camera position to horizontal, zooming in to exclude the distracting elements, and directing her to lift her arm across the frame. The result in 4-3 is a more compelling image. Her eyes are located near one implied intersection in the frame, and her hand is near another. This placement of important elements in the scene, her eyes and her hand, creates an asymmetrical balance in the image.

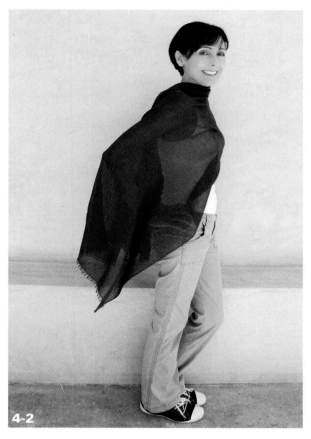

4-2

ABOUT THIS PHOTO *Maria is interesting and full of spirit, but this picture is boring and has no visual message or impact. Taken at ISO 400, f/4.0, 1/100 sec. with a Canon EF 24-105mm f/4L IS lens.*

With a few adjustments to composition and orientation, 4-3 has more impact and conveys simplicity and sophistication. You would never know that she is wearing tennis shoes and casual pants.

Many people place their subjects in the middle of the image because the focusing point on many cameras is located right in the middle of the frame. But a well-composed image may require that you place your subject off-center. How are you going to produce a sharp, focused image of

your subject if she is off-center? Newer digital cameras have multifocusing points that give you more control over how you focus the image, so you don't have to center your subject to focus your shot. And regardless of whether your camera is capable of multifocusing, you can compose your subject off-center by prefocusing with your shutter button. Here is how it works: focus on your subject, press the shutter button halfway to set the exposure and focus, keep holding the shutter button halfway, and recompose your shot.

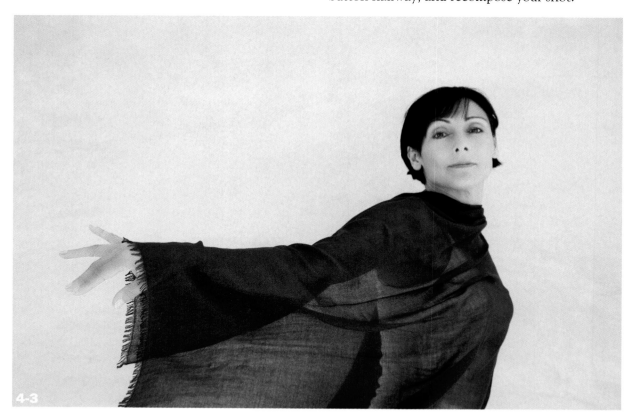

4-3

ABOUT THIS PHOTO *This image has greater visual impact now that I've changed the framing to a horizontal perspective and used the Rule of Thirds. Taken at ISO 400, f/6.3, 1/320 sec. with a Canon EF 24-105mm f/4L IS lens.*

BALANCE

Symmetrical balance in a photograph is achieved when elements on both sides of the frame are of equal weight. This balance is apparent in images where the subject is centered or where objects or areas of light and shadow create a balanced composition within the frame.

Balance can be compared to a playground seesaw; when equally weighted elements are placed on either side of the pivot point, the board is balanced. At its worst, symmetry can be rigid and rather boring; other times it may help convey a sense of rhythm and unity, as shown in 4-4.

LINE, SHAPE, PATTERN

Lines are in everything we see. The straight vertical line of a building, the curved line of an archway, as shown in 4-5, the horizontal line of the horizon, the diagonal line of a runner leaning forward: these are all examples of physical lines. You also create implied lines in your mind's eye, similar to connecting the dots in a children's dot-to-dot

ABOUT THIS PHOTO *This image was captured by my friend, Patricia, in Santorini, Greece. She used multiple lines — diagonal, horizontal, and vertical — to help create visual interest and draw attention to the main subject, which would be me! Taken at ISO 200, f/14, 1/320 sec. with a Canon EF 17-85mm f/4-5.6 IS lens. © Patricia Livinghouse*

ABOUT THIS PHOTO *The repeating pier pylons create a strong sense of symmetry and unity in this image. Taken at ISO 80, f/9.0, 1/80 sec.*

book. Used in image composition, these lines instill a sense of unity, strengthening the composition and guiding the viewer's eye through the photograph. You can control the composition and the resulting level of interest in your photographs by understanding how to work with these lines.

Horizontal lines imply rest and peacefulness; vertical lines give a sense of stability and strength; and diagonal lines are dynamic, implying movement and action. A *leading line* draws your eye into and through an image. This line can begin on any edge of an image, but in Western culture, it typically begins on the lower left and ends somewhere near the right edge or top of the frame.

In 4-6, the diagonal line created by the baseball player in action conveys a dynamic feel.

Converging lines are multiple lines that come together (or come close to one another) and recede into the background of an image. This is a

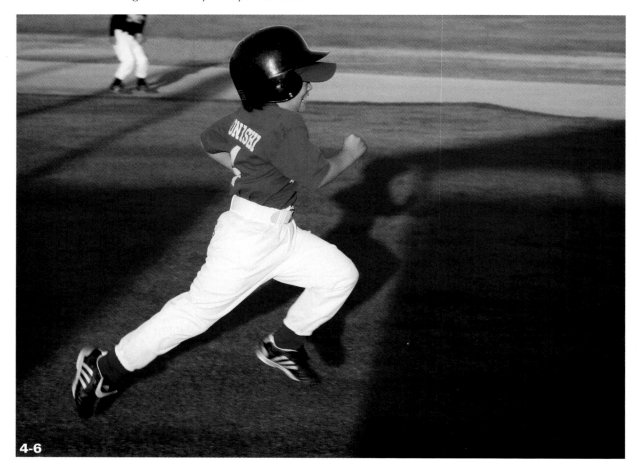

4-6

ABOUT THIS PHOTO *I captured a dynamic diagonal line of Shota running to first base. Taken at ISO 400, f/9.0, 1/400 sec. with a Canon EF 70-200mm f/2.8 lens.*

great technique for capturing the viewer's attention and leading the eye into the frame. In 4-7, I positioned the band members at various distances from the camera inside an elevator and used a wide-angle lens to accentuate the distance between them, from foreground to background. This wide-angle lens perspective helps turn the lines of the elevator interior into diagonal lines that lead into the converging lines of the tracks behind them. These lines help draw your eye through the image.

Small or large, patterns exist wherever lines, shapes, colors, or textures repeat themselves. Stair steps, scalloped house shingles, or trees aligned in a row are all repeating patterns, and when they're used in an image, they can convey rhythm and texture. In portrait photography, pattern is often used as a background element to enhance the scene. You can find interesting patterns everywhere you look. On a recent trip to Venice, Italy, I discovered a beautiful door with a patterned design that provided a perfect backdrop for the red-bloused woman seen in 4-8.

4-7

ABOUT THIS PHOTO *A musician and his new band needed publicity photos and we decided to use an elevator for an interesting shot. Notice how the lines of the elevator continue into the lines of the tracks behind them, converging in the distance. Taken at ISO 400, f/5.6, 1/125 sec. with a Canon EF 17-35mm f/2.8 lens.*

4-8

ABOUT THIS PHOTO *The repeating patterns on this door created an interesting texture in the image. Taken at ISO 100, f/4.0, 1/125 sec. with a Canon EF 24-105mm f/4L IS lens.*

Europe is full of picture-perfect environments, but you don't need to travel very far to find beautiful photo opportunities. I found a nice, patterned backdrop on a recent neighborhood photo-walk with my friend, Maria. It wasn't the most elegant location, as shown in 4-9, but just like shopping at the discount stores, you have to be open and take the time to look for what you want. Would you ever guess that the patterned background in 4-10 is my neighbor's trash bin enclosure?

x-ref

Depth of field (DOF) refers to the zone of sharpness in your image. Your DOF is deep if most of your scene is in focus; it is shallow if a small area is in focus. Chapter 1 explains DOF in greater detail.

ABOUT THIS PHOTO

Who expected that a back-alley trash bin would be the perfect location for a patterned background? Taken at ISO 400, f/6.3, 1/250 sec. with a Canon EF 24-105mm f/4L IS lens.

4-9

ABOUT THIS PHOTO

Using the Rule of Thirds, I placed Maria slightly off-center in front of a patterned backdrop. Shot in midday open shade, the reflection of indirect light from the surrounding buildings created a nice catchlight in her eyes. Taken at ISO 400, f/6.3, 1/250 sec. with a Canon EF 24-105mm f/4L IS lens.

4-10

FRAMING

A framing element in your scene draws attention to your main subject. A well-known framing element is a picture frame, like the one Maria is playing with in 4-11, 4-12, and 4-13. Although it's a literal way to illustrate the point, it does help you remember that a frame focuses attention on your subject by showing your eye where to look. After you become aware of their benefit, whether they are organic or constructed, you can find framing elements everywhere — doorways, archways, windows, overhanging tree branches. You can use any open shape that surrounds your subject on two sides or more in the foreground of your scene. Choose an interesting frame, such as an arched trellis covered in flowers or a unique doorway; this adds to the story conveyed in your image. If your subject and frame lack visual interest due to a similarity in brightness, try finding a frame darker than your main subject. Position your subject in a brighter light than your framing element, and be sure to meter your exposure for the bright light. This enables you to darken the frame around your subject and create greater visual impact.

ABOUT THIS PHOTO *A solid black picture frame helps illustrate my point about framing elements. Taken at ISO 400, f/6.3, 1/250 sec. with a Canon EF 24-105mm f/4L IS lens.*

 note

Your camera's reflective light meter analyzes the light in the scene and determines the proper exposure prior to taking the picture. You can accomplish metering for exposure by pressing your shutter button halfway to read the light from the desired area in the scene.

4-12

4-13

ABOUT THIS PHOTO *Get creative with your framing elements! Taken at ISO 400, f/6.3, 1/250 sec. with a Canon EF 24-105mm f/4L IS lens.*

ABOUT THIS PHOTO *This photo shoot turned out to be a lot of fun. Taken at ISO 400, f/6.3, 1/250 sec. with a Canon EF 24-105mm f/4L IS lens.*

As Maria and I walked around my neighborhood looking for framing elements, I came across a tree with overhanging branches. The first shot, shown in 4-14, has a framing element, but there is too much going on in the background with the houses

behind her and the garage creeping into the frame on the right. As a result, your eye cannot rest on Maria. I moved to my left and captured the image from a different angle (see 4-15). This viewpoint allows the tree to frame her and I have eliminated

4-14

ABOUT THIS PHOTO *The tree branches and grass provide a natural framing element around my subject, but the background is distracting. Both this image and 4-15 were shot in midday sun, in open shade. The indirect reflection of the sun from the surrounding white buildings provided enough light for the exposure. Taken at ISO 400, f/8.0, 1/320 sec. with a Canon EF 24-105mm f/4L IS lens.*

the busy background. Remember this solution when you include a framing element in your scene. Use your sense of simplicity and don't let other objects in your scene overwhelm your subject.

4-15

ABOUT THIS PHOTO *The tree and grass provide a framing element on three sides of the frame. Taken at ISO 400, f/6.3, 1/320 sec. with a Canon EF 24-105mm f/4L IS lens.*

In 4-16 I composed the scene from an interesting angle, used bold primary colors, and included the jungle gym bars in the scene to frame Dylan's face.

4-16

ABOUT THIS PHOTO *This playground structure is a practical element that I used to frame my subject in the image. Taken at ISO 200, f/11, 1/180 sec. with a Canon EF 17-35mm f/2.8 lens.*

Whether organic or architectural, once you learn to look for framing elements you'll find them everywhere. In 4-17 and 4-18, an unusual sculpture on the Greek island of Crete provided an interesting opening for framing my subject.

JUXTAPOSITION

The word *juxtaposition* means placing two contrasting things side by side or next to each other. This placement of two completely different things within a photograph encourages the

ABOUT THIS PHOTO *I zoomed in to focus only on the round, open framing element and my subject. Taken at ISO 100, f/9.0, 1/125 sec. with a compact camera.*

4-17

ABOUT THIS PHOTO *The round opening in this sculpture provided an easy-to-find framing element. Taken at ISO 100, f/9.0, 1/125 sec. with a compact camera.*

viewer to examine the relationship between them and consider their similarities and differences. You can really have some fun with this one; for example, young and old, hard and soft, dirty and clean, big and small, and so on.

Using scale is one way to juxtapose elements in your images. For example, in 4-19 my foot is closer to the lens, making it appear much larger than the beach scene in the background, creating a whimsical juxtaposition. If I wanted to take this idea

further, I could take the same image of my sand-covered toes outside in a snowstorm, creating more disparity between the elements in my frame.

Whether it's intentionally planned or a spontaneous observation, using juxtaposition in an image creates an unexpected and sometimes unconventional way to capture the viewer's attention.

COLOR

Artists and designers use color wheels to study the relationships between colors and how they might affect a painting or the interior colors in a room (see 4-20). The rest of the population makes color decisions every day, from choosing

4-19

ABOUT THIS PHOTO *Juxtaposition opportunities can be found in real-life situations; just be observant and they may pop up in the most ordinary places. Taken at ISO 200, f/9.0, 1/200 sec. with a compact camera.*

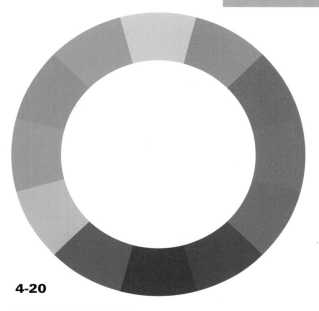

4-20

ABOUT THIS FIGURE *A color wheel is a chart that illustrates color relationships. Analogous colors are located near each other on the wheel; complementary colors are located opposite each other.*

cell phones to automobiles, and carpeting to wardrobes and home appliances. Many of these decisions are based on a favorite color or an intuitive sense of what looks best. However, the study of color is a science and can be very involved and complex. For these purposes, I depart from the complexities of color theory and explain how color can affect a photograph as well as what you should be aware of when you choose colors for your portrait images.

Color appeals to the emotions and creates feeling and response. Warm colors evoke warmth and happiness, while cooler blues and greens are associated with peaceful retreat. Certain color combinations can create punch and impact in your images or evoke a soft, quiet sensibility. Knowing the effect of these color relationships helps you plan the desired result in your images.

Complementary colors lie opposite each other on a color wheel. These opposite colors are complementary because when they appear together, their intensity increases. For example, red and green, blue and orange, and violet and yellow complement each other. Use these colors in combination when you want to create images with strong visual impact.

Analogous colors contain a common hue and are found next to each other on the color wheel. These adjoining colors are similar and blend together nicely, producing a sense of harmony, as shown in 4-21. For example, green and blue, yellow and orange, and red and violet harmonize nicely. Use these colors to convey peace and balance in your images.

Because color is a product of light, the quality of light in your scene is going to affect the intensity (brightness or dullness) of every color. A green tree looks very different in bright midday sun than it does in the late afternoon or on a foggy day. Consider how the atmospheric conditions are going to affect your color choices if you are shooting images outside.

To emphasize your subject's eyes in an image, try experimenting with clothing and backgrounds that match or complement the subject's eye color. In 4-22, I placed Maria in front of a gray wall, draped in a gray scarf. This monochromatic combination of her wardrobe and the background complemented her peach skin tone, brown hair, and brown eyes. The result is an image with subtle color impact that focuses your attention on her eyes.

Use a color wheel and play with the basic color combinations, and then experiment. Shake it up and try something new. Sometimes a happy accident turns out to be a winning image.

POINT OF VIEW AND FOCUS

Are most of your images taken from the same distance and same angle? If so, this may explain why some people are falling asleep during your slide shows. While lenses create different perspectives — for example, a wide-angle perspective or a telephoto perspective — photographers need to understand the importance of their own points of

4-21

ABOUT THIS PHOTO *The pink background, orange shirt, pink and orange flowers, and Dani's red hair provide a harmonious and playful color combination. Taken at ISO 200, f/4.0, 1/250 sec. with a Canon EF 70-200mm f/2.8 lens.*

ABOUT THIS PHOTO *You can also use color to provide an interesting contrast. Gray does not appear on the color wheel, but the gray wall and scarf complement Maria's peach-colored skin and brown hair and eyes. Taken at ISO 400, f/6.3, 1/320 sec. with a Canon EF 24-105mm f/4L IS lens.*

4-22

view. Shifting your point of view includes moving closer or farther away and changing your angle in relation to your subject. The human eye needs variety to maintain interest in an image or collection of images.

POINT OF VIEW

Think about how movies and television shows are edited to tell a story and create visual interest. There is a full shot of an area, then a midrange shot of the scene, and then a detailed close-up, all taken from different angles and varying distances. This dynamic creates visual interest and sends the message, "This is a story, pay attention."

Consider the array of possible viewpoints when you photograph your next subject. Elevate yourself on a ladder or stair and shoot down on your subject. In 4-23, for example, I captured my subject rolling around in the grass on a spring day.

ABOUT THIS PHOTO
The line created by my subject rolling around in the grass is an S-shape and helps draw your eye through the image. The angle captures a natural gesture and expression. Taken at ISO 200, f/5.6, 1/200 sec. with a Canon EF 24-105mm f/4L IS lens.

Vary the distance to your subject. Get up close and capture details about your subject. Perhaps the person has weathered hands or shocking green eyes, and this feature adds to a story. Change your angle and shoot from down below to make your subject seem taller and more important. Image 4-24 portrays a happy high school senior in his graduation hat and gown. I used a wide-angle lens and captured the image by lying down on the ground next to his feet and shooting up. This angle helped me eliminate busy background distractions and focus on my subject. To capture a person looking out the window into the unknown, shoot from behind or from the side of your subject. Take pictures in vertical and horizontal formats to further vary your viewpoint.

Even professional photographers can fall into a visual rut and automatically compose their images a certain way. If your first reaction is to take a picture with a specific composition, go ahead. Next, try to find at least two other compositions for the scene.

4-24

ABOUT THIS PHOTO *Mike was very excited about graduating and I captured his expression from a dramatic angle. Taken at ISO 200, f/7.1, 1/800 sec. with a Canon EF 17-35mm f/2.8 lens.*

SELECTIVE FOCUS

One of the simplest and most effective ways to apply emphasis in a photograph is with depth of field. Depth of field is affected by your aperture setting and this in turn depends upon your lens choice. Most entry-level dSLR cameras include a kit lens that is often an 18-55mm f/3.5-5.6 lens. This lens is cost effective and a good place to begin, but keep in mind that the aperture on this lens is variable, meaning that the aperture varies depending on what focal length you're using (wide or telephoto). The variable aperture of f/3.5-5.6 only allows your camera a maximum aperture setting of f/3.5 when the zoom action is at its widest angle. When you extend your telephoto lens out to its longest focal length, the maximum aperture you can use is f/5.6. If this sounds confusing, refer to the lens section in Chapter 2.

If you have a lens with a wide aperture, such as f/1.8, f/2.8, or f/3.5, you can focus on a single subject and keep the remaining foreground or background detail blurry and out of focus. If you choose a small aperture, such as f/16 or f/22, you can retain an overall sharpness in your image from near foreground to far background. These small aperture settings work with most lenses and cameras.

Your eye is drawn to the sharpest contrast and focus in an image. Rendering my subject in 4-25 out of focus with a shallow DOF enables me to

4-25

ABOUT THIS PHOTO *In addition to using shallow depth of field to focus on the orange, I used the complementary colors of blue and orange to make the orange pop out in contrast to the blue. Taken at ISO 200, f/4.0, 1/100 sec. with a Canon EF 24-105mm f/4L IS lens.*

direct your eye to the orange he is holding close to camera. This is a contemporary way to break the rules and experiment with your images. Depending on your creative intentions, your subjects don't always have to be in focus. Image 4-26 has a main subject in focus in the front and a secondary subject out of focus in the back, placing more importance to the subject in focus. Out-of-focus images can also evoke a dream-like or nostalgic feeling.

With the immediate feedback on your digital camera's LCD viewfinder and the low cost of digital exposure, you now have the convenience and safety to experiment with new ideas. Study the Rule of Thirds, concentrate on framing your subjects, vary your lens perspective, explore multiple points of view, and consider using complementary colors. Don't be afraid to shake it up and try new things and to take a lot of pictures! And remember the words of Leonardo da Vinci: "Simplicity is the ultimate sophistication."

4-26

ABOUT THIS PHOTO *Using selective focus helps direct the viewer's eye and creates visual interest in your image. Taken at ISO 320, f/2.8, 1/320 sec. with a Canon EF 85mm f/1.8 lens.*

Assignment

Use Color

Review the color wheel and choose a color scheme for your next photo shoot. Whether you select a vibrant, complementary color combination or a harmonious, analogous color combination, use color to convey an emotion or attract attention to your image.

When you place complementary colors next to each other, they are intensified. The little girl's green coat and the green grass in the background provide a perfect backdrop for a vibrant punch of complementary color from the flower.

This photo was taken at ISO 200, f/4.0, 1/500 sec. with a Canon EF 24-105mm f/4L IS lens.

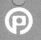 Remember to visit www.pwassignments.com after you complete this assignment and share your favorite photo! It's a community of enthusiastic photographers and a great place to view what other readers have created. You can also post comments, read encouraging suggestions, and get feedback.

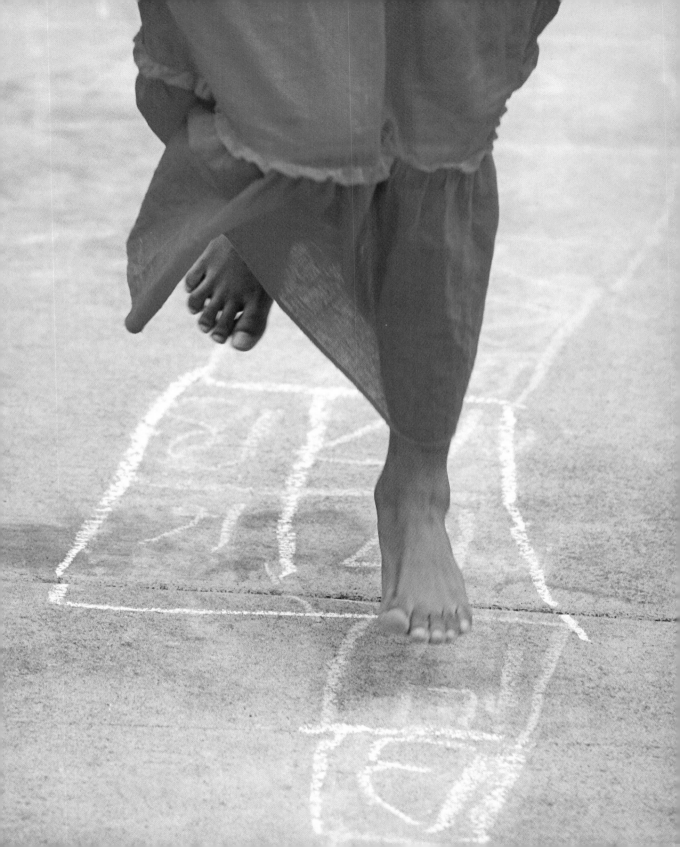

CREATE THE LOOK

EXPLORE THE LIGHT

WORK WITH YOUR SUBJECT

EXPERIMENT

I like to visit art museums and observe how artists have painted, sculpted, or photographed their portrait subjects over time. Although the political, economic, social, and technical context of any era affects the style of a portrait, the inspiration to capture a person's essence and record something important is timeless. Prior to the emergence of photography, a portrait session was reserved only for the wealthy; now with digital photography, everyone can take portraits in a creative, efficient, and cost-effective way.

In addition to the technical and creative execution of your image, a successful photographic portrait captures something significant and identifiable about a person's character and personality. Whether or not you are familiar with your subject, you need to build a rapport and engage him in conversation; observe his expressions, reactions, and body language; and judge how to best capture him in your image. This requires an interest in your subject and sensitivity to human nature. For example, 5-1 reveals my subject's naturally happy disposition. She's involved in high school sports and loves to be outside. I found this out before the photo shoot so we had some topics to discuss while she was in front of the camera. As I positioned her in front of the swimming pool, we also talked about how great her coral-colored sweater looked next to the blue water!

In this chapter, you discover ways to work with your subject, find and create a flattering environment, and capture a compelling portrait.

5-1

ABOUT THIS PHOTO *Alissa was full of smiles after I gave her positive feedback on how beautiful she looked beside the pool. Taken at ISO 100, f/4.0, 1/160 sec. with a Canon EF 24-105mm f/4L IS lens.*

note The eyes are the windows to the soul — focus on them! Unless it's your artistic intent to create a blurred, ethereal-looking portrait, make sure the eyes are in focus.

CREATE THE LOOK

Being resourceful and creative on the fly can be difficult, especially while you are also thinking about the technical requirements of your photo shoot and conversing with your subject. For these reasons, planning a photo shoot beforehand is essential for a successful outcome.

DO YOUR HOMEWORK

Before you begin your shoot, you need to know what your subject expects and how the image is going to be used. Is it for a business brochure or a dating website? A holiday card or an actor's head-shot? A formal sitting or a casual candid portrait? What message should be conveyed in the photo-graph? You can adjust your plans according to the requirements.

Starting with a visual reference is also helpful. A good example is what professionals use when they come up with ideas and need to express them to others on their creative team. Sometimes referred to as "tear sheets," "scrap," or "comps," these visual references can be a page from a magazine or newspaper, or anything that inspires you and helps communicate your idea.

I am constantly on the lookout for visual inspira-tion, whether it's a photograph in a magazine, a painting, a combination of colors, fabric textures, or elements in nature. I save these visual refer-ences in a notebook and refer to them when I begin germinating ideas for photo shoots. I can also use these visuals to convey my intentions and help others articulate their ideas. This enables me to plan a style for my portrait session, and because I have the tear sheet with me, the subject can see the result I am trying to achieve.

SELECT A LOCATION

Portraits are about people, and environmental portraits are about what people do in their lives. When choosing a location for an environmental portrait, try to incorporate the background and location in a way that reveals something about the subject and helps convey a message. For example, a location for a corporate executive's portrait might be inside the office, outside the building, or with the product she provides. Place a teacher in the classroom, a rock climber near the mountains, or a gardener in the garden. The goal is to communicate an idea about a person by combining portraiture with a sense of place.

Finding a location for an environmental portrait is only limited to your imagination, the light, and the time allotted for the shoot. There are so many possibilities. Knowing your location's potential enables you to plan for lighting, props, and ward-robe. For example, if you need to take advantage of natural light, you can rearrange the furniture in the room, or you may discover you need to con-trol the light by reflecting or diffusing it. Remaining flexible invites creativity and new ideas to develop while you shoot.

In 5-2, I created a business portrait for a local real estate broker by using her modern home interior as the location. The portrait was lit with window light, and I used a daylight-balanced softbox to fill in the shadows and add some catch-lights in her eyes. Image 5-3 is an example of how I posi-tioned a design professor in an outdoor location to capture his portrait.

5-2

5-3

ABOUT THIS PHOTO *I photographed a real estate broker inside her home as if she were conducting business. Taken at ISO 400, f/4.0, 1/200 sec. with a Canon EF 70-200mm f/2.8 lens.*

CHOOSE A BACKGROUND

Your subject should be emphasized, and the environment must enhance, not detract from, the overall portrait. Therefore, you need to pay attention to the background. A distracting or busy background can ruin an otherwise good photograph, so look for the simplest background possible. In this section, I cover a few basic background considerations and effective techniques for optimizing your locations.

ABOUT THIS PHOTO *Carm is a design professor and avid baseball fan. We chose a local park as the location to shoot in and brought along some props that convey his interest in baseball, thus combining his love of beauty and baseball. Taken at ISO 200, f/4.0, 1/250 sec. with a Canon EF 70-200mm f/2.8 lens.*

You are at a family gathering and want to capture memorable portraits of your loved ones, but too many distracting elements are behind your subject. Other than clearing out the room, changing your angle, or moving your subject to another location, a good way to eliminate distractions in the background is to stand back and zoom in closer to your subject with your compact camera lens, or to use a longer focal-length lens on your dSLR camera. For example, my mom was visiting for Easter brunch and we thought it was a great

opportunity to take some pictures. I had her sit on the living room sofa facing indirect window light and used a long focal-length lens to zoom in close, as shown in 5-4.

Using a longer focal length has many benefits. It enables you to get closer to your subject and crop out unsightly clutter, and it compresses space, providing a more flattering perspective of your subject. You can also use a longer focal length to create shallow depth of field. Doing this blurs the background and isolates your subject from the surrounding distractions. To achieve this effect, you must move your subject more than a few feet away from the background.

 tip

If you are using a long focal length and shooting in low light, you may need to raise your ISO and/or use a tripod to eliminate camera shake.

Another way to simplify the background is to introduce a backdrop. Professional photographers often use colored background paper or special fabric backdrops purchased from a camera store, but there are other creative alternatives. When you zoom in close to fill the frame with your subject, a smaller backdrop is sufficient and you can use everyday household items in place of professional

5-4

ABOUT THIS PHOTO *This close-up shot places the emphasis on my mom's face. Taken at ISO 320, f/2.8, 1/250 sec. with a Canon EF 70-200mm f/2.8 lens.*

ones. I keep swatches of fabric handy for interesting backdrops, but a blanket, large pillow, or even a scarf works well too. In 5-4 and 5-5 we had fun experimenting with different swatches of fabric as a backdrop and wrapped my mom in colored scarves that complemented her skin tone and enhanced her eye color.

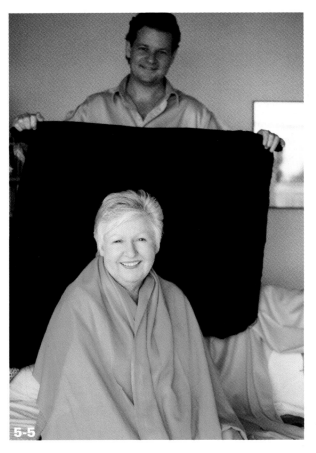

5-5

ABOUT THIS PHOTO *My assistant is holding a piece of black fabric behind my mom as a backdrop to help me set up the shot. Taken at ISO 320, f/2.8, 1/250 sec. with a Canon EF 70-200mm f/2.8 lens.*

If you want to use a larger backdrop, seamless paper rolls and fabric backdrops are available in many colors and are sold in various sizes. You can find inexpensive decorator's drop cloths at building supply stores, or you can create backdrops from sheets or heavy muslin fabric. I have draped backdrops over doors, tables, cars, and beds, but sometimes a designated support system is in order. You can create your own freestanding supports from wood or plastic pipe, or purchase the ready-made version at your local photography retail store or online.

ADJUST WARDROBE, HAIR, AND MAKEUP

Different types of portraits may require different types of clothing, but a proven clothing choice for the portrait photo is a solid color that complements the subject's hair, skin tone, and eyes. Ask your subjects to bring a few different shirts in colors they feel they look good in, for example, a sweater that accentuates a person's eye color. Avoid busy patterns, logos, or bright colors that overpower your subject.

Typically, jewelry and watches are not recommended for portrait photography unless they have a special significance in the photograph or are understated and don't command attention.

Makeup can help enhance a person's best features, even out skin tone, and control the oily shine that causes reflections. If a professional makeup artist is not in the budget, keep the

118

makeup tones neutral, with a soft and pretty finish. Teresa, shown in 5-6, is a natural, fair-skinned beauty and typically wears no makeup at all. I suggested some powder, light eye makeup, and a natural colored lip gloss to add some polish.

tip Powder is a necessity for almost everyone. I keep a few neutral tones of powder compacts in my camera accessories bag; they come in handy when someone needs a touch-up.

ADD PROPS

Props are great for adding an element of interest and purpose in your portrait images. They also help keep your subjects relaxed by giving them something to do with their hands. If you need to use a prop, make sure it's relevant to the message you want to convey. In portrait imagery, fewer distractions result in a more compelling image.

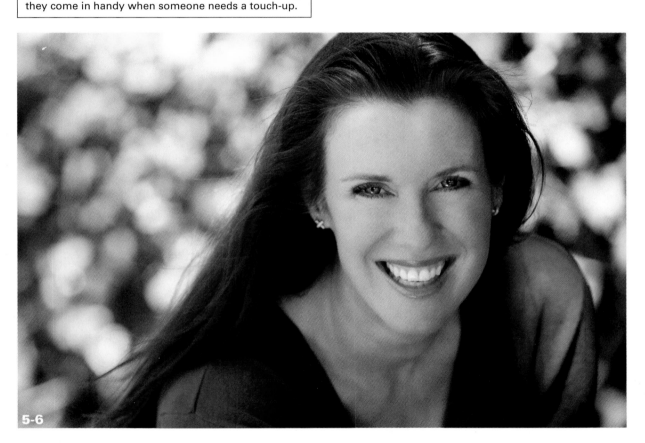

5-6

ABOUT THIS PHOTO *Note the solid purple shirt that complements her skin tone and contrasts nicely with the background. Taken at ISO 400, f/5.0, 1/320 sec. with a Canon EF 70-200mm f/2.8 lens.*

Image 5-7 was designed to reflect Carm's interest in reading and referencing information in his books. We used a magnifying glass to emphasize his interest in examining things while also magnifying the intent look on his face.

In 5-8, the background and props are set up to reflect Carm's interest in the visual arts, and I used his many paintings not only as a prop but to create a visual collage in the photograph itself. His wardrobe is simple and does not detract from his face or the paintings.

Jeffrey's love of surfing and the ocean location suggested the surfboard prop in 5-9. I could have taken a picture of him surfing, but instead chose to have him stand with his surfboard looking out toward the ocean, which gives the photograph a meditative quality — and we didn't have to wait for the big wave.

Introducing another person into the frame with the addition of a prop encourages interactivity between your subjects. In 5-10, an old film camera is used to add some playfulness and a sense of nostalgia to the image.

5-7

ABOUT THIS PHOTO *Positioning Carm in front of his library with a magnifying glass was a fun way to show his interest in reading and examining things. Taken at ISO 200, f/4.0, 1/100 sec. with a Canon EF 70-200mm f/2.8 lens.*

5-8

ABOUT THIS PHOTO *Carm's many paintings made an interesting environmental backdrop and prop. Taken at ISO 200, f/4.0, 1/125 sec. with a Canon EF 17-35mm f/2.8 lens.*

ABOUT THIS PHOTO
Jeffrey lives near the ocean and loves to surf. It was easy to think of this prop and location, and shooting during sunset at the beach is the magical time for light. Taken at ISO 200, f/5.6, 1/250 sec. with a Canon EF 17-35mm f/2.8 lens.

5-9

5-10

EXPLORE THE LIGHT

I prefer to shoot portraits using natural light because it enhances the contours and shading that reveal a person's expressions and facial nuances. Because the direction and quality of sunlight vary significantly throughout the course of the day, it's important to know how to plan for, find, and create beautiful light. After you learn these techniques, your portraits are going to be stunning.

PLAN FOR THE LIGHT

To be fully prepared, you must check your location prior to your photo session to study the light. First, determine where your main source of light is coming from, and then account for the quality of that light and plan your positioning options.

A good rule of thumb is to avoid direct overhead light at all times because it creates deep shadows under the eyes and causes your subject to squint — not a very attractive look.

x-ref

For more on different lighting scenarios and how to work with them, see Chapter 3.

Sunlight is softer and more flattering when the sun is lower in the sky. Early morning and late afternoon are the optimum times for beautiful, natural light. If these times are not feasible, opt for taking pictures in open shade where the light is soft and even. Images 5-11 and 5-12 portray one example for finding and using open shade in a portrait. An overcast day can be a little dull, but the diffuse light works well for portraits.

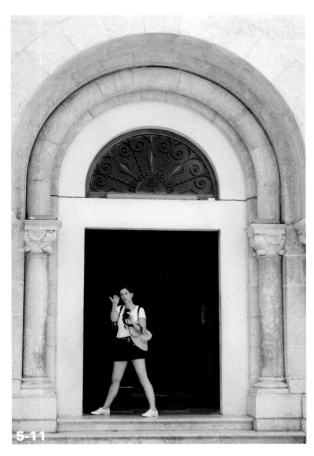

5-11

5-12

ABOUT THIS PHOTO *Open doorways and archways are great places to photograph your subject — they offer beautiful, soft lighting even on a bright, sunny day. Taken at ISO 100, f/4.0, 1/160 sec. with a Canon EF 24-105mm f/4L IS lens.*

ABOUT THIS PHOTO *I zoomed in with my telephoto lens to capture Patricia's portrait. The open archway location provided soft, even lighting on her face. Taken at ISO 100, f/4.0, 1/160 sec. with a Canon EF 24-105mm f/4L IS lens.*

FIND THE LIGHT

Shooting pictures outdoors requires being able to identify good light and knowing how to manipulate it to achieve the look you desire. Tree-filled parks on a sunny afternoon offer open shade for soft, even lighting. When the sun is lower in the sky, you can opt for backlighting your subjects.

Open doorways, north-facing windows, or the shade of a large building or porch are all "good light" possibilities.

> **tip** If your subject's eyes appear dark, use a reflector to bounce soft light into the face and create a catch-light (that little twinkle or reflection) in the eyes.

123

MANIPULATE THE LIGHT

With a few accessories, you can learn to manipulate natural light to your advantage. Your mission is to reflect light into the dark areas and diffuse any harsh light falling upon your subject. For example, I like the "hair light" effect created by backlighting my subjects in late afternoon light. Because my subject's back is toward the sun, his face is in the shade. By reflecting light back into his face, I also create a catch-light in his eyes. A soft gold reflector, a piece of white foam core, or even a car dashboard reflector can be used to reflect the light. When exposing for a backlit portrait, make sure your camera is reading its exposure from the subject and not from the light source. In 5-13, the backlight creates a rim around Pavel's hairline. I bounced some light back into his face with a gold reflector and used a lens hood to avoid lens flare.

Unless it's the early morning light or the golden hour of sunset, direct sunlight can be harsh and unflattering on your subject. You can diffuse and soften this direct light by placing anything translucent or sheer between the light source and your subject. I like to use a silk diffusion panel or a collapsible circular diffusion disk. You can find these

5-13

ABOUT THIS PHOTO
Pavel is an actor in Los Angeles and needed a new headshot. I experimented with different lighting techniques at a local park. In this image, Pavel stands with his back toward late afternoon sunlight. Taken at ISO 200, f/3.5, 1/320 sec. with a Canon EF 70-200mm f/2.8 lens.

items at most professional photography stores. If you prefer to create a homemade diffuser, it's also possible to use a sheer fabric or paper to diffuse the light — white nylon from your local fabric store or tracing paper from the art supply store works well as diffusion material. Experiment taking pictures with these variations of translucency.

It was still bright outside, yet too dark for a good exposure beneath the tree's shade when I was trying to get the shot in 5-14. I positioned Pavel facing the sun and had my assistant hold a circular silk diffuser about two feet in front of Pavel's face to soften the light.

Forcing your flash to fire in bright light fills in harsh shadows and comes in handy if your scene is too dark, but use it sparingly. Flash flattens out features and overpowers the subtle nuances of expression.

5-14

ABOUT THIS PHOTO *Using a diffuser created an even distribution of light on Pavel's face. It also prevented him from squinting and provided a catch-light in his eyes. Taken at ISO 200, f/2.8, 1/250 sec. with a Canon EF 70-200mm f/2.8 lens.*

WORK WITH YOUR SUBJECT

A great portrait is created when a person's true character and essence are captured in an image. Most people don't feel comfortable opening up for strangers or being vulnerable in front of a camera with someone they don't know — that is why connecting with your subject is important to the success of your photo session. It's just you, your subject, and your camera — you need to embrace the relationship. Begin by conversing and finding some common ground. Listen and observe your subject's mannerisms, and, above all, provide an atmosphere of mutual respect.

If you are shooting outside, find a quiet location, especially if you are taking images of someone who is inexperienced in front of the camera. Bystanders can get in the way and distract your subject.

GAIN YOUR SUBJECT'S TRUST

Having a picture taken can be an intimidating and uncomfortable experience for many people. As the photographer, you need to direct and care for your subject. Talk with him about his concerns and alleviate issues he may have about the portrait session and the outcome. It doesn't have to be an elaborate ordeal, just an acknowledgment and a caring response to any questions. When I take portraits of people I've never met before, it may take a little longer to get started, but the investment of time up front always pays off in the final image.

As you take images, be sure to give your subject positive feedback and suggest ways to move or reposition for the camera. "Beautiful! Great! Nice! Wow! Love it! Try turning this way.

That's perfect." Provide any comment that gives the subject direction and communicates something positive about what he is doing. Carry on your conversation while you take pictures. It's easy to capture candid shots when your subject is talking, laughing, and responding to you. If you don't like his position or expression, don't say "No," "I don't like that," or "That's terrible." This only succeeds in deflating your subject's confidence and does not strengthen your connection. Instead, use "Let's try it another way," or "I liked it when you did this." Be sure to communicate clearly so your subject can hear you.

My friend, Dave, is a handsome guy who claimed that he did not "take a good picture." He felt uncomfortable in front of the camera and was convinced that he was doomed to looking bad in portraits. If you did not know him and saw his previous business headshot in the local newspaper, you might think the same thing — but I knew better! With a little coaxing, posing, laughing, and lighting I was able to capture this honest and flattering portrait of him, shown in 5-15. We shot on an overcast afternoon in front of a white brick wall in my backyard. I used a reflector to bounce light into the shadows on his face and to provide a catch-light in his eyes. Now he has a handsome business portrait that looks like him, and from his last report, his picture has even piqued the interest of a few female admirers.

Another way to instill trust in your subject is to get him involved in the process by reviewing some of the photos on your LCD viewfinder. After he sees how good he looks in the images, his worries dissipate and he can relax and enjoy the photo session. Be judicious and set a limit on how many images you choose to show; this is only

an exercise to help relax your subject, not let him control the shoot. Also, be sure to zoom in and check the image you choose to reveal in your viewfinder first to ensure that it's in focus. Your subject/client might ask for that image later, and you may have already eliminated it from the mix if it wasn't sharp enough.

It's necessary to be respectful, encouraging, and flexible, but it's equally important for you to be regarded as competent, knowledgeable, and in charge. Make sure you are comfortable with your camera, and avoid fumbling with your equipment or spending too much time making adjustments for the light. If you aren't prepared to run the show efficiently, your subject loses patience and confidence in you, and may never truly relax in front of the camera.

ABOUT THIS PHOTO **5-15**
*Providing a supportive environ-
ment helps your subject relax
and feel more comfortable in
front of the camera. Taken at
ISO 200, f/5.6, 1/250 sec. with a
Canon EF 70-200mm f/2.8 lens.*

SHARE ON-CAMERA TECHNIQUES

Your portrait session is off to a good start and you are already taking pictures, but your subject looks a little stiff, and her smile seems forced. Don't panic or get discouraged; it's a typical beginning to many photo shoots. Sometimes it takes a while to warm up. To help move the session along, I encourage people to try the following exercises to loosen up in front of the camera:

■ **When your subject tries to smile continu-ously, her face stiffens and her smile does not look natural.** That's when I suggest using the "puffer-fish" technique (shown in 5-16), and I do it with my subjects. Tell them: Take a deep breath, blow up your cheeks like a puffer fish, hold it for a few seconds, and then blow the air out. The result is a relaxed face.

■ **Sitting in one place can be boring and put some people to sleep.** To energize your subject, suggest some techniques to put some life into her on-camera presence. Whether your subject is sitting or standing, she can turn away from the camera and then turn back toward the lens. Add a "Hey" or "Yo" or whatever she wants to say and watch the energy level rise. If she feels silly, you can capture the laughter in a candid image.

■ **Standing in one place can be uncomfortable for many people because they don't know what to do with their hands or body.** Movement helps loosen them up, but how do they move while in the contained shooting area? Instruct them to plant their feet a shoulder's length apart and rock back and forth from one foot to the other foot to create movement and limit any traveling out of frame. It also helps if you demonstrate this technique first.

5-16

ABOUT THIS PHOTO *This is a good example of the puffer-fish technique. Taken at ISO 400, f/3.5, 1/320 sec. with a Canon EF 70-200mm f/2.8 lens.*

■ **Even if your subject is positioned in the shade, bright outdoor light can cause a furrow in the brow and squinting.** When you see this occur, encourage your subject to take a moment, close her eyes, relax her face, softly rub her brow, and open her eyes again when she is ready.

TRY DIFFERENT POSITIONING

Formal and informal posing is an art, especially when the intent is to create a natural-looking portrait. Depending on the subject's comfort level and image requests, I try to include a variety of poses and spontaneous candid shots in each portrait session, along with any last-minute, location-inspired ideas.

There are two basic portrait setups: the head-and-shoulder (headshot) and the three-quarter or full-length. After you study your subject's features, it's time to position him in front of the camera and decide on a flattering way to portray him in the photo. Some people know how to naturally pose in front of a camera, but most feel like a deer in the headlights during a portrait session. Keep a few standard pose ideas in mind and be prepared to suggest some additional ones to compensate for and flatter your subject's body and features.

Adam needed headshots, and we decided that a mix of headshots and three-quarter-length portraits would give him a range of looks to help promote his entertainment career. Image 5-17 is a three-quarter-length portrait that gives the viewer more information about Adam than a standard headshot.

To avoid the dreaded cropped-off arms in the close-up, we added a dark jacket that also provided a nice contrast against the gray backdrop. I directed Adam to lean toward me as if he was talking to me across the table, which resulted in the natural pose and authentic expression you see in 5-18.

Many people don't like the way they look in photographs, but with a few proven posing techniques, you can minimize flaws and enhance their best features.

5-17

ABOUT THIS PHOTO *Casual posing against a solid-colored backdrop creates a simple, yet effective portrait. Taken at ISO 800, f/8.0, 1/250 sec. with a Canon EF 24-105mm f/4L IS lens.*

5-18

ABOUT THIS PHOTO *A close-up headshot should always be included in a portrait photo shoot. Taken at ISO 400, f/6.3, 1/200 sec. with a Canon EF 70-200mm f/2.8 lens.*

Following are suggestions about where to start, what to avoid, and general rules for correcting any posing problems:

- **If your subject is standing, have him place his weight on the back foot and stand at a three-quarter angle to the camera.** Have him also cross his arms or put one hand in a pocket. If there is a wall in the scene, try different leaning poses. Above all, make the pose look and feel natural.

- **If your subject is sitting, use a stool that does not show in the photograph or a chair that complements and does not detract from the** look of your image. Remind your subject not to slump. Experiment facing your subject's body three quarters toward the camera and positioned over the chair back. Try not to shoot your subject facing straight on, unless your intention is a passport photo or driver's license.

- **Mix things up.** Try slanting your subject's shoulders at an angle toward the camera. Have your subject bend slightly at the waist and lean in toward the camera for a more engaging photograph.

- **Don't have your subject lean away from the camera with his chin tilted up high; it appears snooty.**

- **Have your subject tilt his chin down slightly to open up his eyes, but not so low that a multiple chin problem develops.**

- **Shoot overweight people from the side.** Shoot underweight people from the front.

- **Shoot from a low angle to make people appear taller.** Shooting from a high angle makes people appear smaller.

- **Experiment.** It isn't always necessary for your subject to look straight into the camera. Try a variety of head and eye positions. Have your subject turn his head and look off to the side for some shots.

- **For men, a solid pose is to position the head directly at the camera.** Women can look directly into the camera or slightly tilt their heads, but avoid any exaggerated coy poses.

- **Your subjects shouldn't hold their breath for a shot.** Have them take deep breaths and relax their shoulders. Shake it out. Tell women to think "long neck," but don't exaggerate this position or the neck looks like a turtle.

- **Adjust your camera level and experiment with different chin positions to find the most pleasing angle.** Most portrait images are taken a few degrees above the subject's eye line. This is only a guideline; try other viewpoints and see if they work with your subject.

- **Opposite sides of a person's face photograph differently.** Change angles and find the side that works the best.

- **If your subject has prominent ears, hide one ear behind the head by turning the face three-quarters of the way toward the camera.**

- **Watch your subject's hands; this is where tension typically appears in a photograph.** Suggest they rest the hands in the lap or on the back of a chair, or suggest that the chin rests very lightly on one of the hands. If you see the hands clamped around each other or gripping the side of the chair, suggest the subject shake out the hands and let them fall naturally.

- **Encourage multiple expressions for the shots.**

- **Avoid having your subject's arms hanging flat against the sides of the body.** Bend the arms slightly, and try other poses that involve alternate placement of the arms.

Image 5-19 is a good example of natural positioning. I asked Olivia to use her hands in the photograph and she decided on the most comfortable pose.

5-19

ABOUT THIS PHOTO *Olivia's hands become part of the portrait with thoughtful posing. Notice how lightly her hand rests on the side of her face. Taken at ISO 400, f/2.8, 1/125 sec. with a Canon EF 70-200mm f/2.8 lens.*

WHAT EXACTLY IS A HEADSHOT? A headshot is a type of portrait used for marketing purposes in various industries. For example, real estate agents often use headshots on promotional material, and actors and models need headshots to market themselves in the entertainment industry. This style of portrait typically emphasizes the head and shoulders, but this rule may be broken in favor of a three-quarter or full body shot.

CAPTURE CANDID MOMENTS

Posing your subjects works well for formal and casual portraits and is a good place to begin when you take pictures of people, but capturing candid moments is another art form. Successful candid images capture a piece of time that is not rehearsed, posed, or planned. It is a life moment that occurs when people are not aware of the camera or when all conscious thought has momentarily disappeared. This is the authentic human essence that is so sought after in an image, yet so difficult to cajole. It just happens, and you must be observant and ready to capture it. In 5-20, I shot Teresa in front of her favorite painting using a selective focus lens. We were having a conversation about her collection of artwork, and this is the candid moment I captured.

5-20

ABOUT THIS PHOTO
With this dreamy selective focus effect, Teresa's colorful shirt and natural expression become part of the artwork. Taken at ISO 400, f/4.0, 1/60 sec. with a Lensbaby selective focus lens.

EXPERIMENT

A simple portrait can intrigue even the most discerning viewer if it's unique, artful, and emotionally engaging. After you understand the basic photographic guidelines, you can break the rules and get creative. Experiment with your ideas and your equipment. If you make a lot of mistakes, that is perfectly okay. When you shoot with a digital camera, you just erase what doesn't work — but wait until you view your images on a computer screen before you send anything to the trash. Some of the most interesting photographs are happy accidents. You can accentuate an interesting characteristic about your subject, as I did with Courtney in 5-21. He has amazing hair, so I had him swing it around for emphasis.

5-21

ABOUT THIS PHOTO *This hair-in-movement effect creates a unique portrait. Taken at ISO 400, f/4.0, 1/100 sec. with a Canon EF 24-105mm f/4L IS lens.*

CHANGE YOUR POINT OF VIEW

Think about different angles and perspectives when experimenting with your portrait images. Based on the effect you intend to achieve, it isn't always necessary for a face to be present in a portrait or for the image to be in sharp focus. Explore your creative side and let loose.

Sonya is a ballet dancer and her feet are very important to her profession. A typical image would render her feet in focus with a deep DOF. In 5-22, I chose to experiment with a shallow DOF and a different point of view.

TAKE A SELF-PORTRAIT

Now that you understand the basics about taking portraits of other people, try them on yourself by taking a self-portrait. The first step is learning to use your camera's self-timer. By using the self-timer to capture your own portrait, you have control over how you look, how the photograph is taken, and what happens to it afterward.

Press the self-timer icon and cycle through your options. Self-timers on digital cameras vary. Some let you select the time it takes for the self-timer to release the shutter, usually between two and ten seconds. Others have a custom self-timer that allows you to set the countdown time and the number of shots to be taken. The ten-second option gives you enough time to position yourself in front of the camera. Follow these steps to take your picture:

1. **Place your camera on a tripod or stable surface.**

2. **Get rid of any background clutter.**

5-22

ABOUT THIS PHOTO
Sonya's feet are out of focus, yet still a prominent part of the image. Taken at ISO 200, f/2.8, 1/100 sec. with a Canon EF 17-35mm f/2.8 lens.

3. Select a chair to sit on and place it in your location.

4. **Compose your shot by using an object to focus on.** A large pillow or stuffed animal propped up in the chair does the trick. You can also create a group "self" portrait, setting your focus on another person or other people and then moving into the frame, as in 5-23.

5. **Press the shutter button halfway to lock in the focus and exposure; then fully depress the shutter button to trigger the timer.** The red warning light on the front of the camera will blink steadily during countdown, and just before taking the picture it will start to blink faster.

6. **Move into place, get comfortable, laugh, look into the lens, and give the camera a real smile.**

As you take more shots, position your body at an angle to the camera and experiment with various expressions. Keep in mind that smiling and leaning toward the camera convey a friendly, approachable personality.

One way to instantly see how you look is to place a mirror right behind your camera. You can check your expression and see how you look before the picture is taken.

ABOUT THIS PHOTO
This self-portrait of my mom and me was achieved by using my camera's self-timer and a tripod. Taken at ISO 200, f/2.8, 1/320 sec. with a Canon EF 70-200mm f/2.8 lens.

5-23

Assignment

Create a Portrait Using a Visual Reference

Regardless of whether you've constructed a physical visual reference book (which I highly recommend), visual references are around you everywhere. Sometimes, it may not be an exact image that inspires you, but rather an impression of a series of images or a particular style. I like to visit art museums and peruse art books for ideas. I was inspired to create the following image after looking at many paintings over time. I tried to re-create the feel of a Renaissance painting with the selection of my model, her wardrobe, and the lighting. I positioned the model on a chair in my living room and used one softbox from my Home Studio Lighting Kit to illuminate her face.

Taken at ISO 400, f/2.8, 1/160 sec. with a Canon EF 70-200mm f/2.8 lens.

Remember to visit www.pwassignments.com after you complete this assignment and share your favorite photo! It's a community of enthusiastic photographers and a great place to view what other readers have created. You can also post comments, read encouraging suggestions, and get feedback.

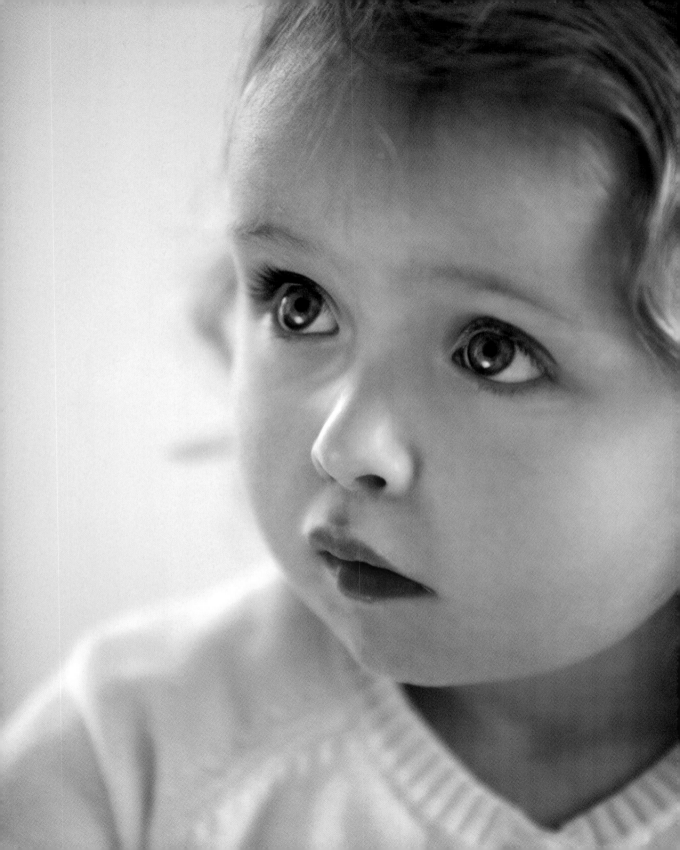

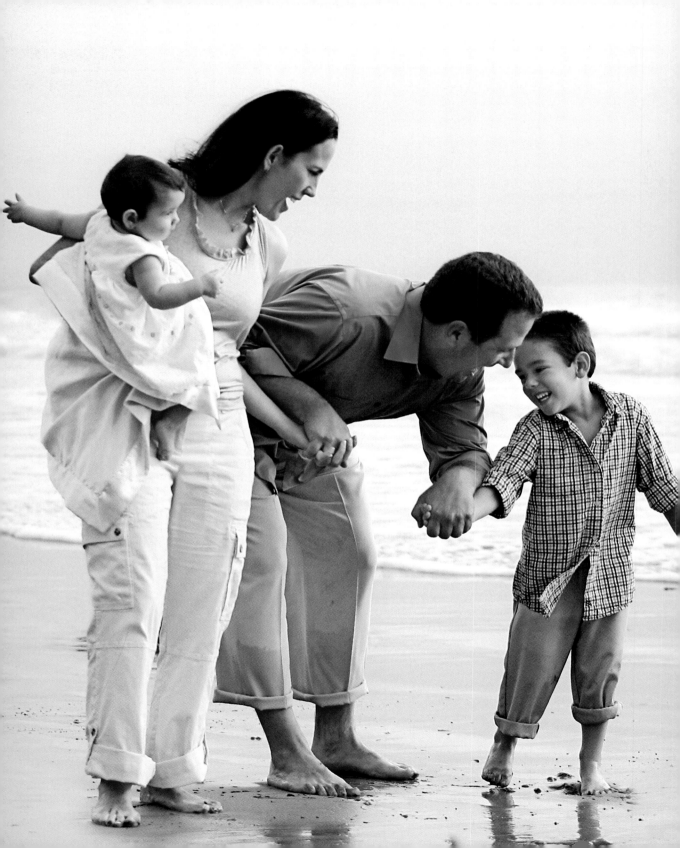

Whether you're celebrating a birthday, gathering for a family reunion, or documenting a child's sports team, photographing groups requires specific preparation and a particular approach to create a successful image.

Your preparation, communication, composition, and attention to light are important and include some of the same considerations as a single portrait; however, there are additional things to think about prior to a group shoot.

PREPARE

Having the luxury of planning a formal group photo session before it happens gives you more control over the outcome than taking photographs as a camera-toting party guest; however, they both require preparation prior to pressing the shutter button.

For large occasions, people may hire professional photographers and ask you to come in and shoot the candid shots; at smaller functions, you may wind up doing a bit of both. If a professional photographer is at the event, you should be aware of photographer etiquette.

Do not follow the professional photographer to his formal portrait setting and start taking pictures over his shoulder. It can distract the group from fully engaging with the professional and is considered to be stealing the shot. As a considerate guest and fellow photographer, wait until these formal shots are over and use your existing relationships and communication skills to connect with people at the event and capture casual, candid shots.

LEARN ABOUT YOUR SUBJECTS

Having knowledge about your subjects prior to taking a photograph helps you think about various locations, positions, and directions to use for the photo session. Whether you're capturing formal groups or candid shots, you need to find out the number of people involved, the approximate age range, height, genders, and relationships among your subjects. The size of the group dictates the location. Is it a 50-person reunion or a family of four? Is there a wide age range? Think about how you would arrange a group of 80-year-olds versus a sports team of 7-year-olds. Would some people be more comfortable sitting than standing? Is the relationship among the subjects personal or professional? Be considerate and make sure that your posing suggestions don't make anyone feel inappropriate or uncomfortable. Is there a guest of honor? All this information assists you in making a thoughtful plan and provides ideas for creating an image everyone loves. When you are confident and happy about your photo session, it shows, and your subjects mirror your relaxed, cheerful attitude.

KNOW THE DESIRED RESULT

Some group photographs are meant for a specific purpose. Know what the purpose is and make sure you plan your location, lighting, and positioning accordingly. A casual group photo might incorporate an unusual background and more spontaneous moments, but a formal group portrait would more likely include a simple background and a traditional pose. If your subjects request a certain style — formal or casual — you need to know how to produce the desired result. For example, I captured a series of contemporary, casual portraits at the beach that included a family of four along with portraits that expressed individual relationships between members of the family, as shown in 6-1. In this photo, a father and his infant daughter share a special moment together as she dips her toes into the water.

This is an extreme example, but I'm hoping the visual helps you remember this important element in your images. A compelling photograph captures and helps define the relationship between people in an image. Think about the possibilities before taking the shot. It's good to always have a series of ideas in your head because sometimes you only have a few minutes before positioning and photographing your subjects.

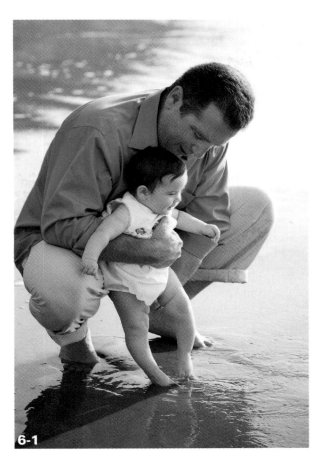

ABOUT THIS PHOTO *A casual beach feel with candid moments was exactly what this family wanted for their family portraits. Taken at ISO 100, f/4.5, 1/400 sec. with a Canon EF 24-105mm f/4L IS lens.*

CONSIDER RELATIONSHIPS

There is a different dynamic when more than one person is in front of the lens. Just by including people together in a photograph, a particular relationship between them is assumed by the viewer. The relationship varies depending on the type of group you're photographing. A photo of a newly engaged couple, as shown in 6-2, implies a more intimate and casual relationship than a group portrait of attorneys at a professional law firm.

ABOUT THIS PHOTO *Posing for a casual engagement photo reveals a more intimate relationship — and portrait photos for newly engaged friends are always a welcome gift. Taken at ISO 200, f/4.5, 1/400 sec. with a Canon EF 70-200mm f/2.8 lens.*

CHOOSE A LOCATION

Are you shooting a large group or a small one? A large group requires more space, and you or some of your subjects need to be elevated to include everyone in the scene. Scout various locations for your shoot if you are planning it in advance. Look for simple backgrounds and evaluate the available light around the same time of day you plan on shooting.

During the day, indirect, even lighting, found just inside an open garage door or under a shady tree in midday sun, is ideal for photographing couples and small groups. Early morning and late afternoon afford the most flattering light for your subjects. If you are photographing a large group, position your subjects with their backs to the sun and fill in the shadows on faces with a reflector or fill flash. You don't want your subjects squinting into the camera.

If you are a party guest and just wandering into the location for the first time, look around and locate simple backdrops and places to sit or stand that afford even lighting. If you're shooting inside in low light, consider turning off your flash to capture ambient light in the room. If your exposure is too dark, raise your ISO setting. This allows more light to pass through the lens and enables you to expose for the low-light scene without using flash.

The downside of using a high ISO speed is the possibility of digital noise and artifacts in your final image. Experiment with different ISO settings until you find one that captures the mood of the ambient light in the scene. When shooting in low-light without a flash, you may need to stabilize your camera on a table or tripod to eliminate blur caused by camera shake resulting from a slower shutter speed.

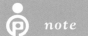 *note*

> Noise is the digital version of film grain. It creates discolored pixels, also knows as *artifacts,* throughout your image.

Some parties and events occur in very low-light situations and require a flash to see people's faces. In these locations, use the Night Flash or Slow Sync mode on your camera. This setting uses a slower shutter speed with the built-in flash and picks up the beautiful ambient light in the room while it lights up your subject's face. Keep your camera very still in this mode or use a tripod to eliminate camera shake and blurred images.

My neighbors asked me to capture some family photos of them on the beach, and fortunately they were willing to be adventuresome and creative when I posed and positioned them in different locations. The lifeguard stand in 6-3 offered an elevated perspective for positioning the entire family.

LOOK AT THE LIGHT

Your eyes are capable of seeing a greater dynamic range of light than your camera can, so you must be aware of harsh contrasting light in your scene and try to avoid it when positioning your subjects.

Natural light creates some of the most beautiful images. However, contrasting lights and darks throughout your scene make it difficult for your camera to correctly expose the shot — and harsh shadows across faces are not attractive. Neither are squinting eyes due to facing bright sunlight. If you are shooting outdoors, make sure you place your subjects in an evenly shaded area or face their backs toward the sun. If the scene is too dark, fill in shadows with a fill flash or bounce soft light into their faces with a reflector.

ABOUT THIS PHOTO

The elevation of the ramp on the lifeguard stand provides an interesting and practical location for this family photo. Taken at ISO 400, f/13, 1/50 sec. with a Canon EF 24-105mm f/4L IS lens.

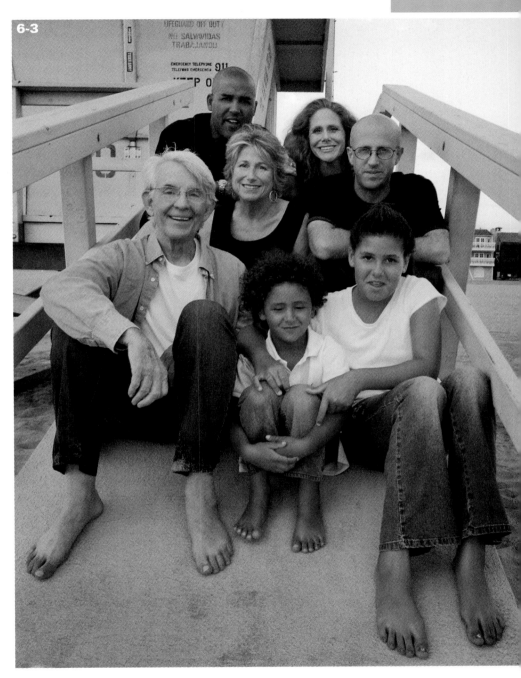

The early morning light or very late afternoon light is the most flattering. During these times it's easier to position your subjects anywhere, even facing the sun, because the light is softer and casts a beautiful glow. Image 6-4 illustrates how the last few minutes of golden light prior to sunset are soft enough to evenly illuminate faces without harsh shadows or squinting.

6-4

ABOUT THIS PHOTO *Late afternoon light casts a golden glow upon Gianina and her best friend, Buddy. Taken at ISO 200, f/4.0, 1/125 sec. with a Canon EF 24-105mm f/4L IS lens.*

The eyes look bright and alive when a *catch-light* (a twinkle of light) is present. Look in your subject's eyes and make sure you see that twinkle. If not, create a catch-light by reflecting soft light into your subject's face.

If you are inside, pay attention to the type of light in your scene. Is it harsh or soft? Natural or artificial? Take some test shots to see how your camera is recording the light in the environment and adjust your camera settings to fit your intentions.

ANTICIPATE SURPRISES

Regardless of whether you are asked to take a portrait spontaneously or you are at a scheduled shoot, be prepared for the unexpected.

Imagine you have planned a photo session in advance, you have the perfect location, the light is just right, and everyone is there, feeling happy and ready to go. You have positioned the entire crowd and they are patiently awaiting your direction, the sound of your camera shutter firing, and beginning the shoot. Then something goes wrong. It could be anything — your camera malfunctions, the media card is damaged, you drop the lens, the battery dies and it's your last one — the list goes on and on. Nothing is more embarrassing than having technical difficulties right in the middle of a shoot, in front of many people.

Professional photographers always have a backup plan. They bring an extra camera, extra batteries, extra media cards, extra lenses, and additional lights, and they have them ready and available. There are always things that are unexpected and beyond your control. If you're a beginning photographer, you may not own additional cameras or have extra accessories with you, but you can bring extra batteries and do some thinking in

advance about the situations you might encounter and the techniques you will be using. For example, consider the time of day you plan on shooting and think about possible areas within your location to position your subjects. Have a selection of locations, just in case one doesn't work out.

I had once planned a photo shoot for a local garage band at an urban graffiti wall. I prepared for the shoot days before by scouting the location to check the lighting and the surroundings. What I hadn't accounted for was the city's plan to paint the wall the day before the photo shoot. Fortunately, I had a few backup locations in mind and the photo shoot was saved. Remember that the success of any photo session depends on how you handle these unexpected situations.

tip

On every shoot, hope for the best and plan for the absolute worst. Planning a photo shoot in advance helps you alleviate problems before they begin.

DIRECT AND POSITION THE GROUP

Patience is fleeting when an organized group of people is waiting for you to entertain, direct, and impress them with your creative and technical skills. Your job as the photographer is to be prepared and keep everyone happy, together, and interested by taking control of the situation in a firm, friendly manner.

x-ref

I discuss motivation techniques in Chapter 1.

Here are some tips for positioning groups:

- **Give direction.** Communicate and motivate your group. Get your subject's attention by communicating clearly and firmly. Gain trust by being prepared and confident. Let your group talk and interact until you are ready to take the shot. Use the time between shooting intervals to praise them, move them closer together, or adjust their positions slightly.

- **Suggest poses.** Try to avoid the look of a police lineup. Instead, position your subjects in an overall shape, such as a circle, triangle, rectangle, or square, with some people sitting and some standing in a variation of body angles toward the camera.

- **Get focused.** Regardless of the size of the group, when your subjects within the scene are positioned at different distances from the camera, they are on different focusing planes. This means that some people may be out of focus unless you use a deep enough depth of field (DOF). To counter this problem, use the Aperture Priority mode on your camera to select an aperture of f/8.0 or higher to ensure everyone is in focus. Use your Depth-of-Field Preview button on your dSLR to check the focus in your scene before taking the shot. If you are using a compact camera, use your Infinity or Landscape mode to ensure a deep DOF and render everyone in focus in your image.

- **Take a lot of pictures.** The odds are against you when trying to photograph a large group because people blink, talk, and glance in other directions. It's important to take as many pictures as possible to increase the odds of capturing everyone looking good at the same time. Set the proper expectation and tell the group that you're going to take a lot of

photographs once they are in position. I like to give people a time limit; this prevents them from walking away once the first few shots are taken.

EXPLORE POSING TECHNIQUES

The formal group portrait has been a tradition for centuries. Depending on the artist and the era, historical paintings depict glorious portrayals of families and groups, often dressed in formal clothing and in reserved poses. When photography hit the scene in the late-nineteenth century, families and other groups dressed in their best clothes and had a formal portrait taken at a photography studio. Due to the limitations of their equipment, photographers required their subjects to sit still for very long periods of time to execute a proper exposure. Hence, there are very still and solemn expressions in many old photographs. Once cameras became more available to the masses, lots of family gatherings were captured more informally.

The old family photograph of my relatives in 6-5 appears as though it was taken during or after a celebration or family event. It looks as though they attempted to organize themselves for the picture, yet the posing is very informal. It's not the most interesting composition, but this photo is a rare and priceless recording of my heritage. I'm very thankful that someone brought a camera to the party!

A formal group portrait is usually requested to achieve a conservative and traditional portrayal of the subjects to commemorate milestones such as graduations, weddings, birthdays, or anniversaries. Simple positioning is a good place to begin, and your direction as a photographer is key in organizing the group. If you are posing a large group, your choices are limited to arranging

6-5

ABOUT THIS PHOTO *This informal group portrait of my relatives dates back to the early 1900s.*

people in rows on a flat surface and shooting the picture from a slightly elevated position, as in 6-6, or staggering your subjects on ascending steps to capture everyone in the scene. Remember those old school photos taken on the bleachers?

School pictures, sports team shots, and even traditional wedding photos have their own rules, and the subjects in them are often lined up in a very linear, static style. Portraits of families, friends, and business groups offer more creative freedom. For smaller gatherings, a good rule of thumb is to build the group into a particular shape, arrange the heads in a pleasing composition, and then concentrate on where to put the

bodies. For example, don't position people's heads directly on top of one another, and avoid eye lines directly in line with another. Instead, build your group into a pyramid and stagger the distance between them and their eye lines for a more visually interesting image. Use chairs, phone books, boxes, crates, pillows, or anything else suitable for your subjects to sit on or stand on. It doesn't matter what the group looks like from behind, you're only photographing the front!

The formal wedding portrait in 6-6 was taken by Robert Holley, a professional wedding photographer. Robert positioned the wedding party around the bride and groom in a linear fashion according

to height. Everyone is visible and on the same focusing plane. If you are ever called upon to photograph a friend's wedding, this is one traditional group portrait posing option you can use.

If you are posing a smaller group of people, the previous choices apply, but you have other options, too. Rather than lining everyone up, try positioning your subjects in a casual group to allow for a more intimate feel. In 6-7, I positioned the group in two rows, but it's a small group and the gestures imply emotional closeness.

PLAN A CASUAL SHOOT

Casual group portraits are considered more contemporary and have grown in popularity over the years. The location, clothing, and physical formation of your group can be varied and unique. From classic poses in casual clothing to creatively wacky arrangements of people in the scene, a casual group portrait can be a lot of fun. One of my favorite families to photograph is my friends and neighbors, the Tainters. Over the years, I've worked with the mom, Suzie, in developing

6-6

ABOUT THIS PHOTO *The photographer fulfills a formal group portrait request by positioning his subjects in the classic wedding-party pose. Taken at ISO 400, f/11, 1/160 sec. with a Canon EF 17-35mm f/2.8 lens. © Robert Holley.*

unique ways to document her family in a group photograph. The locations, lighting, and clothing are varied, but the central theme is that they are a close, active family with a lot of energy.

The Tainters like to take time to think through possible scenarios for their family photographs, and we work as a team to create the images they want. Rather than providing instructions, I am there to capture those moments that are part of their natural interaction with each other. While some feedback may be helpful when shooting informal groups, it's important not to force anyone to do something that feels uncomfortable. To avoid the

artificial, staged shot, let the action unfold naturally before your lens and be ready to capture the spontaneous moments. To prompt ideas regarding activities or locations for photo shoots, I often show shots to people that I've done for other families or groups to inspire their creativity.

Because we had planned this pajama-party setup prior to the shoot, the Tainters were already enthusiastic about having a pillow fight as the family portrait was taken. For simplicity, the adults wore classic pajamas in solid colors with small stripes. The kids had on their favorite "jammies," as you can see in 6-8.

ABOUT THIS PHOTO
Here is a formal pose with a contemporary feel. This family wanted a simple, classic group photograph. Their expressions and relationships are the focal point in the image. Taken at ISO 400, f/4.0, 1/250 sec. with a Canon EF 70-200mm f/2.8 lens.

6-7

6-8

ABOUT THIS PHOTO
An organized yet chaotic activity, a pillow fight, was a fun idea for this family portrait. Taken at ISO 200, f/8.0, 1/250 sec. with a Canon EF 17-35mm lens and a Canon Speedlight external flash.

I positioned them on a solid-colored bedspread and yelled out "let the pillow fights begin!" I encouraged the pillow fighting and joined in the laughter. To illuminate the scene, I used an external flash on my camera that I alternated pointing at the white ceiling or the walls for bounced light on my subjects. Capturing the action was easy; I just set my camera in Continuous shooting mode and took continuous sets of pictures for about five minutes. There were a lot of good shots to choose from.

If you run out of ideas for casual portrait shots, think about forming your group into an overall shape. For example, if you were shooting an image of ten people from above, it might look interesting to direct them into the shape of a circle, a square, or, as classic artists have done for centuries, triangles. Image 6-9 depicts the use of two triangles formed by all the members of the family group. This is a more casual example of a traditional pose. Use chairs, stools, or boxes to arrange everyone at various heights. Try to avoid lining up people's eyes at the same level; this creates a static, boring look. The goal is to draw the viewer's eye through the image with a pleasing composition. Experiment and have a few ideas up your sleeve if things become boring.

ABOUT THIS PHOTO
A casual family portrait with a classic triangular posing technique creates a visually interesting photograph. Taken at ISO 400, f/4.0, 1/125 sec. with a Canon EF 24-105mm f/4L IS lens.

6-9

CAPTURE CANDIDS

Not every photo you take will be posed or planned. Both formal and casual portrait sessions offer opportunities for candid images. It could be the emotion shared among people before or after a formal pose is struck, or the natural reaction to something funny that occurred during the casual pose. Whatever happens, you need to be fully present, keenly aware of what is happening with your subjects, and capable of anticipating and recognizing an important moment. Here are some tips for shooting candids:

- **Give your subjects something to do.** Capturing a candid moment is easy when you place your subjects within the context of objects or activities. When your subject is doing something, your image tells a story and becomes much more interesting.

- **Use Continuous shooting mode.** When an emotion or reaction occurs, capture every second by using the Continuous shooting mode setting on your camera. Hold down the shutter button to capture multiple frames in quick succession.

In 6-10 you see a poignant moment between father and son during a walk along the shore. This particular photo shoot included posed, casual family shots along with candid moments between individual family members. During an outdoor photo shoot, I often pair up siblings, or a parent and child. I ask them to walk around and

explore while I take pictures, or we find an area away from the group where individual moments are encouraged.

6-10

ABOUT THIS PHOTO *This candid moment between father and son was captured in between the posed group portraits. The black-and-white effect was created in Photoshop Elements with Nik Software Silver Efex Pro 2. Taken at ISO 100, f/4.5, 1/400 sec. with a Canon EF 24-105mm f/4L IS lens.*

Many staged group portrait shots may begin with more formal poses, but if you pay attention to the reactions that occur between the posed shots, you can capture authentic candid shots showing personality and a group dynamic, as illustrated in 6-11.

> **tip** Always observe the way the light in your scene falls on each person. If you are taking a portrait of a large group, make sure everyone is positioned in similar light; otherwise, part of your image may be under- or overexposed.

Candid, less posed shots can be captured even when you have given some general direction — your group may naturally produce an imaginative arrangement. You have to be prepared to capture such moments though.

Stealth-like observational skills come in handy when capturing candid images. Sometimes your subjects may not be aware of your presence or photographic intent. Image 6-12 captures a moment and tells a story about the groom surrounded by bridesmaids. All the people in this image are looking toward another camera, which gives this image a natural, candid feel.

ABOUT THIS PHOTO
A posed portrait often includes many candid moments in between the shots. Taken at ISO 200, f/5.6, 1/100 sec. with a Canon EF 70-200mm f/2.8 lens.

6-11

ABOUT THIS PHOTO *A candid image taken from another angle captures a natural moment with the formally posed group. Taken at ISO 100, f/1.8, 1/160 sec. with a Canon EF 50mm f/1.8 lens. © Robert Holley.*

GET CREATIVE

Couples, small family groups, and large groups all have one thing in common — a relationship with each other. It's your job as the photographer to capture this relationship in the image. Use your imagination, look around for ideas, and try some of them out with willing subjects in your photo sessions. Not all people have an adventurous streak, so use common sense when suggesting

anything unusual with people you don't know. Practice on your friends and family first; experiment and see what happens. You might create a masterpiece. With the immediacy of digital photography, you can check out your images as you shoot and take as many pictures as your media card can hold.

Have a few ideas in mind before you begin your photo shoot and think about shooting from unique angles and distances. Consider spacing

out the people in the groups to accentuate depth and draw the viewer's eye through the image, from the foreground to the background. By placing the groom in the foreground of 6-13 and the grooms-men and mountain range in the background, a sense of three-dimensional space is created in the image. The photographer used a deep depth of field to ensure that everyone was in focus.

To capture more candid shots, give your subjects something to do so they are more comfortable. The image in 6-14 shows how suggesting activities your subjects are interested in can help you take natural, candid shots. Courtney and Tabitha are good friends and had a lot of fun taking self-portraits with his new camera.

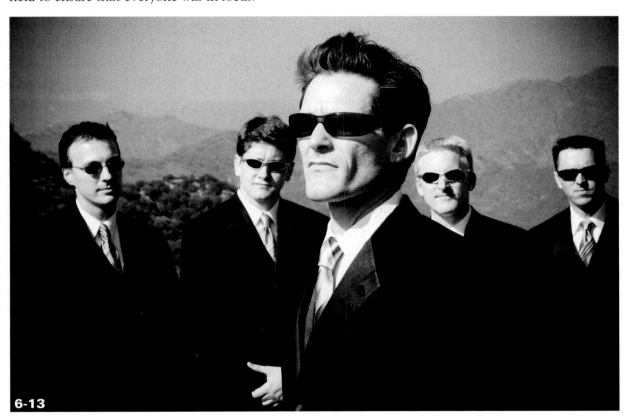

6-13

ABOUT THIS PHOTO *The groom is the person of honor and the focal point in this contemporary group portrait. Taken at ISO 200, f/20, 1/125 sec. with a Canon EF 24-105mm f/4L IS lens. © Robert Holley.*

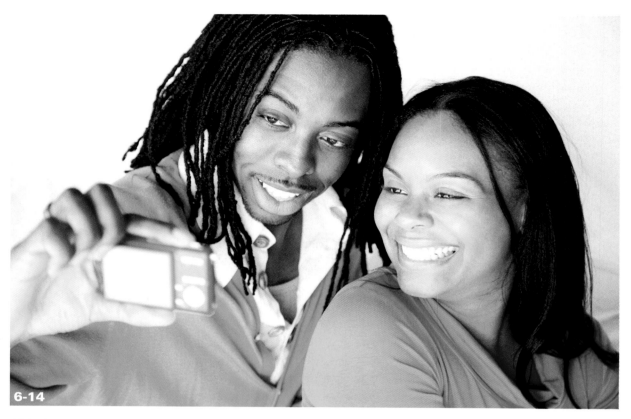

6-14

ABOUT THIS PHOTO *Using a simple prop and indirect window light, I took a picture of a fun couple taking pictures. Taken at ISO 400, f/4.0, 1/125 sec. with a Canon EF 24-105mm f/4L IS lens.*

Image 6-15 is a fun way to compose a group portrait. These three siblings were energetic, so my simple direction of "group hug" was an easy, creative way to capture all three of their faces in the frame.

Image 6-16 was one of many fun shots taken in honor of Mary and Bob's 50th wedding anniversary. They were both very good sports as I suggested various ideas and activities to give their

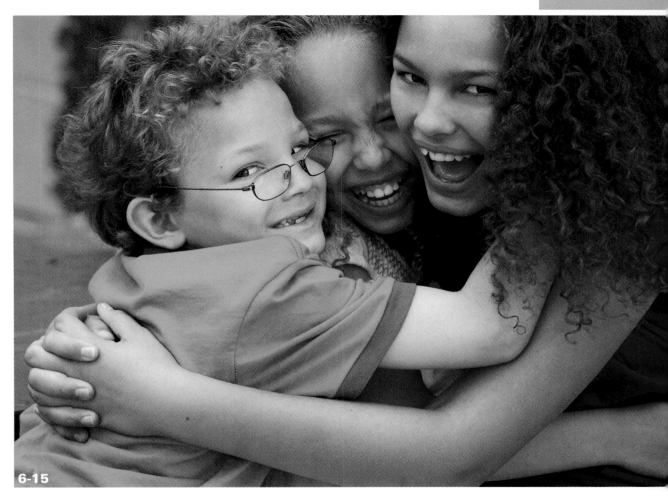

6-15

ABOUT THIS PHOTO *Take advantage of the natural energy that children possess and channel it into creating fun photographs. Taken at ISO 200, f/6.3, 1/200 sec. with a Canon EF 70-200mm f/2.8 lens.*

portraits a dynamic feel. Twirling each other, hugging, standing cheek to check, and dancing were just a few poses I photographed. As marriage is a sort of dance through life together, I thought this image of Mary and Bob depicted their closeness and zest for life.

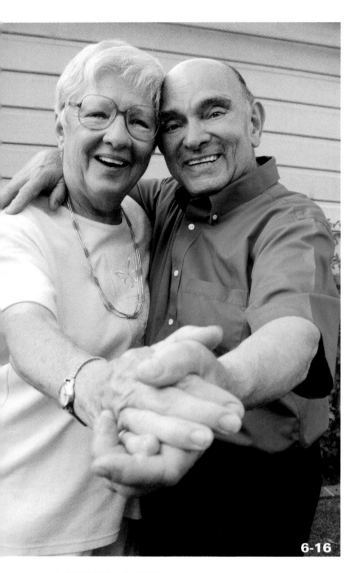

ABOUT THIS PHOTO *I experimented with a wide-angle lens and directed Mary and Bob to move in close together and close to the camera to create an unusual viewpoint. Taken at ISO 400, f/5.6, 1/180 sec. with a Canon EF 17-35mm f/2.8 lens.*

OPTIMIZE YOUR CAMERA SETTINGS

Your camera is a wonderful tool, but it's up to you to know how to use it to its fullest potential so that you can exercise your creativity and technically capture the image when dealing with groups. Use these special settings to gain more control over your camera:

■ **Continuous shooting mode.** This setting enables your camera shutter to fire multiple times and capture images in quick succession so you never miss that special expression or great candid moment.

■ **Self-timer mode.** Use this setting when you decide to join the group and get in the shot.

■ **Aperture Priority mode.** This gives you control over the DOF in your image by allowing you to choose the aperture setting; the camera then adjusts the shutter speed for the correct exposure. This setting is useful when you have larger groups and want to keep everyone from front to back in focus.

■ **Shutter Priority mode.** This setting gives you control over the motion and ambient light in your image by allowing you to choose the shutter speed setting; the camera then adjusts the aperture for the correct exposure. Try this setting when the light is less than perfect or the light isn't as strong.

■ **Landscape mode.** The camera chooses a small aperture to ensure both foreground and background elements are in focus and to ensure the fastest shutter speed depending on the light in the scene.

■ **Portrait mode.** The camera chooses a wide aperture that isolates your subject from a softly blurred background.

■ **Flash-off mode.** The camera's flash does not fire regardless of how little light exists in the scene. The mode is great for museums, plays, or capturing the subtle nuance of expression in natural light.

■ **ISO.** This setting is similar to film speed but instead it measures your digital camera sensor's sensitivity to light. Raising your ISO allows more light into your exposure and enables you to use a faster shutter speed for motion or a smaller aperture for greater DOF.

note Remember that using higher ISOs may result in noise in your image. This translates to discolored pixels throughout your image. Some people compare this to traditional film grain.

■ **White balance.** This setting compensates for different light temperatures and can be used to adjust how your camera interprets the colorcast of any type of light. For example, if you are shooting on an overcast day, there is likely a WB setting on your camera that counteracts the blue tone of the overcast skies with a warmer tone, neutralizing the colorcast in your image.

Assignment

Organize a Group Shot

The next time you're with a group of people, take that courageous leap and organize a group shot, whether it's your cousin's wedding reception or your child's soccer team. Check your location, consider your light source, get out your camera, use your directing skills, and give it a whirl!

To complete this assignment, I organized a group shot at Annie's high school graduation celebration. The party was held outside, so I found the best light in open shade and positioned Annie and her friends in a circle. I grouped the girls' faces close together, and positioned them sitting and kneeling in order to vary their eye lines. Taken at ISO 200, f/4.0, 1/250 sec. with a Canon EF 24-105mm f/4L IS lens.

Remember to visit www.pwassignments.com after you complete this assignment and share your favorite photo! It's a community of enthusiastic photographers and a great place to view what other readers have created. You can also post comments, read encouraging suggestions, and get feedback.

Kids are a lot of fun to photograph because they have seemingly limitless expressions, emotions, and energy. On the flip side, sometimes they have short attention spans and can be uncooperative and cranky, so it's important to understand how to prepare for taking a great picture. Kids grow up quickly, but with the following tips, you can make the most of recording those unexpected, fleeting moments and capture priceless memories.

Family portraits of children at different ages offer opportunities and challenges. You can capitalize on the natural dynamic between them, but you really need to be watchful for special moments. Siblings can interact positively or negatively, revealing a lot about their relationship. In this chapter, not only do you learn some great ways to work with kids, you learn to recognize these kinds of moments and capture them yourself.

DIRECT THE KIDS

When you are directing kids in a photo shoot, it's important to have an understanding of their particular needs, given their ages and individual temperaments. Find ways to help them relax in front of the camera, perhaps making jokes about their interactions with and reactions to each other or other members of the family.

Try to engage children in the photography process. This helps them become involved and cooperative. Standing behind your camera and occasionally saying a few words to your subjects is not going to capture their attention or give you the expressions you were hoping for.

I attended a 14-year-old's birthday beach party and had a great time documenting the day and coming up with ideas for fun group shots. These teenagers were happy to have their group picture taken, but I had to give loud and clear directions with an upbeat attitude to stay in sync with the party atmosphere. Nothing dampens a party mood faster than an adult forcing kids to pose perfectly. In situations like these, it's important to understand and accept the mood of the party, and then incorporate that into your photograph. These kids were fun to direct and they even came up with some of their own fun ideas for the photos, as shown in 7-1, 7-2, and 7-3.

Whether you're an invited guest or a professional hired to conduct a portrait session, it helps to have some assistance with organizing and entertaining your subjects. A prior client had referred me to her neighbor and I was hired to photograph three siblings at the beach, one of my favorite places to shoot. I typically ask kids simple questions such as where they go to school, how old they are, what they had for lunch, what their middle names are, or anything else I can think of to begin getting to know them, but due to a tight schedule, we had very little time to converse beforehand. We had a lively conversation when the kids were in front of the camera, yet I was capturing images with semi-comfortable expressions. I decided to enlist their mother as the sideline entertainment. To be exact, I positioned her right behind me and just above my camera so the kids would look in the right direction. Fortunately, she was a good sport, jumping up and down and making funny faces as I composed the shot. Typically, I reserve this sort of directing for infants and younger children, but it also works for older kids if you have a willing assistant. You can always take a posed shot, but the most compelling images are captured during spontaneous moments with real expressions and emotions (see 7-4).

ABOUT THIS PHOTO
This is one way to include everyone's face in the shot! Taken at ISO 200, f/4.0, 1/250 sec. with a Canon EF 24-105mm f/4L IS lens.

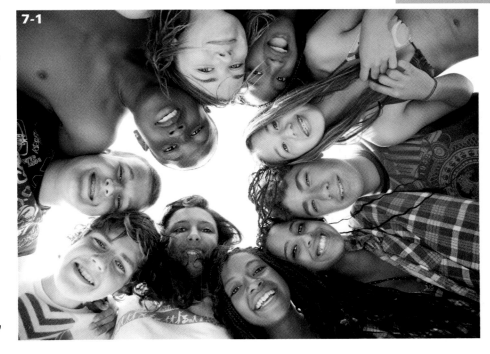

7-1

ABOUT THIS PHOTO
I asked everyone to line up so I could document all the teenager beach attire in its entirety. Taken at ISO 200, f/8.0, 1/250 sec. with a Canon EF 24-105mm f/4L IS lens.

7-2

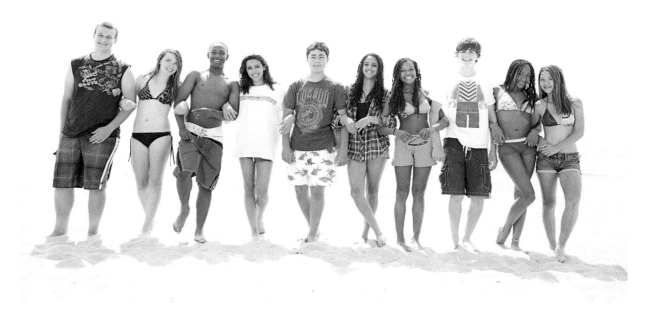

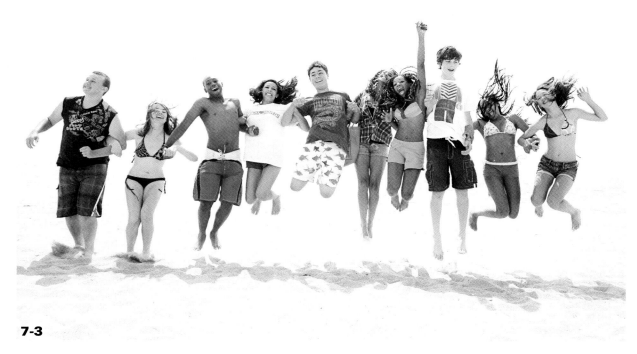

7-3

ABOUT THIS PHOTO *Standing in a line is not too exciting, so the kids started jumping around. I took quite a few shots and directed them to jump all at once. I like the energy! Taken at ISO 200, f/8.0, 1/250 sec. with a Canon EF 24-105mm f/4L IS lens.*

DIFFERENT AGES, DIFFERENT STAGES

An awareness of a child's general developmental stages will help you take better photographs. From the terrible twos through the teenage years, children react differently to the camera depending on their age, personality, and comfort level. Small children have short attention spans and become

bored with a formal photo session in minutes, so be prepared with your setup and equipment before bringing the child into the picture-taking area. If an informal portrait or candid shot is what you're after, take time to observe the child; this way you can anticipate the special moment or unexpected expression. Play with toys, make funny noises, and be quick with your shutter button.

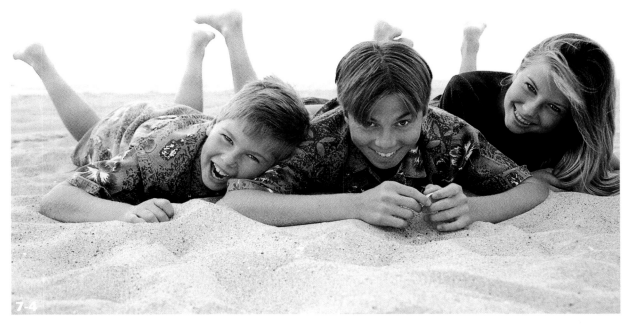

ABOUT THIS PHOTO *An afternoon at the beach is always full of photo possibilities. Taken at ISO 200, f/8.0, 1/200 sec. with a Canon EF 70-200mm f/2.8L lens.*

Children ages four through ten are often experienced in front of the lens, which can be a problem. They may have learned to force a smile to please picture-takers. Avoid poses; instead, distract them from the camera and get them involved in a fun project. Making cookies, petting the dog, swinging on the swing, or blowing bubbles is much more fun than posing awkwardly and saying "Cheese," and these activities create opportunities to capture children's natural, spontaneous expressions. Preteens through 18-year-olds are often more self-conscious in front of the camera and are very aware of your presence. Encouragement and acceptance go a long way in gaining their trust for a photograph. Concentrate on who the preteen or teen is in that moment and your image will express a thousand words, even if she is silent. Allowing her to do what she feels, as in 7-5, might result in getting the shot you want. It's reverse Psychology 101 — try it!

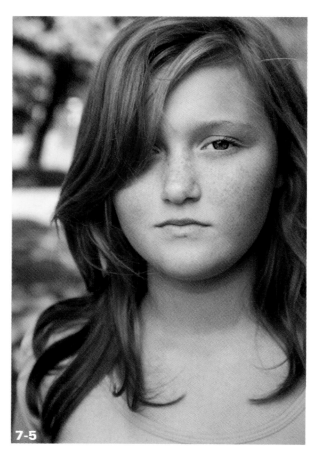

7-5

ABOUT THIS PHOTO *Smiling isn't everything it's cracked up to be. This teenager was having a moment and I decided to capture it. Taken at ISO 200, f/6.3, 1/250 sec. with a Canon EF 24-105mm f/4L IS lens.*

GET THEM INVOLVED

Kids grow more interested in participating in your photo shoot if you take the time to include them in the process. One of the benefits of shooting digital images lies in the ability to see what you've shot as you progress. As you review images on the LCD screen, share what you've captured with the kids. If you show them what's happening

behind the lens, they feel more important and invested in your photo project. Let them take self-portraits and have fun controlling the outcome, as in 7-6.

Another way to include the kids in your photo quest is to have them choose their favorite place as a location for your photo shoot. Knowing they helped plan your production builds their enthusiasm about having their picture taken.

I recently went on a trip to one of Jack's favorite places, the golf course. He had a photo project for school about "his favorite place," and instead of planning the shoot, I tagged along in hopes of taking great candid pictures of his adventures. It worked. He was so engrossed in his project that I was able to follow him around unnoticed and, by anticipating his expressions and gestures, record the moments of the day, as shown in 7-7.

GET THEIR ATTENTION

Candid photographs involve observing and capturing real moments. Often this means that your subject is not looking into the camera lens, and she may not even be aware of the camera's presence. I love this type of photograph. But what if you need to capture a child's attention? Some kids refuse to cooperate if they are directed to look at the camera, while others may give you the perfunctory "cheese" smile, resulting in a forced and unnatural expression. Depending on the age of the child, appropriate off-camera entertainment could be anything from a noisemaker, a play toy, or another child or parent making funny faces. If you're using any of this entertainment at your photo shoot, be sure to position the object or entertainer right behind you as you shoot so the kids are looking in the right direction.

ABOUT THIS PHOTO
Older kids love to take self-portraits. Get them involved in the photo-taking process. Taken at ISO 200, f/5.6, 1/250 sec. with a Canon EF 24-105mm f/4L IS lens.

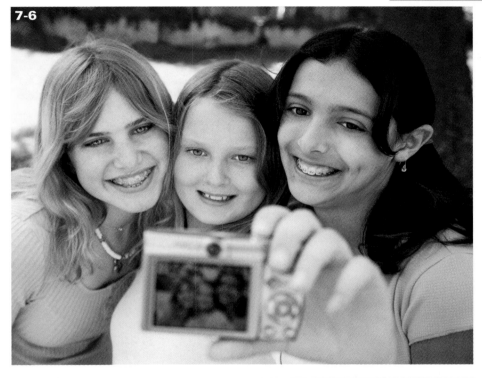

7-6

ABOUT THIS PHOTO
Documenting life moments doesn't always include a gaze toward the camera. I had fun watching the activity and captured a lot of candid photos during this adventure. Taken at ISO 200, f/5.6, 1/200 sec. with a Canon EF 24-105mm f/4L IS lens.

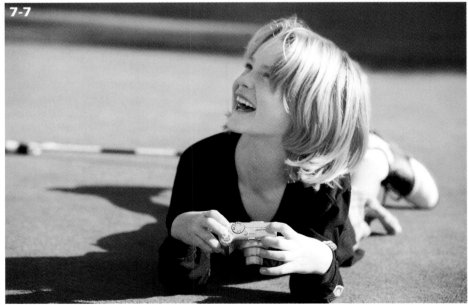

7-7

Older kids may gaze at your lens for a few pictures, but then their attention span wanes. I suggest instigating a lively conversation with questions, jokes, and weird sounds to evoke some interesting expressions. And if you tell them in a friendly manner, most kids will enjoy the game of reverse psychology, as in "whatever you do, do *not* look into the lens" or "please don't smile" or a multitude of other things you claim that you don't want them to do, but in reality, you do. You'll have to assess your particular situation and do some experimenting to see what works best.

I've also had success by asking children eight and older to simply try to see their own reflection in the lens; that coaxes them to gaze intently at it, at least for a few shots, as in 7-8.

BRING A "KID WRANGLER"

Don't be afraid to enlist other people to help you entertain the kids on a photo shoot. Along with patience and skill, photographing children requires timing and teamwork. You're probably already aware that kids are full of energy and

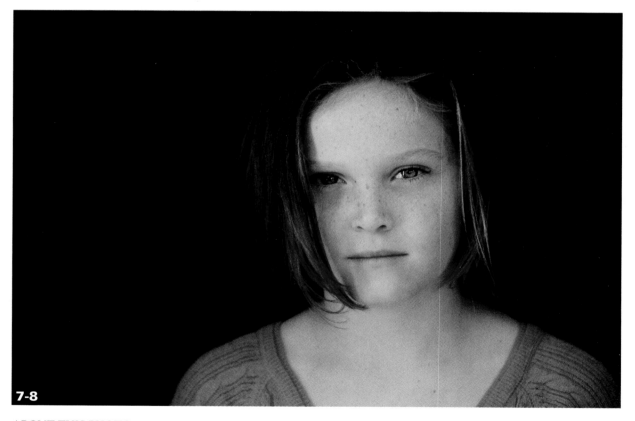

7-8

ABOUT THIS PHOTO *Genevieve was easy to work with and full of natural, soulful expressions directed right at my camera lens. Taken at ISO 100, f/4.5, 1/125 sec. with a Canon EF 24-105mm f/4L IS lens.*

easily distracted, and sometimes it's difficult to keep up with them, especially when you have multiple children in a photograph. Having an extra set of eyes and ears on the set keenly attuned to the mood and actions of the kids can help keep the atmosphere cheery and fun, and you can pay more attention to the light, camera settings, composition, movement, and expressions.

I enjoy being around kids, and I'm always amazed by every little personality I see in front of my lens. This attitude helps me cajole and capture real expressions, such as the one in 7-9. I also have assistants and friends who are great with kids, and they know every duck sound, silly song, and funny question that a child might react to. When I'm photographing children and large families, this help is crucial.

Sometimes it makes sense to involve another family member in the entertainment by including him in the photograph. This interactivity can involve movement and help reveal relationships in your images. Image 7-10 shows a father and his

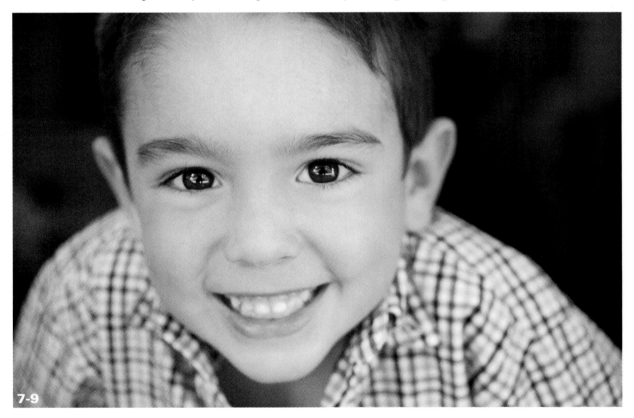

7-9

ABOUT THIS PHOTO *Stephen's energetic and personable expression was captured right after my "kid wrangler" assistant had asked him a lot of silly questions. Taken at ISO 400, f/3.5, 1/100 sec. with a Canon EF 50mm compact macro lens.*

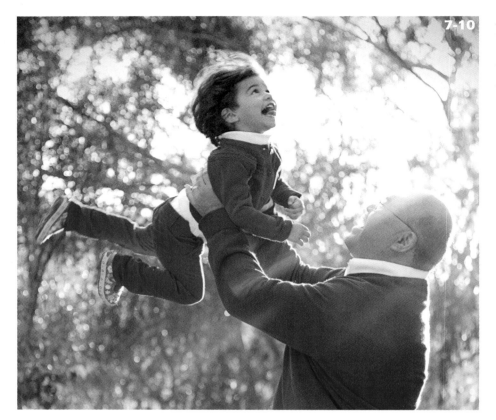

ABOUT THIS PHOTO
Involve the parents and other family members to help entertain the kids. It's a great way to capture natural expressions. Taken at ISO 400, f/4.0, 1/200 sec. with a Canon EF 24-105mm f/4L IS lens.

young daughter playing and having fun during an outdoor family photo session. The activity keeps her entertained and evokes a natural expression on her face.

PLAY AROUND

Play with various setups and props, play with your ideas, play with the light, and let the kids play in front of your camera. That's a lot of playing, but now you only have to remember one word to initiate a change in your photographic process when you feel too restricted during a shoot and your subjects have forced expressions on their faces.

Regarding the kids, it's always a good idea to ask what a child likes to do and what toys he likes to play with before beginning a photo shoot. In 7-11, Nicolas mentioned that he loved to jump on his trampoline in the front yard, so I took full advantage of this prop's potential. He had fun jumping up and down, and it gave me an opportunity to capture a lot of up-in-the-air shots.

ABOUT THIS PHOTO *Remember to play! Taken at ISO 100, f/13, 1/200 sec. with a Canon EF 24-105mm f/4L IS lens.*

7-11

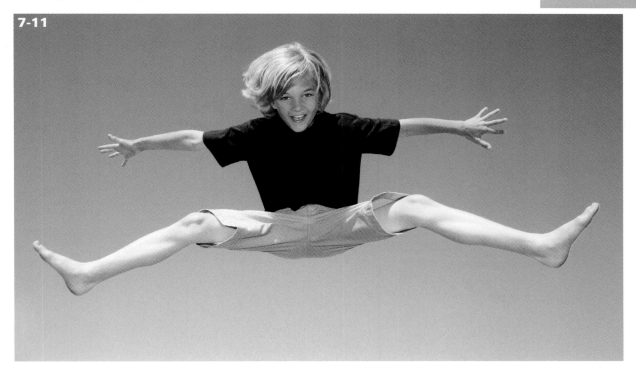

KEEP IT REAL

A compelling photograph captures an authentic moment, look, or gesture that elicits a feeling from the viewer. Instead of forcing a child to strike a pose or force a smile, choose a location for your shoot, and then encourage play, action, and activity.

BE OBSERVANT

Once children feel comfortable in your presence and forget about the intrusion of the camera into their world, you have the opportunity to observe their play and interactions. Your mission is to be

ready for moments that are most revealing of the child's personality and responses to the environment. To be successful in your mission, you must be prepared.

To get your camera ready, look through your viewfinder, find your subject, and then hold down the shutter button halfway to lock the exposure and prefocus. Keep holding down the shutter button halfway until the special moment occurs, and then depress the shutter button the rest of the way. Doing this eliminates the usual shutter lag and allows you to quickly take the picture. Setting your camera to Continuous shooting mode is also an easy way to shoot a sequence of

shots as the action is occurring. The amount of pictures you take is only limited by the capacity of your media card. Take a lot of pictures, even when you think the moment has passed, because that is often when real-life moments begin to happen. Don't wait for someone to look perfect or try to contrive an emotion; capture life as it is — perfectly imperfect. Authenticity in a photograph is something everyone can connect with. The little girl shown in 7-12 was playful and energetic for most of our photo shoot, but she eventually settled in to a more thoughtful mood and then became interested in finding flowers in the grass. I quietly observed her search and was ready for the shot when she turned her head.

tip Use the scene settings on your camera's Mode dial and experiment. Use Portrait mode to take headshots, Landscape mode to keep people in focus in the foreground and background, Night Flash or Slow Sync mode to flash your subject's face yet capture ambient light in the background, and Sports mode to freeze the action and reduce blur.

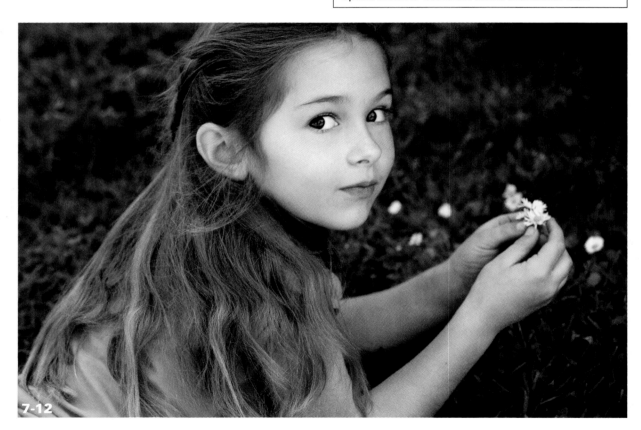

7-12

ABOUT THIS PHOTO *Let kids play and become absorbed in their activities and prepare to capture anything that might occur. Taken at ISO 200, f/6.3, 1/250 sec. with a Canon EF 24-105mm f/4L IS lens.*

ENCOURAGE REAL MOMENTS

Anticipating a moment means being observant of the people you are photographing and being technically ready to control your camera to get the shot. Whether you are planning on shooting a formal portrait or following the action in a stealth-like manner, you need to be aware of kids' reactions and relationships to successfully capture them in an image.

If you already have a relationship with the kids, then you are probably aware of their personalities. If not, you need to create opportunities that allow the child's personality to emerge. A lot of people feel that the camera is something they have to tolerate and perform for, and kids are no exception. If children are forced to do anything, that reluctant expression is going to show up in the photograph. You have a better chance of capturing a natural expression and a real moment when children are allowed to be themselves.

When I began the photo shoot, these little girls were standing nicely posed, waiting for my direction. I could have let them stand there sweetly with forced smiles, looking into the camera, but I knew they were best friends, so I asked them to give each other a big hug instead. The result was a real, candid moment that revealed their personalities and relationship, as shown in 7-13.

Most people are happier when they are doing things they like to do or spending time with people they care about. When photographing children, include their friends, family, pets, or toys in your photo shoot and watch the fun begin.

In 7-14, Alexis and the beloved family pet both seem to be comfortable in their relationship and don't mind sharing it with the camera.

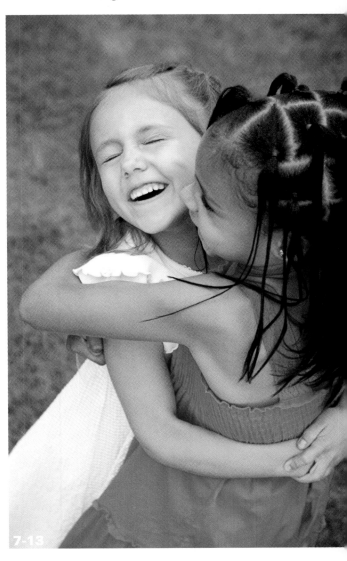

7-13

ABOUT THIS PHOTO *Suggest an action or activity that might evoke a natural expression and be ready to capture it. Taken at ISO 200, f/5.6, 1/200 sec. with a Canon EF 24-105mm f/4L IS lens.*

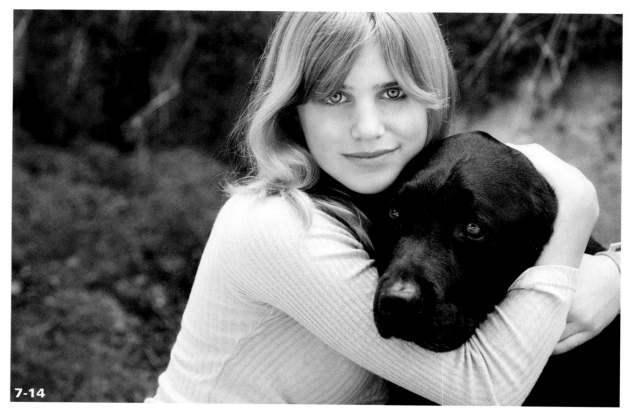

ABOUT THIS PHOTO *Including the family pet in a photograph often evokes natural body posture and expressions. Taken at ISO 200, f/5.6, 1/125 sec. with a Canon EF 70-200mm f/2.8L lens.*

COMPOSE THE SHOT

Images of children require some special considerations. Kids are smaller, they have more energy and less patience, and their latest pictures are usually in demand by family and friends. Make your images something everyone enjoys seeing by following these rules of thumb.

EXPERIMENT WITH ANGLES

Nothing is more boring than watching someone's slide show with images that are all taken from the same distance and perspective. You can create a compelling story with your images by experimenting with various angles. Take pictures from different distances and perspectives. An image

shot from below your subject will look very different from one taken from above. Think about all the angles you can try, and don't forget to turn your camera from horizontal to vertical to capture elements above or below your subject.

For image 7-15, I positioned my camera near the ground and looked up at this little boy, rendering him powerful and larger than life. Image 7-16 depicts a vantage point that suggests a youthful and diminutive feeling in an image. Mix things

7-15

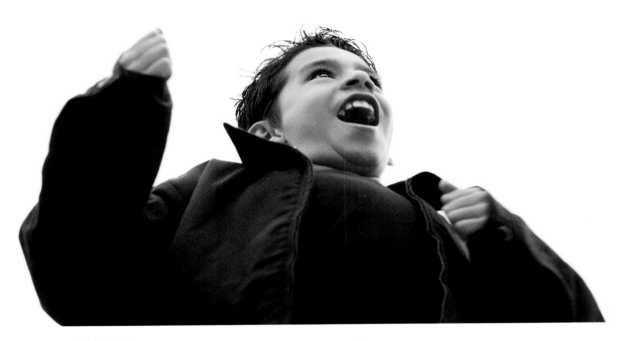

ABOUT THIS PHOTO *A portrait captured from below my subject portrays him as strong and powerful. Taken at ISO 200, f/5.6, 1/160 sec. with a Canon EF 24-105mm f/4L IS lens.*

up — think of every possible angle from which you can shoot your subject and incorporate these angles into your next photo session.

x-ref

Refer to Chapter 4 for more information on composing your shot.

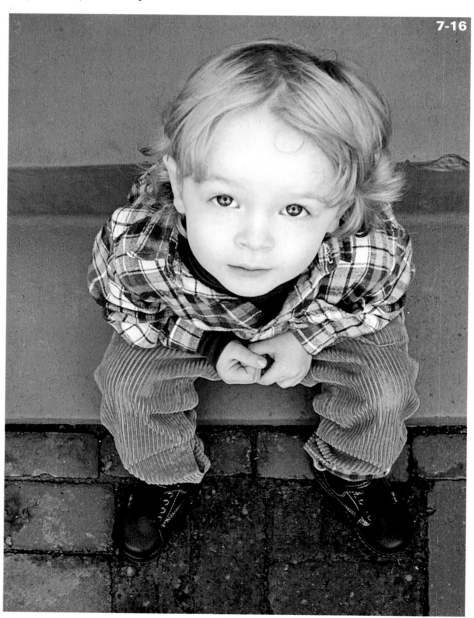

7-16

ABOUT THIS PHOTO
Taken from above Jack's head for an exaggerated effect, this angle portrays him as small and sweet. Taken at ISO 100, f/5.6, 1/100 sec. with a Canon macro EF 50mm f/2.5 lens.

GET DOWN ON THEIR LEVEL

By positioning your camera at a child's eye level, you can create images that are more intimate and compelling. Kids can relate to you, and you can capture more of their personalities and less of the tops of their heads. Be flexible: kneel or sit down next to them, have a conversation, and take a lot of pictures. This image of TJ in 7-17 was captured as I knelt down near his highchair and used my telephoto lens to get in close and fill the frame with his cute face.

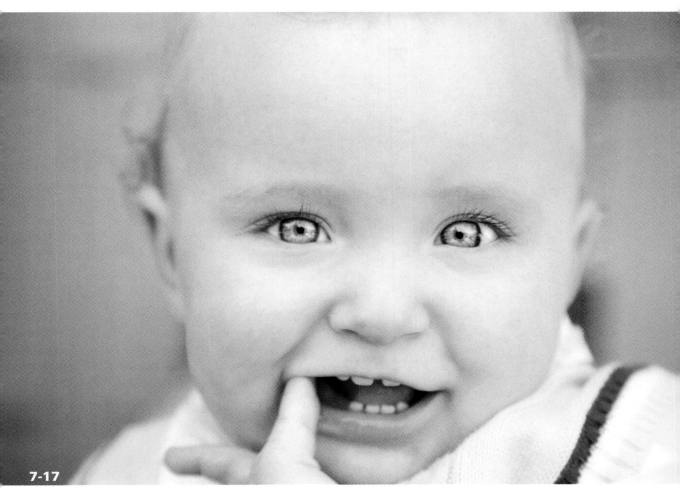

7-17

ABOUT THIS PHOTO *Get down on a child's level to capture an image with emotional impact. Taken at ISO 100, f/5.0, 1/100 sec. with a Canon EF 24-105mm f/4L IS lens.*

GET CLOSE

Fill the frame with your subject to create greater visual impact, as shown in 7-18. Use your camera's zoom or long focal-length lens to get closer and fill the frame. By zooming in and emphasizing what's important, you also exclude any distracting background clutter surrounding your subject. Unless you intend to create a wide-angle effect, be careful not to get too close to your subject using the wide aspect of your camera's lens because your subject will appear distorted.

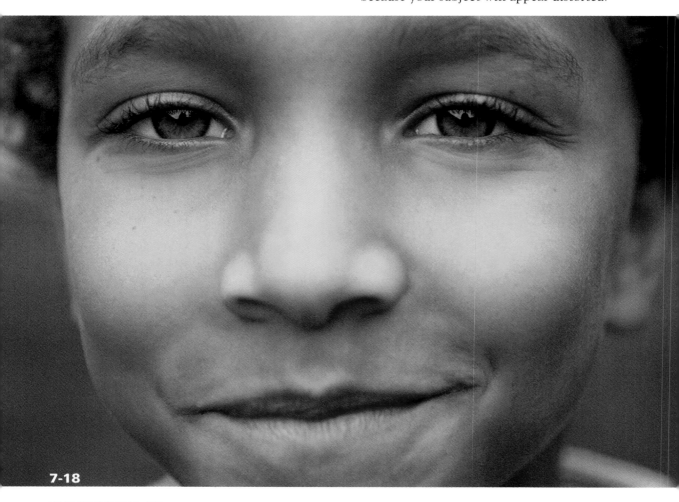

7-18

ABOUT THIS PHOTO *Zooming in close enabled me to eliminate any background distractions, and Vincent's beautiful eyes become the main focal point. Taken at ISO 200, f/2.8, 1/100 sec. with a Canon macro EF 50mm f/2.5 lens. © Erin Manning/Getty Images.*

SHOOT FAST, SHOOT A LOT

Kids have a lot of energy and can move around quickly. Don't lose the shot because you're not ready to capture it! Turn on your camera's Continuous shooting mode to take pictures in quick succession, hold down the shutter button, and fire away. Taking multiple images of a child's expressions ensures that you won't miss a unique mannerism or great candid moment. In 7-19, 7-20, and 7-21, I captured a succession of facial expressions while Stephen voraciously devoured his birthday cupcake.

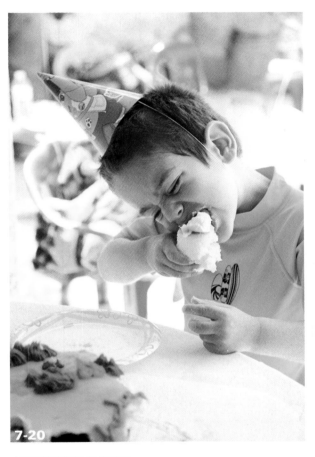

7-19

7-20

ABOUT THIS PHOTO *I captured a progression of expressions on Stephen's face as he devoured his birthday cupcake. Taken at ISO 200, f4.0, 1/100 sec. with a Canon EF 24-105mm f/4L IS lens.*

ABOUT THIS PHOTO *I used the Continuous mode setting on my camera to capture every "cupcake moment" on Stephen's face. Taken at ISO 200, f/4.0, 1/100 sec. with a Canon EF 24-105mm f/4L IS lens.*

The best advice I can give you is to have fun, have patience, and keep things stress-free. Enjoy spending time with kids and sharing their adventures and games. Childhood lasts for but a moment; be sure you capture it well.

7-21

ABOUT THIS PHOTO *On to the next cupcake! Taken at ISO 200, f/4.0, 1/100 sec. with a Canon EF 24-105mm f/4L IS lens.*

Assignment

Capture a Real Moment

For this assignment, bring your camera and take one or two kids to a park, or even the backyard. Have some fun — laugh, run, spin the kids around, and roll in the grass. Or bring a toy or game that helps them forget about the camera. It might help to have a friend assist you. Follow the kids' actions and capture candid shots from different angles. Choose your most compelling image, post it online at www.pwassignments.com, and tell me why you like it.

To complete this assignment, I diverted Riley's attention by playing with soap bubbles in the backyard. She was mesmerized with blowing the bubbles, which made it easy to capture an authentic expression in this image. Taken at ISO 200, f/4.0, 1/250 sec. with a Canon EF 24-105mm f/4L IS lens.

© Erin Manning

 Remember to visit www.pwassignments.com after you complete this assignment and share your favorite photo! It's a community of enthusiastic photographers and a great place to view what other readers have created. You can also post comments, read encouraging suggestions, and get feedback.

Get Comfortable with the Baby

Keep It Simple

Use Soft Light

Seize the Moment

There is one subject in the world you can never have too many pictures of — a baby! Other than just being really cute subjects, babies experience a lot of "firsts," so it's important to take pictures often, capturing each phase of a baby's development before he or she grows up. Perhaps more memorable in the long run are the things babies do all the time while growing up: eating their oatmeal, playing with a puppy, standing up in their crib, crying, laughing, or doing any daily activity that depicts the reality of life.

Whether you're a parent, an aspiring baby photographer, or someone with a lot of friends and family with babies, follow these rules for photographing the little darlings and you're on your way to capturing magical moments and creating fantastic images that are treasured forever.

GET COMFORTABLE WITH THE BABY

The term "comfort" is subjective for many adults, but for babies there is a special formula to ensure their comfort. If you intend to shoot for more than 30 seconds and capture happy, spontaneous expressions, these guidelines should help.

> **note** The approximate age of a baby is zero to eighteen months old, and a toddler can be defined as twelve months to two years old. There is crossover — some babies develop faster than others.

PLAN THE TIMING

One way to photograph babies is to make sure they are already rested, fed, and changed before your photo shoot; then position them in the area

you've prepared for the photo session. Another way is to follow the action in a photojournalistic manner and record moments during a baby's daily rituals. Either way, you need to adjust your photo shoot around the baby's schedule. Every infant has a ritual of eating, sleeping, bathing, and changing with some crying, bonding, and playing intertwined. If you're the parent, by now you know your child's optimum times for interacting. If you're photographing someone else's baby and don't have all day to follow the action, be sure to communicate with the parents about the baby's schedule. Ask them when the child seems most engaged — some babies are more alert in the morning, while others seem more animated in the afternoon. Ciaran, perched on his father's shoulder, had just finished a nap and was giggling at my assistant's funny faces when I captured the shot in 8-1.

CREATE THE RIGHT ENVIRONMENT

If you show up with a camera and abruptly start shooting pictures, you run the risk of upsetting the baby and missing out on those special moments you intended to photograph. If you aren't familiar with the baby, take the time to slowly introduce yourself with smiles and coos, get down on the baby's level, and say hello. If you plan on getting in close for upcoming baby shots, it's a good idea to introduce your camera, too.

My photo shoot with seven-month-old Lily and her family began inside my house as we looked over clothing, smoothed her hair, and prepared to go outside. This gave me time to meet, coo, and

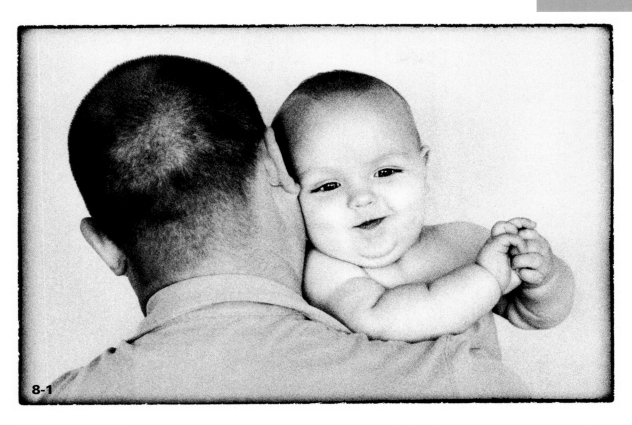

8-1

ABOUT THIS PHOTO *Ciaran faces indirect window light as he looks over his father's shoulder. The sepia image and sloppy border effect was created with Silver Efex Pro 2 from Nik Software. Taken at ISO 400, f/2.8, 1/160 sec. with a Canon EF 85mm f/1.8 lens.*

play with Lily a little bit before the shoot. In 8-2, Lily and her mother shared an embrace at the beach while I captured the candid moment.

When babies feel comfortable with your presence and your camera, they soon forget the camera, and this can lead to capturing many memorable pictures.

Just like Baby Bear's porridge, the temperature must be just right for the baby, which means erring on the warm side. If you're shooting outside, bring blankets and warm clothing and avoid extreme weather conditions. If you are inside,

make sure the shooting environment is cozy and quiet. Music can also influence the ambiance. Newborn babies are soothed by soft music and are startled and frightened by loud, unexpected noises. For a more active photography session, older babies through toddlers can be energized by rhythmic dance music.

You might be short on time or frustrated with your equipment, the light, or other people in the room, but do not allow this stress to enter into the shoot. Babies and toddlers are human sponges, picking up all the emotions and tension

8-2

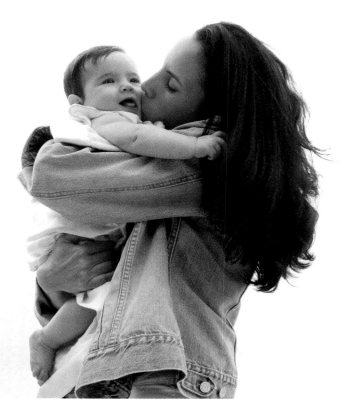

in the room. Take a deep breath, be patient, and don't let any negativity ruin your baby photo session. These moments are important and priceless.

ACCOMMODATE FOR THE AGE

Depending on the age of the baby you are photographing, certain challenges can be expected. For example, newborn infants are like rag dolls and must be held for any pose, while 18-month-old babies walk, explore, play, and, unless they are sleeping, are in constant movement. The following list explains how babies generally behave and respond according to their age, and it offers ideas for forming your approach:

■ **Zero to three months.** Babies in this age range have no mobility or strength. Unless they're sleeping or in horizontal poses, they must be held for a photograph. They sleep a lot. Take some shots of the baby sleeping and being held by friends or family members, and don't forget those close-up pictures of fingers and toes. Anya is only six weeks old and needs to be held to take the photo, as shown in 8-3. Outside, in soft, open shade, I positioned her in the doorway and zoomed in close to capture her expressions and isolate her from the background, as shown in 8-4 and 8-5. This helped eliminate any surrounding distractions and you'd never know that she was being held.

■ **Three to six months.** At this age, babies can raise their heads and chests when they are put down on their tummies. Take shots of the baby lying on the floor, in a crib, or with a parent, or position the baby over a blanket mound or sofa cushion. Little three-month-old Poppy is positioned on a furry blanket in a classic baby portrait pose in 8-6.

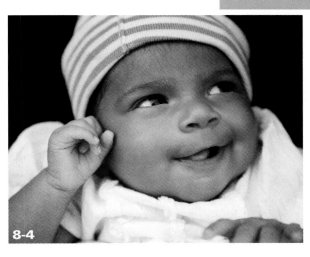

ABOUT THIS PHOTO *Zooming into the frame with a telephoto lens helps eliminate any background distractions. Taken at ISO 200, f/4.0, 1/250 sec. with a Canon EF 24-105mm f/4L IS lens.*

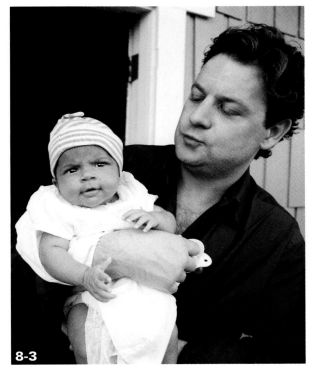

ABOUT THIS PHOTO *This little baby needed to be held, but I was still able to capture some great shots. Taken at ISO 200, f/4.0, 1/200 sec. with a Canon EF 24-105mm f/4L IS lens.*

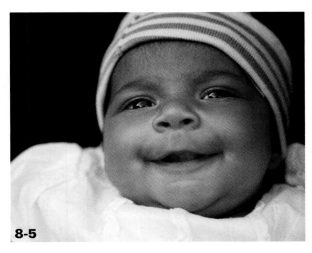

ABOUT THIS PHOTO *Getting in close to the baby provides an intimate feel to the image. Taken at ISO 200, f/4.0, 1/320 sec. with a Canon EF 24-105mm f/4L IS lens.*

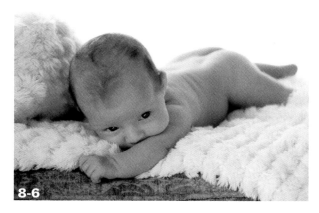

8-6

ABOUT THIS PHOTO *Three-month-old Poppy was comfortable and happy when I positioned her on a warm blanket. Taken at ISO 400, f/4.0, 1/1000 sec. with a Canon EF 70-200mm f/2.8 lens.*

■ **Six to nine months.** Most babies are beginning to sit up on their own and can feed themselves with finger foods. You can creatively pose them, but prepare for movement at any time. Think about taking candid action shots when they are eating or playing. Six-month-old Amelia was sitting at a table, happily playing with her toys when I captured the candid moment shown in 8-7.

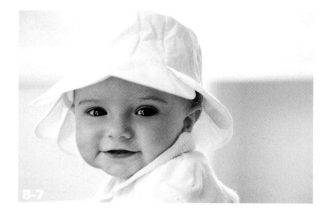

8-7

ABOUT THIS PHOTO *By positioning myself at Amelia's level and remaining ready with the shutter button, I was able to capture a natural expression in this photograph. Taken at ISO 200, f/5.0, 1/100 sec. with a Canon EF 24-105mm f/4L IS lens.*

■ **Nine to twelve months.** Now they are reaching for toys, can pull themselves up, and may be beginning to walk. Capture a moment with a baby and his blanket or favorite stuffed animal. Image 8-8 captures a playful moment between eleven-month-old Mia and her dad.

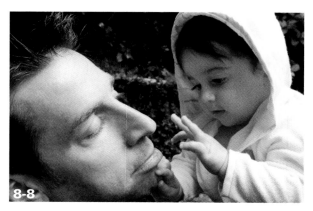

8-8

ABOUT THIS PHOTO *I placed Mia on her dad's lap and took a lot of photographs when they began to play. Taken at ISO 800, f/11.0, 1/125 sec. with a Canon EF 17-35mm f/2.8 lens.*

■ **Eighteen months.** The baby is walking — get ready to follow the action! The world is a new and exciting place for babies and toddlers. Try to capture their interactions and fascination with the experience. Eighteen-month-old Natalie is full of wonderful expressions as she reacts to her mother's storytelling in 8-9.

KEEP IT SIMPLE

Less is more when taking beautiful baby portraits. Think Zen. Clean, calm environments with few people, minimal noise, and unobstructed backgrounds allow you to focus completely on the baby and produce quality images that everyone wants to see.

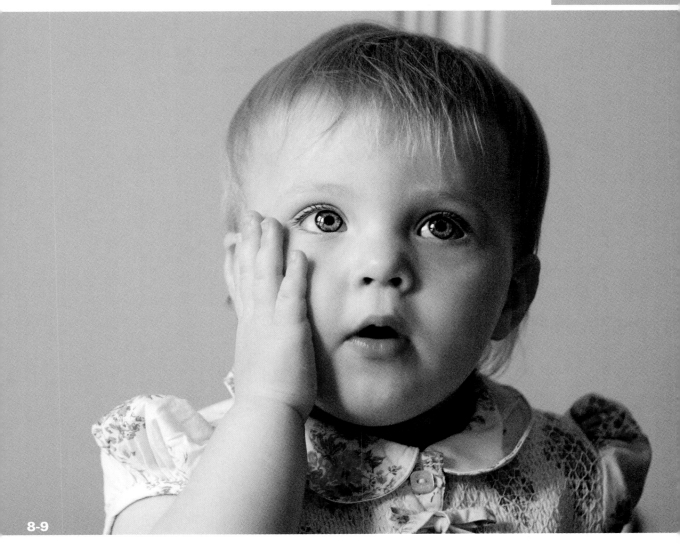

8-9

ABOUT THIS PHOTO *Natalie was running around the house but stopped to listen to her mother's stories. Taken at ISO 800, f/2.8, 1/90 sec. with a Canon EF 70-200mm f/2.8 lens.*

PREPARE THE BACKGROUND

If you are taking pictures inside the home, check your surroundings and remove any background clutter before taking the shot. Clear out items that get in the way and compete for attention in the photograph — keys, toys, shoes, boxes, dying plants, anything that can distract the viewer's eye.

Another way to simplify the background is by using a backdrop, and you don't need to purchase a professional one from the camera store. Get creative and look around your house for solid-colored blankets, throws, sheets, and even fabric remnants, which work well as backdrops. Pictures of a baby lying on a sofa or on a bed offer perfect scenarios for using a white sheet. It's a large, inexpensive backdrop and also reflects light, filling in the shadows beneath the baby. In 8-10, I placed four-month-old Ciaran on the bedspread and used a daylight-balanced florescent Home Studio Light softbox to help brighten the indirect light coming in through the window. I shot the image as I stood above him, and I made sure to secure my camera by tightening the camera strap length around my neck. It's wonderful to get in close to a baby to get the shot, but be extra careful not to drop anything or fall on the baby as you compose the shot. You already know this, but I'll say it anyway: babies are very delicate creatures!

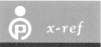

Find out more about lighting in Chapter 3 and lighting equipment in Chapter 2.

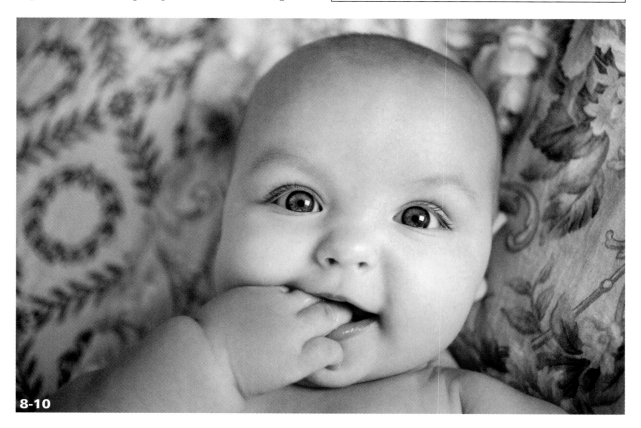

8-10

ABOUT THIS PHOTO *The bedroom comforter makes an interesting and comfortable backdrop for four-month-old Ciaran. Taken at ISO 500, f/2.5, 1/125 sec. with a Canon EF 50mm f/2.5 compact macro lens.*

Photographing a baby propped up in a colorful car seat or baby carrier is common, but also presents a challenge. While these seats enable the baby to sit securely and upright, they don't provide the most photogenic background. Often the fabric covering is very bright and colorful and has the manufacturer's nametag located near the infant's head. This is very distracting. You can easily fix the problem by placing a soft-colored solid blanket or throw under or around the baby. Choose a background color that enhances the baby's eye color. Have a friend or family member

hold the backdrop or blanket behind the baby and zoom in to eliminate anything distracting in the background.

A solid-colored blanket can become a very handy backdrop when the background in your scene is distracting. In 8-11, the bedroom has beautiful natural light, but a skylight in the background and other furniture distracts from the scene. I had Ciaran's father hold up a cream-colored blanket as a backdrop so I could zoom in and fill the frame with Ciaran and his mother, as in 8-12.

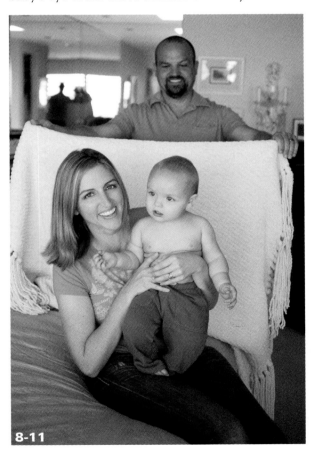

8-11

ABOUT THIS PHOTO *An easy way to simplify the background is by using a solid-colored blanket or sheet as a backdrop. Taken at ISO 400, f/3.2, 1/125 sec. with a Canon EF 50mm f/2.5 compact macro lens.*

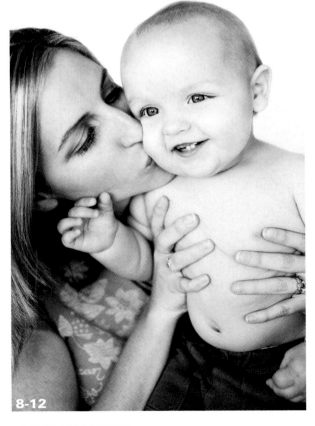

8-12

ABOUT THIS PHOTO *I positioned myself close to Ciaran and his mother so I could fill the frame and eliminate the edges of the blanket in the background. The black-and-white effect was created with Silver Efex Pro 2 from Nik Software. Taken at ISO 400, f/3.2, 1/125 sec. with a Canon EF 50mm f/2.5 compact macro lens.*

PREPARE THE BABY

Given many successful baby photographs are taken at close range, do yourself a postproduction favor and make sure the baby is completely clean before beginning the photo shoot. When you look at an image up close, you will see dirty fingernails, boogers, eye goop, stray blanket fuzz, and forgotten food that you wished you had taken the time to wipe off. It's possible to fix these problems later in an image-editing software program, but after retouching the twentieth image with dirty fingernails, you might change your mind. One way to begin the photo shoot is in the sink or bathtub. This activity is multitasking at its best. You can capture poignant, timeless shots and clean the baby at the same time — just make sure you have help.

CHOOSE THE RIGHT CLOTHING

The simplest outfit for a baby is nothing at all. Naked babies are cuter than almost anything; however, not all photo opportunities call for bare bottoms. The clothing selection for a baby's photo shoot is similar to the background selection: Look for clothes that are soft, light, or solid colors, as in 8-13. Avoid busy patterns, stripes, logos, or

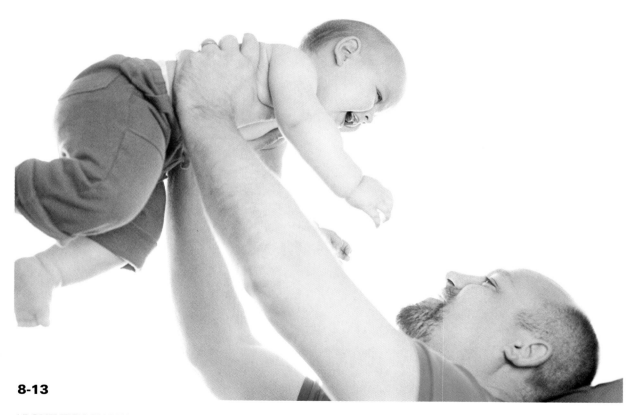

8-13

ABOUT THIS PHOTO *Less is more when it comes to baby's clothing. Taken at ISO 400, f/3.2, 1/100 sec. with a Canon EF 50mm f/2.5 compact macro lens.*

food-stained clothing that distract from the subject. Soft-texture knits, silk, angora, faux fur, or anything that denotes softness enhances your photo.

HOW TO POSE BABIES

I am an advocate of natural poses, which aren't really poses at all, just thoughtful positioning. You need to consider the environment you are working in, the age of the baby, and your light source when positioning a baby for a photo shoot. Do not force a baby into any dangerous, uncomfortable, or contrived pose or position. Any images created in this manner look phony and forced and you could possibly go down in family history for baby endangerment. You can set up a

backdrop, safely place the baby in the picture-taking area, and encourage a reaction with various tricks of the trade, such as tickling the baby with a feather, playing with favorite toys, or even feeding the baby yummy treats. You then follow the action with your camera poised and ready to go or you patiently wait for the moment to occur. You are only the adult here; in baby photography, the baby rules.

In 8-14, I've placed Ciaran safely on the bed and have enlisted the help of a 12-year-old boy named Jack to help me entertain him and make him smile, giggle, and laugh. As you can see in 8-15, it worked. Jack also helped coax many of Ciaran's other expressions in images throughout this chapter. (Thanks, Jack!)

ABOUT THIS PHOTO
Enlist the help of friends, family, or an assistant to help you entertain the baby. Taken at ISO 400, f/4.0, 1/80 sec. with a Canon EF 24-105mm f/4L IS lens.

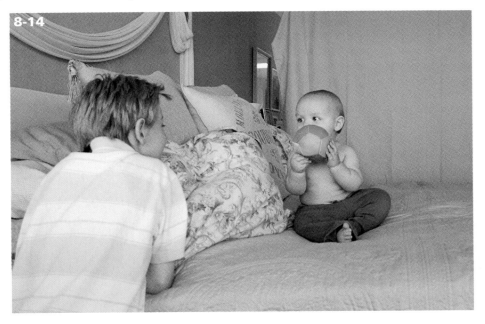

8-14

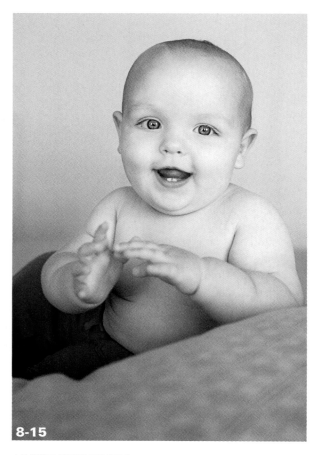

8-15

ABOUT THIS PHOTO *Ciaran looks comfortable and happy after I placed him on the bed next to a pillow. Taken at ISO 400, f/3.2, 1/125 sec. with a Canon EF 50mm f/2.5 compact macro lens.*

PLAY WITH PROPS

You don't have to use props, but they can be fun to experiment with, especially if they have significant meaning or convey a message. Blankets, stuffed animals, favorite toys, flowers, Easter eggs, and holiday wrapping paper are just some of the many options. And props don't have to be

inanimate objects. Friendly family pets and even other babies can make a photo shoot much more interesting. Just remember that the prop must be shown in a natural way with the baby or it will look contrived. In the series of photos shown in 8-16, 8-17, and 8-18, you can see that little Max was thrilled to play with bubbles in the backyard. My assistant held a diffuser over Max to soften the harsh sunlight as Max's dad turned on the bubble machine. I was able to capture some really authentic expressions — the kind that can only be captured by entertaining a baby with props.

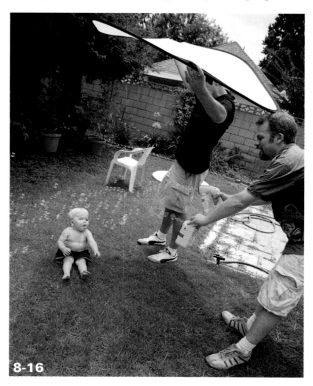

8-16

ABOUT THIS PHOTO *With a little help, I used bubbles as a prop as I photographed Max in the backyard. Taken at ISO 200, f/4.0, 1/800 sec. with a Canon EF 24-105mm f/4L IS lens.*

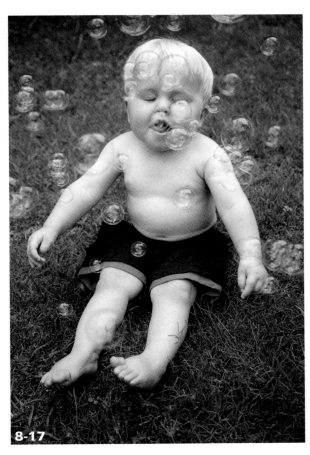

8-17

ABOUT THIS PHOTO *Max had so much fun playing with the bubbles that he forgot I was there with my camera. Taken at ISO 200, f/4.0, 1/800 sec. with a Canon EF 24-105mm f/4L IS lens.*

USE SOFT LIGHT

Everyone knows that babies are delicate, soft creatures, but did you know that delicate, soft light can result in beautiful baby images? Soft light is flattering to almost any subject, especially a baby. The hard, harsh light produced by an on-camera flash or open, midday sun flattens the shape and form of a baby's face, casts harsh shadows, and eliminates the natural light and

ambiance in the scene. So how do you find or create the most effective light for your photographs?

You can achieve a beautifully lit scene by following the suggestions outlined in the following sections.

FIND SOFT LIGHT

Indirect light is soft and even and can be found inside with window light, in an open doorway, under a skylight, or outside in open shade. For example, the father and daughter in 8-19 were captured on a sunny afternoon, but they were positioned beneath the ceiling on my porch so soft light enveloped them evenly. Locations such as these, with soft, indirect light, are good places to take pictures because they provide even lighting and eliminate harsh shadows and bright highlights.

> *idea* As an exercise, look around your house, inside and out, during different times of the day, and locate areas that provide soft light.

CREATE SOFT LIGHT

One way to achieve soft light is by turning off your on-camera flash and using natural light. Although studies have shown that a camera flash at close range apparently does not damage a baby's eyes, my thought is, why take a chance? Not to mention, a harsh on-camera flash can startle and irritate a baby. If you turn off the flash, you have an opportunity to capture photographs that are more natural looking and depict the true ambiance of the scene.

ABOUT THIS PHOTO *I zoomed in and filled the frame and blurred the background by using a longer telephoto lens. Taken at ISO 200, f/5.6, 1/500 sec. with a Canon EF 70-200mm f/2.8 lens.*

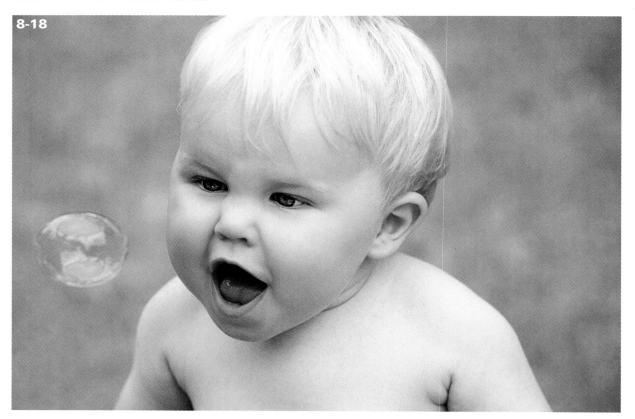

8-18

8-19

ABOUT THIS PHOTO *Soft light is everywhere; from doorways, archways, and porches to indirect window light. Taken at ISO 400, f/3.5, 1/100 sec. with a Canon EF 85mm f/1.8 lens.*

Suppose that you've turned off your flash and now it's a little too dark on one side of your subject's face. You can control natural light by reflecting it back into your scene with a reflective object. Professional reflectors come in white, silver, and gold, but homemade reflectors can also do the job. Use a car reflector, a whiteboard, or cover a baking sheet with aluminum foil. By reflecting light, you are filling in the shadows and creating a catch-light in your subject's eyes. This method is called *bouncing light*.

x-ref

For more information about light and controlling the light, refer to Chapter 3.

If it's too dark to turn off your on-camera flash, try using an external flash. External flash units allow you to point your flash in almost any direction. By directing your flash toward the ceiling, the light bounces off the ceiling, diffuses, and falls softly upon your subjects below. This method works best if the ceiling is not more than 12 to 15 feet high, because the flash may not reach that far. The color of the ceiling will reflect back onto the baby, so make sure it's a light color and doesn't look unnatural. Reflected white light is more flattering than other colors, especially on a baby.

tip

Catch-light is the twinkle of light found in your subject's eyes. If your subject is lacking a catch-light, you can create a twinkle by bouncing soft light back into his or her face. A catch-light draws attention to the eyes and livens up the face.

Placing your subject in direct sunlight can cause squinted eyes and harsh shadows across the face. It's not the optimum lighting situation, but there are those rare occasions that require a photograph outside in midday sun. A solution for eliminating shadows is to force your camera's flash to fire while shooting outside in bright light and fill in those harsh shadows on the baby's face. A good rule of thumb is to stand about 6 to 9 feet away and use your camera's zoom or long lens to get in close and fill the frame with your subject. This ensures the flash reaches the baby yet won't overexpose the baby's face with intense light. Consult your camera manual to check your camera's flash range.

tip

Turn off your flash and use a fast shutter speed (1/250 second or higher) to capture the action and produce sharper images. Newborns can move unexpectedly, and older infants and toddlers are always on the move. If the light is too low and you cannot use a fast shutter speed, try increasing your ISO.

SEIZE THE MOMENT

You've probably heard the expression *carpe diem*, which is Latin for "seize the day." In photography, it's a reminder to observe and capture those fleeting moments in life. Some moments unfold quietly on their own; others need some coaxing to get started. Either way, it is necessary to be technically prepared and visually attentive to recognize and capture human nuances that comprise a meaningful photograph. In 8-20 and 8-21, you can see twins TJ and Riley celebrating their first birthday with very different expressions and reactions to the festivities.

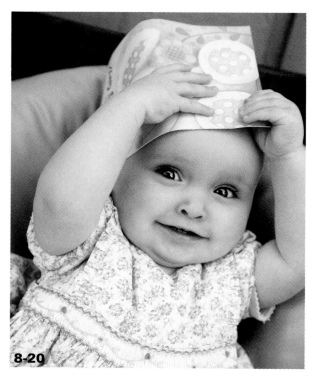

8-20

ABOUT THIS PHOTO *Twins TJ and Riley have very different personalities and a wide range of expressions. Taken at ISO 200, f/5.0, 1/125 sec. with a Canon EF 24-105mm f/4L IS lens.*

 x-ref

Isolating your subject from the background requires a shallow depth of field. For more on DOF, refer to Chapter 1.

CAPTURE SOMETHING MEANINGFUL

Relationships, emotions, and reactions come in many shapes and forms, and if you capture any of them in a photograph, you have created an interesting image. It's possible to photograph myriad

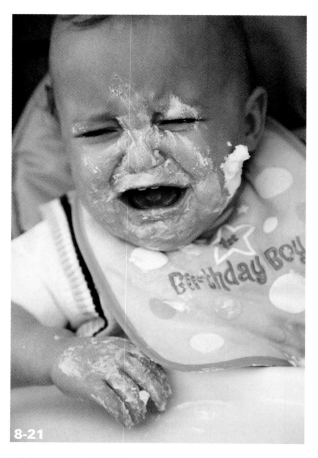

8-21

ABOUT THIS PHOTO *Capture every emotion. Taken at ISO 200, f/5.0, 1/250 sec. with a Canon EF 24-105mm f/4L IS lens.*

emotions if you are prepared and patient when shooting pictures of a baby. Keep your camera ready — a telling expression or emotion could occur at any time, as shown in 8-22 and 8-23.

idea

Design a special birth announcement using an image of a baby's feet or hands.

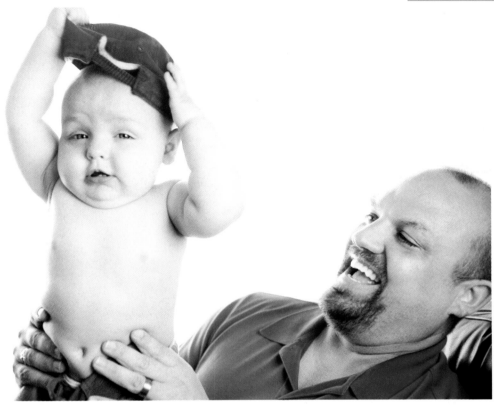

8-22

ABOUT THIS PHOTO *I used Continuous shooting mode to take pictures in quick succession during this playful father-and-son interaction. Taken at ISO 400, f/3.2, 1/100 sec. with a Canon EF 50mm f/2.5 compact macro lens.*

FOCUS ON THE EYES

The eyes are the first place people look when viewing a portrait, so make sure the baby's eyes are in focus in your image. To ensure sharpness, use the autofocus lock. Focus on the baby's eyes and press the shutter button halfway to lock in the focus. Continue holding the button until you compose your shot, and then depress the shutter completely to take the shot.

Ciaran is the son of friends of mine, so we have had a few different photo sessions over time. This image of nine-month-old Ciaran in 8-24 is not a traditional-styled portrait; it has a contemporary feel with Ciaran's proximity to the camera, his cropped head, and his parents behind him rendered in a shallow depth of field. You can't help but stare into his big, blue, beautiful eyes.

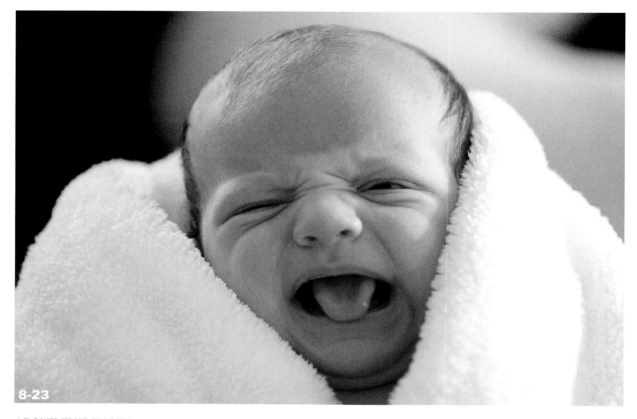

8-23

ABOUT THIS PHOTO *Every expression can't be happy. As I photographed her in the afternoon, inside a home with a lot of indirect window light, three-month-old Poppy was being held after a feeding and was ready for a nap. Taken at ISO 800, f/2.8, 1/250 sec. with a Canon EF 70-200mm f/2.8 lens.*

USE CONTINUOUS SHOOTING MODE

Babies are often in constant movement. This is where your action photography skills come in handy. To capture a sequence of images in rapid succession, use your camera's Continuous shooting mode. Using this mode helps to ensure you won't miss any moments-between-the-moments and the action will be included in your sequence of images. Remember to keep taking pictures even after you think the moment has passed. This is often when magical, unexpected things happen.

REMEMBER THE DETAILS

A baby's fingers and toes are tiny for only a short time, so don't miss the opportunity to photograph these details. Set your camera to the Macro mode and get in close to fill the frame. Closeness represents intimacy in an image and creates visual impact. In 8-25, Anya's six-week-old hands are delicate and expressive. I used the Rule of Thirds to compose the shot and was careful not to crop out any of her fingers.

ABOUT THIS PHOTO *Experiment with proximity to your subject and depth of field, and be sure to focus on the eyes. Taken at ISO 400, f/4.0, 1/250 sec. with a Canon EF 50mm f/2.5 compact macro lens.*

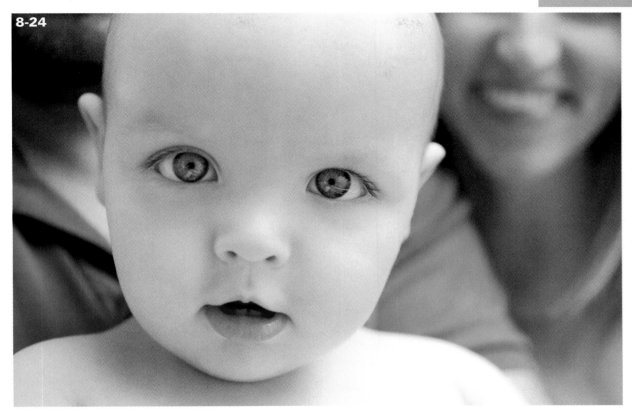

8-24

ABOUT THIS PHOTO
Close-up shots of a baby's hands are precious and important details to photograph. Taken at ISO 200, f/4.0, 1/125 sec. with a Canon EF 24-105mm f/4L IS lens.

8-25

 x-ref

Learn more about creative composition techniques in Chapter 4.

All parents want a photograph portraying their relationship with their child. Hands and fingers are one of the many ways to communicate this special connection, as shown in 8-26.

8-26

ABOUT THIS PHOTO *A relationship between parent and child can be captured beautifully when photographing hands. Taken at ISO 400, f/5.0, 1/80 sec. with a Canon TS-E 90mm f/2.8 lens.*

Assignment

Tell a Story

I believe that everyone likes to hear a story. You can tell a visual story with your images by capturing pictures from different angles and distances, or your story can be a sequence of images that convey a message. When you place these images together they create a dynamic and interesting narrative.

To complete this assignment, I took a series of images that revealed various expressions. From bewilderment to curiosity and joy, Ciaran's range of expressions captures your attention and guides you through his reactions to the football. Taken at ISO 500, f/2.5, 1/125 sec. with a Canon EF 24-105mm f/4L IS lens.

 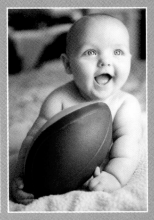

 Remember to visit www.pwassignments.com after you complete this assignment and share your favorite photo! It's a community of enthusiastic photographers and a great place to view what other readers have created. You can also post comments, read encouraging suggestions, and get feedback.

Use Your Camera and Lens

Freeze the Action

Blur the Motion

© Maria Catalano-Monroe

Action captured in a photograph denotes movement and life, giving an image a dynamic feel. Some action images freeze a moment in time, and others blur reality with a dream-like aesthetic. The first step in learning how to capture and create these effects is understanding the options available on your particular camera and lens, which are covered first in this chapter. Then you learn about the techniques for capturing motion, whether you want it crisp or blurred.

USE YOUR CAMERA AND LENS

If you are using a smartphone or a compact digital camera, your ability to capture fast-action photographs like the pros is very limited. Although you can use a few settings to capture action with your smartphone or compact camera, to get those close-up, fast-action, blurred-background, professional-looking shots, you need a dSLR camera and a fast lens. Whichever type of camera you use, you can creatively capture action, provided you understand its limitations and the options. The next sections provide tips for capturing action with a smartphone, a compact digital camera, and a dSLR.

COMPACT CAMERAS AND SMARTPHONES

If you don't have a dSLR, or opt not to bring it with you, it's better to capture a snapshot with your smartphone camera or compact camera than not at all. Of course, these cameras are limited and lack the quality that a dSLR camera and lens can provide, but this is generally known and expected with documentation-style smartphone photography. One way to improve the outcome is to enhance your images "in phone" with a

smartphone application. With a few clicks or swipes, your ho-hum, out-of-focus snapshot transforms into a nostalgic, film-like image that presents well on a smartphone, tablet screen, or computer. Instantly sharing your documented life moments on social media sites has become easier, too, whether you're uploading your images via a smartphone or using a compact camera with a Wi-Fi memory card. It may seem so simple that photo tips for these cameras would not be important, but there are some basics to keep in mind. Knowing how to capture the best shot can help save your photo moment.

| mobile technology | Smartphone applications are also known as *mobile apps*. These apps are either preinstalled by the phone manufacturer or downloaded from an app store or other mobile software distribution platform and then installed onto your smartphone. |

As of the publication date of this book, most smartphones do not have any of the bells and whistles that compact cameras possess, other than slight zoom capability and perhaps an on-camera flash, so it's back to basics. Just consider smartphone photography an opportunity to exercise your newfound knowledge on lighting and composition! Following are a few tips to help you create on-the-go and action images that stand out above the rest, and optimize them for possible in-phone enhancement afterward:

- ▪ **Lighting.** Lighting can make or break your smartphone photo. It's best to capture your images in soft lighting with very little contrast. Shooting in open shade, on overcast days, or in the early morning or late afternoon is optimum. If you can see the details in the highlights and shadows of your image, it's a

good candidate for smartphone app enhancements later. Image 9-1 was taken while on a long Mother's Day walk with my mom. It was easier to take along my smartphone, and the added safety benefit of a phone was important as we walked in semiremote areas. Fortunately, it was a typical "May Gray" day along the Southern California coast, which resulted in beautiful soft light for the photo.

■ **Depth.** Smartphones don't have the capability to render the illusion of depth in your image like a dSLR camera and lens can. To create depth, compose your image with foreground and background interest and use diagonal lines to draw the viewer's eye through the image, as shown in 9-1.

9-1

ABOUT THIS PHOTO *Soft light and creative composition helped enhance this smartphone snapshot of my mom. Taken with an iPhone 3GS and further enhanced with the Plastic Bullet mobile application.*

- **Angles.** Get creative and use unusual angles to create interest in your images. Shoot from down below or up above, or tilt your phone to add a dynamic diagonal effect. Image 9-2 was taken on a busy street in New York City as I was walking between appointments. By pointing the smartphone down and tilting it a bit, I captured a series of anonymous legs on a diagonal, creating a dynamic sense of movement.

- **Motion.** At this point, it's challenging to capture images with a smartphone in low light — the images often turn out blurry and underexposed because there aren't many options for controlling the camera. Smartphones are better at capturing the action in bright light. For the best action photo results, shoot outdoors on a sunny day, as shown in 9-3.

ABOUT THIS PHOTO *I captured this action photo of Jack in the pool at high noon on a bright summer day. Taken with an iPhone 3GS.*

ABOUT THIS PHOTO *An ordinary daily experience, such as walking down the street, can be composed, captured, and enhanced with a simple smartphone camera. Taken with an iPhone 3GS and further enhanced with the Plastic Bullet mobile application.*

 x-ref

See Chapter 2 for more information on Wi-Fi memory cards.

Compact cameras have an Action (or Sports) mode that automatically adjusts the exposure settings to capture action with a faster shutter speed. The optical zoom feature allows you to get a little closer to the action, and you have the freedom to experiment and take as many pictures as you

want. Just delete the ones you don't like. Here are a few pointers for optimizing your action-shot chances when shooting with a compact camera:

■ **Set your camera to Action mode to achieve the best results when you're photographing people in motion.** Action mode automatically increases the aperture to let in more light and uses a faster shutter speed to capture a moving subject.

■ **Prefocus your shot.** Your camera needs time to focus, and you might experience a slight delay when you fully press the shutter button in one move. By pressing the shutter button halfway while tracking your shot and then fully pressing the shutter to capture the shot, you can time your shots and minimize the impact of any shutter lag. Another way to focus your shot is to prefocus on a point you anticipate your subject is going to cross and then fully press the shutter button when the moment occurs.

■ **Get closer to the action by using your camera's optical zoom.** Most compact digital cameras have 3x optical zoom. The more optical zoom you have, the farther away from the action you can be. If you plan to take a lot of pictures of soccer games or baseball, you may want to invest in a camera with 10x to 12x optical zoom.

To show you specifically what I mean, check out 9-4 and 9-5. Both photos are taken from the same location, and the subject is in the same location. In 9-4, I used a 3x optical zoom. I can get three times closer to him with a 3x optical zoom lens, but it's still not close enough to capture his expression. In 9-5, I used a 12x optical zoom, which enables you to zoom in closer to your

subject to capture expressions and detail. This is especially useful if you are in the stands and still hope to get good pictures of the action on the field, for example.

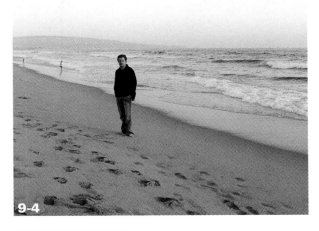

ABOUT THIS PHOTO *Michael was positioned at quite a distance from me. With a 3x optical zoom on my compact camera, I was able to get a little closer. Taken at ISO 100, f/3.7, 1/125 sec. with a compact digital camera.*

ABOUT THIS PHOTO *Using a 12x optical zoom allowed me to get really close, as in 9-3, without physically moving. Taken at ISO 100, f/3.7, 1/160 sec. with a compact digital camera.*

DSLRS

Smartphones and compact cameras are everywhere; they conveniently capture moments that might otherwise go unrecorded. This phenomenon has inspired a greater interest in photography than ever before. After you learn how to manage a smartphone or compact digital camera, you might be ready for the next level of photography and all the photographic possibilities a dSLR camera offers. Higher-quality images, more control, and the ability to interchange your lenses are some of the important benefits of using a dSLR camera. Following are the basic settings and modes to use when capturing action shots with your dSLR:

■ **Continuous shooting mode.** Compose your shot and hold down the shutter button to take multiple shots in succession. This mode enables you to catch every movement and expression within multiple images.

In 9-6 through 9-10, I used Continuous shooting mode to capture a sequence of movements.

■ **Semiautomatic Shutter Priority mode.** This mode gives you complete control over the shutter speed. Set a fast shutter speed (1/250 sec. or higher) to freeze the action or use a slow shutter speed (1/60 sec. or lower) to blur the action. This is a great setting when your exposure time is more important than your depth of field. In this mode, even if the light varies, the shutter speed won't change. The camera keeps up with the changing light by adjusting the aperture automatically.

■ **Predictive autofocus or focus tracking.** Trying to focus on your subject when she is moving can be challenging. You can use the prefocusing techniques I suggested for the compact digital cameras, but to take advantage of your dSLR features, use your dLSR's predictive autofocus. This might be the time to whip out that camera manual to find the setting in your menu system. On your lens, make sure the focus mode switch is set to autofocus (AF). On your camera, set the Mode dial to Shutter Priority mode and find your camera's AF button; then adjust to set it on AI Servo or Continuous Focus (depending on your camera manufacturer). This focusing mode is for moving subjects when the distance keeps changing. The best way to use this feature is to press the shutter button halfway to activate the AF system, and then fully press the shutter button when the decisive moment arrives. This gives the AF system time to acquire the subject and do its predictive calculations.

■ **ISO.** The ISO rating measures the light sensitivity for your digital camera's imaging sensor. Similar to film speed, your camera's ISO works in unison with the shutter speed and aperture to create the right exposure for your shot. If you are shooting in a low-light situation and don't want to use a flash, adjust the ISO to 400 or higher to increase the amount of light that reaches the camera sensor. A higher ISO means that you can use a faster shutter speed and capture more of the action.

ABOUT THIS PHOTO *I used Continuous shooting mode to capture all the action when Jack threw his fastball. Taken at ISO 320, f/32, 1/30 sec. with a Canon EF 24-105mm f/4L IS lens.*

ABOUT THIS PHOTO *The wind up shot captures his intense expression. Taken at ISO 320, f/32, 1/30 sec. with a Canon EF 24-105mm f/4L IS lens.*

Just be aware that higher ISO levels can create noise in your image, which is the digital equivalent to film grain, as shown in 9-11. Digital noise appears as random discolored pixels, also known as artifacts, throughout your image.

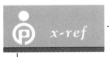 x-ref

You can find more information on dSLR cameras and lenses in Chapter 2.

LENS SPEED

Every lens has a limit to how wide it can open up and how much light it allows in to create an exposure. This limit is called the *maximum aperture*. The maximum aperture of every lens is listed as part of the lens identification. For example, a 28-135mm f/4 lens has a maximum aperture of f/4.0. The smaller the number, the wider the maximum aperture. A 28-75mm f/2.8 lens lets in more light than an 18-55mm f/3.5-5.6 lens.

ABOUT THIS PHOTO *You can capture similar shots by using your camera's Shutter Priority mode with a fast shutter speed. Taken at ISO 320, f/32, 1/30 sec. with a Canon EF 24-105mm f/4L IS lens.*

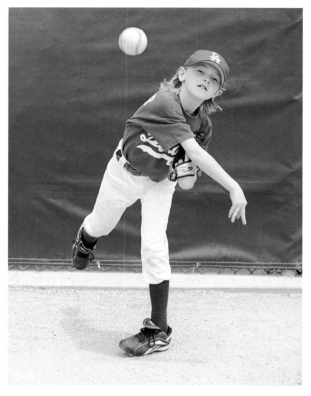

ABOUT THIS PHOTO *Continuous mode captures the ball in midflight. Taken at ISO 320, f/32, 1/30 sec. with a Canon EF 24-105mm f/4L IS lens.*

A lens that lets in more light allows you to use faster shutter speeds — the shutter does not have to be open for long periods of time because enough light is passing through the lens to get a correct exposure. Because lenses with wide maximum apertures let you use faster shutter speeds, they are commonly called *fast* lenses. If you want to capture fantastic-looking action shots, you're going to need a fast lens.

Zoom lenses can either have *variable* or *constant* maximum aperture. When a zoom lens has a variable maximum aperture (for example, f/3.5-5.6),

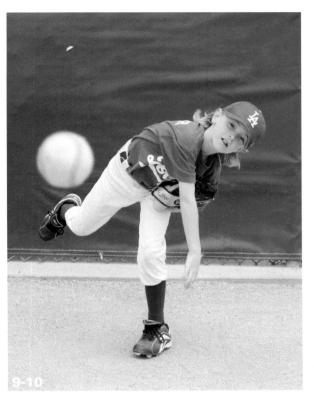

9-10

ABOUT THIS PHOTO *It looks like the ball is flying my way! Taken at ISO 320, f/32, 1/30 sec. with a Canon EF 24-105mm f/4L IS lens.*

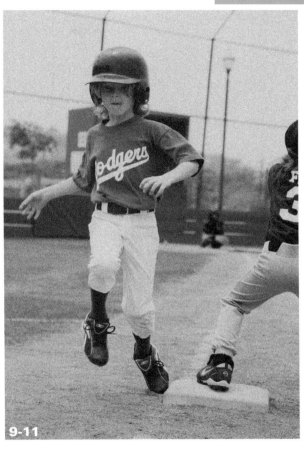

9-11

ABOUT THIS PHOTO *Using a high ISO enabled me to use a faster shutter speed, but this tradeoff results in more digital noise in the image. Taken at ISO 1000, f/6.3, 1/800 sec. with a Canon EF 24-105mm f/4L IS lens.*

the maximum opening of the lens changes as you zoom. When you have your lens extended or zoomed all the way out, your widest aperture possible is f/5.6. When the lens is zoomed all the way in, your maximum aperture changes to f/3.5. The problem with variable maximum aperture lenses is that when you zoom, your exposure settings change. Because the lens lets in less light at the telephoto setting, this affects the shutter speed that you are using, slowing it down.

A constant aperture has one maximum aperture and does not vary (for example, f/2.8). By comparison, a zoom lens with a constant maximum aperture does not change, no matter how much you zoom. You can distinguish these lenses because they indicate only one number for maximum aperture (for example, 28-105mm f/4). If you want your shutter speed to be consistent when you're taking action photos, use an action lens with a constant maximum aperture.

Most dramatic sports shots are taken with the lens wide open or 1 stop from wide open. Photographers do this for two reasons:

- **You need the shutter speed to be as fast as possible, which means you shoot at maximum aperture.**

- **The background in many action shots is not controlled and can be very distracting if it's in sharp focus.** A wide aperture isolates your subject from the background with a shallow depth of field, as shown in 9-12.

LENS FOCAL LENGTH

Lenses come in different focal lengths, and this length is a measure of how far away you can be from your subject and still get a close-up. The farther away you are from any action, the longer the lens you need to capture the shot. A telephoto lens allows you to stand on the sidelines of your favorite sporting event and capture nice close-up shots of the players in action. As a general rule of thumb, each 100mm in lens focal length gives you about 10 yards in coverage.

In 9-13, I was standing behind a fence near the outfield and was able to capture this action image due to my long focal-length lens (70-200mm).

9-12

ABOUT THIS PHOTO *I used a fast shutter speed and a wide aperture to freeze Nicolas's jump in midair and to blur the background. Taken at ISO 250, f/3.2, 1/800 sec. with a Canon EF 24-105mm f/4L IS lens.*

The best action lens has telephoto focal length, which means it is anywhere between 100 and 300mm. Fast telephoto lenses contain a lot of glass, are larger and heavier than slower, variable maximum aperture lenses, and consequently come with higher price tags.

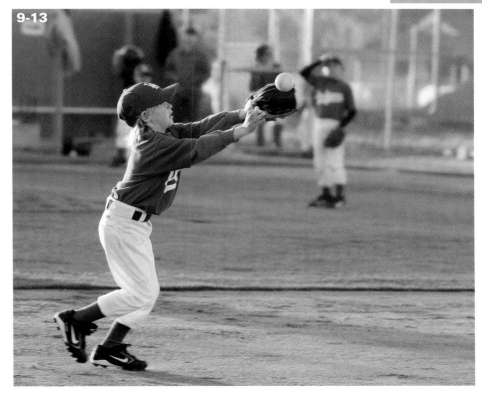
9-13

FREEZE THE ACTION

Our eyes cannot capture a millisecond moment and freeze it in midair, but a camera can capture that moment and freeze it forever in a photograph. With stop-action photography, the purpose is to freeze the subject so the viewer can see it clearly. Stop-action is effective only when the viewer realizes that the subject was moving when the picture was made. To enhance your action photo, include a point of reference in the image that conveys a story. What is your subject doing? Is there anything in the background that gives the viewer more information about your subject? For example, if you are shooting a pole vaulter,

include the pole and perhaps the jump point; when shooting a volleyball player, include the ball and the net.

Another way to stop action is to take the picture at the peak of action. Shoot when the basketball players are at the highest point of their jump. Make your exposure the instant the action is suspended. Photograph a child the moment his swing pauses to reverse its direction. Stopping action at its peak is possible with a medium shutter speed, but your timing must be perfect.

Use your shutter speed to your advantage for action shots. Following are some examples of shutter speeds used in different action situations:

Swimmer: 1/125 sec.

Runner: 1/250 sec.

Skateboarder: 1/500 sec.

Cyclist: 1/500 sec.

Car at 50 mph: 1/750 sec.

Skier: 1/1000 sec.

Water droplets: 1/2000 sec.

Capturing your subject in action is affected by three things:

- **How fast the subject is moving.** Faster movement requires a faster shutter speed to stop the action.

- **How far the subject is from the camera.** The closer your subject, the faster your shutter speed needs to be to capture the action. For example, when you're driving on a highway, the scenery on the side of the road near the car appears to move rapidly, but the distant view you see through the windshield appears to move slowly.

- **Direction of your subject's movement in relation to the camera.** A person in motion perpendicular to your frame creates a lot more blur than motion toward or away from your camera. For example, if your subject is running across the frame, your image requires a faster shutter speed than if the subject is running toward the camera.

Timing the decisive moment is very important when you're trying to capture your subject in action. You must anticipate any action that is about to occur in your scene and press the shutter button before that action happens. If you can see the action with your naked eye, you missed the shot due to the delay between the image hitting your optical nerve and the shutter closing.

LIGHTING FOR STOP-ACTION SHOTS

The lighting conditions in your scene are also important; if you don't have enough light, you may not be able to use a fast shutter speed without using a flash. Your exposure depends on the aperture, shutter speed, and ISO settings on your camera, and these three factors are reciprocal, meaning that each one affects the other. For example, a faster shutter speed requires a wider aperture, and depending on the light in your scene, you may need to increase your camera sensor's sensitivity to the light (ISO). Following is a situation that required my using a high ISO and wide aperture setting: My friend, Karen, stopped by to show me her new haircut one afternoon and we decided to take a few quick pictures. Although she has contributed to many of my photo shoots as a makeup artist, she is not very comfortable in front of the lens, so I suggested she swing her hair around to loosen up. She looked great, but the natural lighting conditions were a challenge. The brightest spot for her to stand was in the open sliding glass doorway that looks out onto my patio. I needed more light in order to use a fast shutter speed, so I raised my ISO to 1600, and used a fast, prime lens that allowed me to use a wide aperture setting of f/1.8. The combination of a high ISO and wide aperture setting allowed me to use a fast shutter speed (1/1250 sec.) to freeze the action and catch her hair in midswing, as shown in 9-14.

A high ISO of 1600 is typically not a good idea if you want a super-sharp image without noise (discolored pixels), but there are times when this may be your only solution in order to use a fast shutter speed. A general rule of thumb: the better your camera, the better the sensor and the less noise you'll see at higher ISO settings.

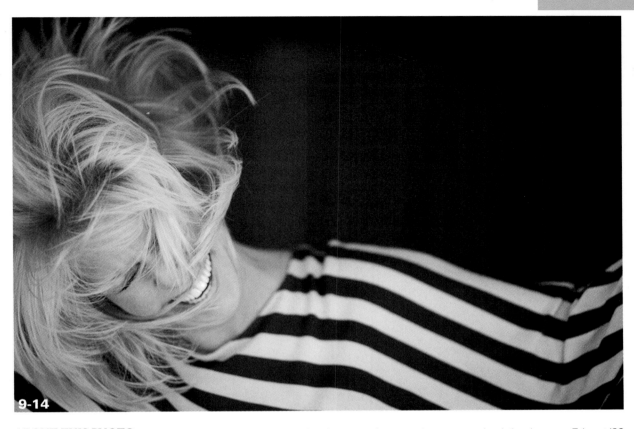

9-14

ABOUT THIS PHOTO *Karen is swinging her hair around, and a fast shutter speed captures that movement in relative sharpness. Taken at ISO 1600, f/1.8, 1/1250 sec. with a Canon 85mm f/1.8 lens.*

FAST SHUTTER WITH FLASH

With shutter speeds of 1/4000 sec. or faster, it's easy to stop action in your photographs; however, the challenge with using a fast shutter is that it also reduces the amount of light passing to the image sensor. Remember, the combination of shutter speed, aperture, and ISO all work together to create the right exposure for your scene. In low light, you have to open up to maximum aperture (f/2.8 on a fast lens) or increase your ISO (400+), or both. Even then, you might not have enough light to render a good exposure.

Good news! There is a workaround for these limits; your camera's electronic flash or an external flash can stop the action when you don't have enough light to use a fast shutter speed. And, if you do have enough light, using a flash works better than using your camera's highest shutter speed to freeze action. Why? Your camera's shutter speed may top out at 1/4000 sec., but most flash units can emit short bursts of light in durations as short as 1/50000 sec. Unless you have a high-end camera and flash combination, it's best to use a shutter speed of 1/200 sec.

With flash adding so much to your scene, you don't have to do much with your aperture and ISO speed; the camera does it for you.

Check your manual to find out your flash range. Most on-camera flash emits light for up to 12 feet; after that, the light falls off and doesn't reach your subject. Make sure that you are not too far away to fully flash your subject and freeze the action. Image 9-15 illustrates how flash can help capture your subject in midair.

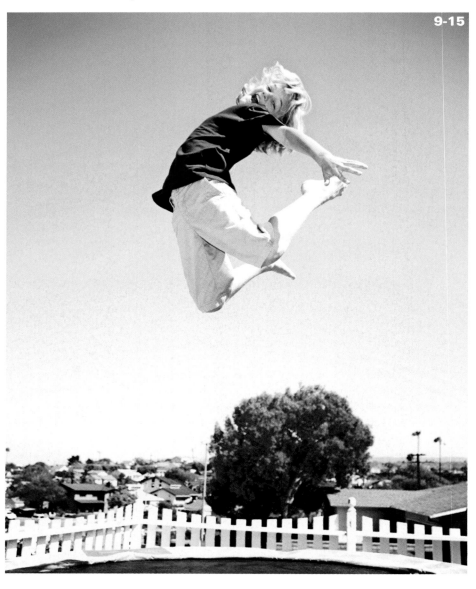

9-15

ABOUT THIS PHOTO
Using a flash to photograph Nicolas on his trampoline enabled me to freeze his jump in midair and produce a sharp image. Taken at ISO 200, f/4.5, 1/200 sec. with a Canon EF 17-35mm f/2.8 lens.

BLUR THE MOTION

Motion blur denotes movement in your images and can create a dream-like feeling in an image, which a stop-action photo could never achieve. Although blurred images are not an exact science, it's possible to keep some of your image in focus while allowing other parts to blur around the edges. You can use different techniques to achieve an interesting blur in your images. You may end up with a lot of experiments and throwaway shots, but you might also capture a stunning image.

In 9-16, I experimented by adjusting my camera settings to ISO 200, an aperture of f/3.2, and a shutter speed of 1/50 sec. to allow the movement of her hair to blur for a more artistic effect.

Sometimes a sharp, fast-shutter image just doesn't communicate the movement that a blurred, slow-shutter image evokes, as in 9-17.

USE A TRIPOD

All motion blur incorporates a slower shutter speed than you would use for a fast action shot, but if you are using a shutter speed slower than 1/60 sec., you need to stabilize your camera on a tripod or other solid surface. Otherwise, your entire picture, not just the subject's movements, may be blurry from camera shake.

To record image blur from subjects in motion, yet keep your background in sharp focus, do the following:

- Stabilize your camera on a tripod and use a slow shutter speed.

- Find an interesting, or dramatic, background in which people are in movement.

- Set your camera to Shutter Priority mode and use a slow shutter speed (1/4 sec. or slower).

- Turn on your camera's self-timer or use a remote shutter release and start taking pictures.

ABOUT THIS PHOTO
Karen's movement is recorded as a blur by using a slow shutter speed. Taken at ISO 200, f/3.2, 1/50 sec. with a Canon EF 85mm f/1.8 lens.

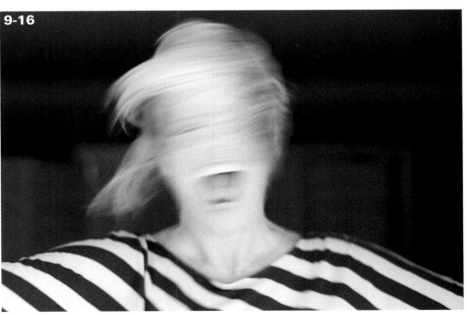

9-16

221

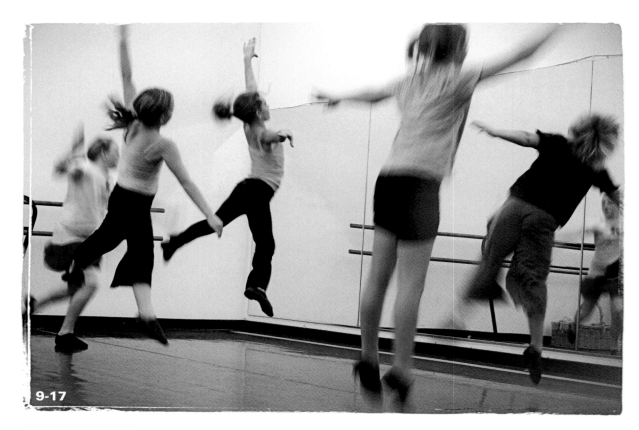

9-17

ABOUT THIS PHOTO *These dancers are caught in midair, yet their movement is blurred with a slow shutter speed. The sloppy photo edges were created in Photoshop Elements. Taken at ISO 200, f/9.0, 1/30 sec. with a Canon EF 50mm f/1.4 lens.*

Use different shutter speeds to alter the effects. You can create some interesting images with people in motion. Abstract colors and ghost-like images depict human movement in unique ways, as seen in 9-18, where I had Michael stand still on the stairs while the crowd moved in a blur around him.

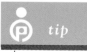 *tip*

When experimenting with motion blur, use a range of shutter speeds for varying degrees of blur.

PAN

Panning with the action keeps the subject in focus and blurs the background, creating streaks all around your subject that indicate motion and speed. To achieve this effect, here are a few essential tips:

- **Ensure a steady stance.** Keep your feet firmly planted, and twist from your waist to follow the moving subject with the camera.

- **Press your shutter button halfway and track your subject.** Don't let him run out of your viewfinder's frame.

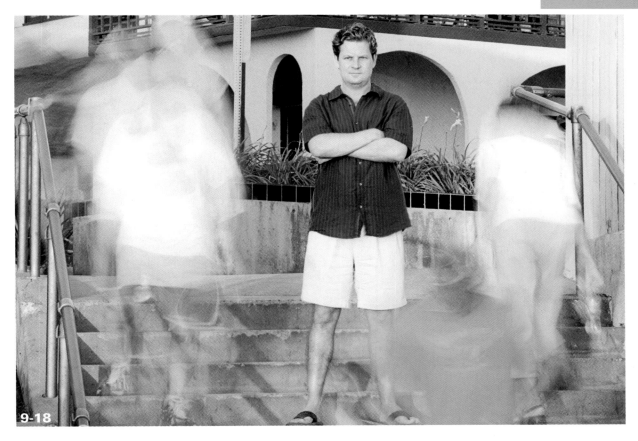

9-18

ABOUT THIS PHOTO *Using a neutral density filter in bright afternoon sunlight allowed me to use a slower shutter speed and record the motion blur in the image. Taken at ISO 250, f/32, 1 sec. with a Canon EF 70-200mm f/2.8 lens and a 3-stop neutral density filter.*

■ **When you decide the moment is right, fully press the shutter button.** Because the camera keeps pace with the moving subject, the subject is sharp and the background is blurred.

Panning requires some practice. If you are shooting with a compact digital camera, follow these basic steps:

1. **Prefocus on the spot where you plan to photograph your subject by pressing the shutter button halfway.**

2. **As your subject approaches, follow the action through your camera's optical viewfinder.**

3. **Fully depress the shutter button when your subject reaches the spot on which you originally focused.**

When panning with a dSLR, follow these general steps:

1. **Set your camera to Shutter Priority mode.**

2. **Turn on your predictive autofocus/focus tracking.**

3. **Set the camera to Continuous shooting mode.**

4. **Press the shutter button halfway to activate the focusing, and then follow the action through your viewfinder.**

5. **Fully press the shutter button.** Continue holding down the button to enable the multiple-shot Continuous shooting mode to fire away.

Continuous shooting mode tells your camera to take many sequential images prior to recording them to your memory card. Capturing multiple images in quick succession gives you more chances for recording the winning shot. Check your camera manual to confirm the maximum number of images your camera can capture in each burst sequence.

Using a tripod that pivots smoothly can also assist you in following the action. If you have a willing subject, ask the subject to run back and forth in front of the camera so you can adjust your tripod setup and practice keeping him or her in the frame.

Take a lot of photographs and experiment by using various shutter speeds from 1/60 sec. and slower — and just like a good golf or tennis player, follow through with your panning motion even after you release the shutter. In 9-19, you can see an example of panning with the action. I

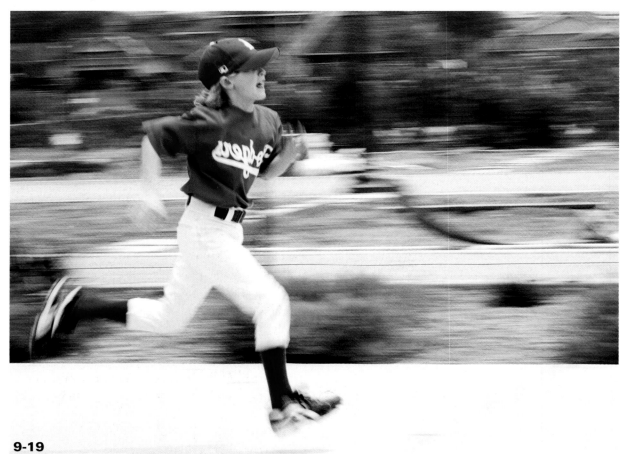

9-19

ABOUT THIS PHOTO *Panning the pace of Jack as he ran across the frame enabled me to create streaks of motion in the background and keep him in relative focus. Taken at ISO 320, f/32, 1/50 sec. with a Canon EF 70-200mm f/2.8 lens.*

followed Jack with the camera as he ran across the frame, and I pressed the shutter button simultaneously to create a blurry, streaked effect in the background.

ZOOM

To give the appearance of motion to a static subject, shoot with a zoom lens and change the focal length by quickly zooming in or away from your subject during the exposure. This technique takes practice but can transform a lifeless scene into something dramatic and exciting. The effect creates light streaks radiating from the subject, as shown in 9-20.

You must use a slow shutter speed to allow enough time to zoom in or out during the exposure. Depending on the effect you want to achieve, you can handhold the camera or mount it on a tripod to hold it steady and maintain the composition you want while zooming.

SLOW SHUTTER WITH FLASH

There are two basic ways a camera captures a flash photo in low light:

- **The camera uses a fast shutter speed to minimize camera motion blur, and the flash illuminates your subject, leaving the background dark.**

- **The camera uses a slow shutter speed to capture the ambient background light.** The flash illuminates your subject with a softer flash, and depending on movement in the scene, might record various amounts of image blur. This technique is called slow sync, slow shutter sync, or dragging the shutter.

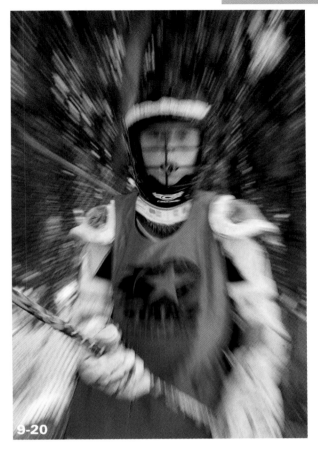

9-20

ABOUT THIS PHOTO *I twisted my zoom lens from the telephoto focal length to the wide-angle focal length as I pressed the shutter button to create this zoom effect. Taken at ISO 200, f/13, 1/40 sec. with a Canon EF 24-105mm f/4L IS lens.*

Compact digital cameras have a Night Scene setting that enables you to illuminate your subject with flash while using a slow shutter to record more of the ambient light in your scene. Use this setting when taking pictures at parties or other low-light events. It allows you to illuminate your subject's face while also capturing the beautiful golden glow of candlelight or other ambient light

that would otherwise be obscured in darkness with a normal flash setting. For nighttime images without blur, carry a minitripod for stabilizing slow shutter shots anywhere you go.

Digital SLR cameras enable you to use a slow shutter with flash by using Mode dial settings of Shutter Priority mode, Aperture Priority mode, and Manual mode — you can't use it in Program mode or most of the creative modes (icon modes).

Sometimes slow shutter sync is used to provide dynamic motion in flash photos. A photo taken with flash and a slow shutter speed can create an interesting mix of a flash-illuminated subject and ambient-light-illuminated motion blur. The effect is difficult to predict but can be very striking and exciting when it works.

Some high-end dSLR cameras have a second-curtain sync function. This setting is found in your Custom Functions menu. When shooting with second-curtain sync, the flash fires at the end of the shutter opening, as opposed to the standard first-curtain sync flash that fires at the beginning of the shutter opening. Second-curtain sync is a technical feat performed by your camera and flash that captures a blurred light trail following movement by your subject. In 9-21, the flash illuminates the golfer while the slow shutter speed combined with the second-curtain sync function captures the path of the golf club and the golf ball.

You might end up with a lot of images you won't like when you're experimenting and photographing people in motion. Don't be discouraged. It isn't easy to capture people when they are moving

around. Even professional action photographers have to sort through a lot of images to find just the right shot. Take a lot of photos and take time to review all of your images on the computer — you might be surprised to find a few perfectly artistic and magical moments.

9-21

ABOUT THIS PHOTO *Using flash with a slow shutter speed and second-curtain sync enables you to record motion blur in a unique way. Taken at ISO 100, f/14, 1/30 sec. with a Canon EF 24-105mm f/4L IS lens.*

Assignment

Freeze the Action

Experiment with using various shutter speeds and capture someone in motion by freezing the action with a fast shutter speed. Shoot in bright, natural light and set your camera to Shutter Priority mode. Use a shutter speed of 1/250 sec. to begin. Take a lot of pictures, and then increase your shutter speed and practice capturing the action.

To complete this assignment, I used a fast shutter speed on a bright afternoon and captured a stop-action shot of Alissa as she jumped up into the air. Taken at ISO 100, f/2.5, 1/640 sec. with a Canon EF 85mm f/1.8 lens.

Remember to visit www.pwassignments.com after you complete this assignment and share your favorite photo! It's a community of enthusiastic photographers and a great place to view what other readers have created. You can also post comments, read encouraging suggestions, and get feedback.

Manage Your Images

Basic Image Editing

Share and Save Your Images

Technology is always evolving, but the need to document and share precious life moments is constant. With a laptop, mobile device, or wireless camera, you can share your images from anyplace (see 10-1). After you take oodles of digital images and import them onto your computer, you have many ways to organize, enhance, and share your images. Although the array of options can be complicated and overwhelming, if you follow a few of these tips and suggestions, the bewildering after-the-shot path becomes easier to navigate.

MANAGE YOUR IMAGES

When you begin downloading digital images onto a computer, keeping track of all those files can be very confusing. Even if you begin with one folder and place all your images within it, you have not established a detailed method for researching and accessing those images.

Fortunately, computer software, external hard drives, online servers, and printers make it very simple to import, view, organize, find, and save

ABOUT THIS PHOTO *The contrast of man and technology in nature is a classic theme. I like how small the subject is in relation to the outdoors. Taken at ISO 200, f/5.6, 1/125 sec. with a Canon EF 17-35mm f/2.8 lens.*

your digital images — all you need to do is incorporate them into your digital-image routine. By using these tools, you can thoughtfully assemble, easily control, and readily share your image collection.

Many computer software applications enable you to import, view, organize, enhance, and save your images. A number of these applications may share similar features but place more emphasis in a particular area. For example, if you intend to get more involved in editing and enhancing your images, an application focused on image editing is going to be more robust and give you more options. If your image enhancements are minimal, an application focused on image organizing might be sufficient.

Whether you're using a free image-organizing application included with your computer, a free online application, or a more robust image-editing application that includes an organizing catalog feature, or perhaps none of the above, this chapter should give you a better idea of where you're at and where you need to go.

YOUR WORKFLOW

While capturing images is obviously a very important aspect to your photography, your postproduction workflow process is equally essential. Although local photo labs and online print fulfillment houses can produce beautiful prints from your digital files, they are no longer the one-stop shop for processing and printing, unless you're shooting film. Digital photography requires you to transfer, organize, adjust, enhance, and save your digital files. A bit more work, yes, but you also have a lot more creative freedom and control. And as the saying goes, "with freedom comes responsibility."

Every workflow may vary depending on the hardware and software used, and your working style, but at the minimum your workflow will include

- Capturing images
- Copying image files to a computer
- Adjusting the image files (cropping, color correction, retouching)
- Sharing and saving images
- Backing up images

A reliable workflow includes a consistent backup process from the beginning, always keeping duplicate copies of your images at every step. A typical progression of steps might look like this:

1. **After you capture images on your camera's memory card, you need to transfer those images to a computer.** You can either connect your camera to your computer via the supplied USB cable or insert the memory card into an internal or external card reader. Either way, the memory card will "mount" on your desktop and you're ready to begin the transfer process.

2. **Transfer (copy) the images to a folder on your computer, and duplicate the files onto a separate hard drive as a backup.** Additionally, it's also a good idea to upload them to an online account for safekeeping.

3. **When you are satisfied that the files are successfully transferred and backed up, you can reformat the card in the camera before shooting more images, as shown in 10-2.**

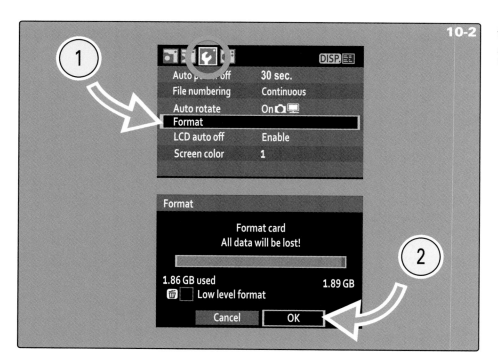

ORGANIZE YOUR IMAGES

Quite a few image-organizing software programs are available for free online or come already installed on your computer. A full exploration of every image-organizing software application available is well beyond the scope of this chapter, so in the spirit of keeping things simple I'm providing an overview for three options: Picasa, iPhoto, and Windows Live Gallery.

■ **Picasa.** Picasa is a free software download from Google that helps you locate and organize all the photos on your computer. This software collects and organizes all the images on your computer, scanning the images and automatically sorting them by date while you watch. A new and useful feature is facial recognition technology that locates and groups faces throughout your collection of images. You can add name tags to these faces, and new albums are created to help you keep track of everyone. And enhancing your images is easy with the included Picnik photo editor. You can add effects to your photos with a few simple clicks and then share your photos with others through e-mail and prints and the web — and it's free. I really like the new Face Movie feature that helps you quickly create a slide show featuring someone special with transitions, music, and captions. Go to http://picasa. google.com and download the software to begin. An example of the Picasa workspace is shown in 10-3.

10-3

ABOUT THIS FIGURE *Picasa is a free image organizer that scans your computer and external hard drives for images and includes basic image-editing and sharing features.*

■ **iPhoto.** For Mac users, iPhoto is a photo-organizing, viewing, and editing software program, and it comes bundled with every Apple computer. iPhoto allows you to import, organize, edit, retouch, and share your images with a user-friendly, intuitive interface. You can organize your images by Events, Faces, Places, or Albums and create slide shows set to music with animated themes. I especially like the new Places theme slide show that creates a

custom photo map by combining GPS data with your photo locations. With web galleries, easy image e-mailing features, and new Facebook enhancements, you can quickly and creatively share your images with friends and family. iPhoto also has beautiful photobook templates and unique letterpress cards. An example of the thumbnail view in iPhoto with organizational folders to the left is shown in 10-4.

10-4

ABOUT THIS FIGURE *An example of the iPhoto window with organizational folders*

■ **Windows Live Photo Gallery.** This program, for managing, fixing, printing, and sharing photos on a Windows PC, is available free of charge with the Microsoft Windows Live suite. To download Windows Live Photo Gallery (shown in 10-5), you must create a Windows Live ID (this is free); visit www.live.com to get started.

Once your images are loaded into an organizing application, you can search for images by the general metadata (data that describes your images; also see the sidebar later in this chapter) stored in every image captured by a digital camera. Accessing this metadata and adding your own customized keywords (significant words that describe the images) to your images allows you to search for specific photographs by date, name,

10-5

ABOUT THIS FIGURE *With Windows Live Photo Gallery, you can easily manage, fix, and share your images.*

camera type, and shutter speed, just to name a few criteria. The possibilities are endless when you add your own descriptions and keywords to create a custom digital filing system. You may never waste another minute looking for those hard-to-find images, because the software program does it for you. An example of the information (metadata) automatically captured in every digital image you take is shown in 10-6.

PROCESS RAW IMAGES

Most dSLR cameras now offer the ability to set the image quality to RAW when capturing images. Shooting in RAW format stores the data from the camera sensor in an unprocessed state and offers a great deal of flexibility afterward during postproduction. If you want to change the exposure, color balance, or size of the image, you get better results by working with a RAW image

| Description | IPTC | IPTC Extension | Camera Data | Video Data | Audio Data | Mobile SWF | Categories | Origin | DICOM | Histo |

Make: Canon	Pixel Dimension X: 2400
Model: Canon EOS 5D	Y: 3000
Date Time: 2/19/2011 – 12:43 PM	Orientation: Normal
Shutter Speed: 1/160 sec	Resolution X: 300
Exposure Program: Manual	Y: 300
F-Stop: f/4.5	Resolution Unit: Inch
Aperture Value: f/4.5	Compressed Bits per Pixel:
Max Aperture Value: f/2.8	Color Space: Uncalibrated
ISO Speed Ratings: 400	Light Source:
Focal Length: 175.0 mm	File Source:
Lens: EF70-200mm f/2.8L USM	
Flash: Did not fire	
No strobe return detection (0)	
Compulsory flash suppression (2)	
Flash function present	
No red-eye reduction	
Metering Mode: Spot	

10-6

ABOUT THIS FIGURE *This screenshot is an example of the metadata information stored in every digital image.*

file. That's the upside. The downside is that there is no industry standard yet for RAW files; each manufacturer uses its own unique and proprietary specifications, so you see files ending in .NEF, .CRW, .DNG, or others. And you also need to process these image files using the software that comes with your dSLR camera, or with the Camera RAW processor in Photoshop Elements

(PSE). Once your RAW image is opened within a Camera RAW dialog box, as shown in 10-7, you can begin adjusting everything from the exposure to color vibrance and contrast, and just about everything else you can envision enhancing in your image to make it look its best. Once saved, the modifications you make are saved alongside your image, so you can go back and tweak the RAW settings later if you so desire.

> **note** The image-editing examples in this chapter use Photoshop Elements; however, most image-editing software packages contain similar features for you to work with. If you don't use Photoshop Elements, you can still use the information here as a guide when working with your chosen software.

10-7

ABOUT THIS FIGURE *An example of a Camera RAW dialog box*

BASIC IMAGE EDITING

From making small adjustments and enhancements to redesigning the final image in countless ways, using image-editing software is where your creative vision can come into play. An image-editing software program is used primarily for editing and enhancing your images; however, it can also help you organize your images so you can easily find them.

Digital cameras are often packaged with proprietary image-editing software that delivers limited control and creative options. These programs are fine for minimal editing tasks, such as adjusting contrast and brightness and cropping and rotating, but the best way to optimize your digital-image experience is to use a more robust software program such as Adobe Photoshop Elements.

METADATA Metadata is stored within digital images captured by a digital camera and is a record of the settings that were in effect when the digital image was created. Information included is the date, time, pixel resolution, shutter speed, aperture, focal length, ISO, white balance, metering pattern, and whether the flash was fired. This information is saved in a standard format called Exchangeable Image File (EXIF).

When you initially launch Photoshop Elements, the Welcome screen opens. This is a convenient starting point for launching either the Organizer or the Editor, the two main components of Photoshop Elements. The Windows and Mac versions of Photoshop Elements differ slightly in their functionality, but are overall very similar. A good way to navigate through either platform is to hover your mouse over one of the icons or buttons so a description flag pops up. The information provided inside the pop-up flag indicates the specific tasks that are performed when you click the icon.

You'll often want to go to the Organizer first, perhaps to import files or to find files you want to work with in the Editor. When you use Photoshop Elements 9 or later, both the Mac and Windows platforms work as follows:

1. **To acquire new images from your digital camera, memory card, or from folders on your computer or external hard drives, click Organize in the Welcome screen to open the Organizer.** Next, the Media Browser workspace opens by default, and you can click Get Photos and locate the images you want to import.

2. **You can import images from a variety of places: digital cameras, media card readers, scanners, DVDs or CDs, and mobile phones, or you may already have existing image folders on your computer's hard drive.** Follow the directions provided by the camera, media card reader, or mobile phone manufacturer to ensure your images are imported correctly onto your computer.

3. **After you import your photos and launch the Media Browser within the Organizer, your image files display as thumbnails, making it easy for you to organize, find, and view your images.** Photoshop Elements also enables you to tag, or add keywords to, your images with visual identifiers so you can easily find images by people, places, and events.

The three editing workspaces within Photoshop Elements are the Quick Edit workspace, the Guided Edit workspace, and the Full Edit workspace. The Quick Edit workspace offers quick fixes with easy-to-use sliders for fixing common image problems, the Guided Edit workspace offers a little more handholding, and the Full Edit workspace has the most features and is somewhat similar to the full professional version of Adobe Photoshop.

If you are new to digital imaging, Quick Edit is a good place to start enhancing your photos — many of the basic tools for enhancing your images are located here. You can easily correct red-eye, make a variety of color and tonal enhancements, crop, and sharpen your images with a few simple mouse clicks.

QUICK FIXES

An example of the Quick Edit workspace is shown in 10-8. This workspace contains simple tools and commands to quickly fix common problems. The menu bar located on the right of the window contains all the automatic enhancement commands necessary to improve your image. Try using one of the Auto control buttons in each section. If the control doesn't achieve the desired effect, click Reset and try another one. The slide controls also allow you to make slight adjustments. Play around and experiment in the Quick Edit workspace.

Notice that I have chosen the Before and After view to compare my changes with the earlier version, by using the drop-down menu in the lower-left corner of the window. This is one of the many tools that help you adjust and control your image enhancements.

10-8

ABOUT THIS FIGURE *An example of the Quick Edit workspace in Photoshop Elements*

THE GUIDED EDIT WORKSPACE

If you want to start with a little more assistance than what's offered in the Quick Edit workspace, try the Guided Edit mode, as shown in 10-9. You can access it by selecting Guided in the Edit pane. Clicking a task in this mode gives you step-by-step instructions on performing basic editing tasks. Some of the Guided Edit options include the following:

■ Simple adjustments such as Brightness, Contrast, and Enhance Colors.

■ Guide for Editing a Photo, which walks you through all the editing steps.

■ Photomerge tools such as Scene Cleaner and Group Shot.

■ Fun photographic effects such as Touch Up Scratches and Blemishes, Out Of Bounds, and Lomo Camera effect.

10-9

ABOUT THIS FIGURE *The Guided Edit workspace*

THE FULL EDIT WORKSPACE

As you develop your skills, start exploring the Full Edit workspace. With features similar to the professional version of Photoshop, the Full Edit workspace is a more powerful image-editing environment than either the Quick Edit or Guided Edit workspace. The toolbar contains many options for editing and enhancing your images, such as image defects correction, lighting and color-correction commands, and tools to add text and painting to your images.

> **note** The workspace you choose may also be called the Standard Edit workspace, depending on your platform and version of Photoshop Elements.

In the Full Edit workspace, as shown in 10-10, you can further edit and enhance your images with more customized control. To learn what each tool does, explore the toolbar (on the left) by moving your pointer over the various tools and reading the Tool Tips that pop up. No clicking yet, just slowly move your pointer over each tool.

10-10

ABOUT THIS FIGURE *An example of the Tool Tips pop-up in the Full Edit workspace in Photoshop Elements*

 tip If a Tool Tips flag does not appear when your mouse is hovering over an icon, choose Edit ➪ Preferences on a PC or Photoshop Elements ➪ Preferences on a Mac and make sure the Show Tool Tips check box is selected.

USE LAYERS

When you initially open an image into the Photoshop Elements Full Edit workspace, it consists of one *layer*. In some cases you may be performing a simple change to an image, such as cropping, so there is no need for creating multiple layers. But if you plan on retouching, enhancing, or otherwise using more complex image-editing tools, I highly recommend taking advantage of using layers. Understanding this concept makes your life a lot easier when it comes to working with your images.

Layers are the backbone of any robust image-editing program because of the flexibility and control they give you in the editing process. Think of layers as stacked, transparent sheets of glass on which you can make independent changes to an image until you decide to combine, or merge, the changes. It can be confusing at first because even though you've created multiple layers of an image, it appears as one unified picture.

Using layers gives many more options and more control when you edit your images. For example, you can easily maneuver between each independent layer to make adjustments, turn off the visibility of that layer, discard a botched enhancement attempt, and save all the layers for future editing without altering your original image.

By changing a layer's hierarchy or opacity, you can modify the way each layer interacts with the layers below it in the Layers palette. Using layers is the key to advancing in the world of digitally altered photos and for creating various effects.

Don't panic if this seems like too much information — it begins to make sense as you move through the process. Begin with this simple rule in every image-editing effort that requires more than cropping: create a duplicate layer, also known as a copy of your original image, and make any changes to your image on this layer.

1. **Choose Layer ➪ Duplicate Layer, as shown in 10-11.** The Duplicate Layer dialog box appears.

2. **Accept the default duplicate layer name "background copy" or customize the layer and give it a different name.** The new duplicate layer appears in the Layers palette, which is located to the right of your screen by default.

By creating a duplicate layer, your original image is preserved. By building your knowledge over time, your comfort level increases as do the infinite creative possibilities of things to do with your images.

An example of a Layers palette with two layers, the background (original) and a background copy, is shown in 10-12. Background copy is highlighted, indicating that it's an active layer. You can perform any alterations on this active layer without affecting the original image (which is beneath it in the Layers palette). This is called *nondestructive editing*. When you make changes to the duplicate, you can't damage the original. The only exception to this rule is when you crop your image. If you crop a layered file, the crop is applied to all the layers in the layer palette. If you plan on cropping an image, it's best to make a copy of your original file and only work on the copy. This completely preserves your original file. If you don't like what you create on the Background copy layer, delete it. Right-click the layer and choose Delete Layer from the

10-11

ABOUT THIS FIGURE *Before you begin editing and enhancing any of your images, it's a good idea to create a duplicate background layer in your Layers palette so you can work on a copy of your image.*

contextual pop-up menu or click the layer to activate it and then click the Trash icon in the Layers palette.

When you finish editing your image, first save it as a PSD (Photoshop Document) file so you preserve your work and you have the option to make changes at a future time. Next, consolidate your layers so you can print and share your images online. When you duplicate your image and work in layers, the file size increases exponentially; this makes it difficult to print. Due to the large file

size, it's also virtually impossible to share online. For these reasons, you must flatten your image file and save it under another name, or add an additional identifier in the file-naming process. Merging and flattening are permanent actions, and you should perform them only when you are finished editing the photo.

When saving your images for online sharing and printing, save your image file in a different file format, such as JPEG or TIFF, because a PSD file may not be compatible with other software.

10-12

ABOUT THIS FIGURE *An example of the Layers palette in Photoshop Elements*

1. **Choose File ⇨ Save As to open the Save As dialog box.**

2. **Select a file format by clicking the Format drop-down menu (see 10-13).** Choose JPEG if you intend on using the image for on-screen and online purposes. JPEG is a compressed file format that reduces the size of the image for online purposes. Choose TIFF if you intend to print the image. TIFF uses loss-less compression — no resolution is lost when saving to this format. This is a critical factor when archiving images and printing.

10-13

ABOUT THIS FIGURE *An example of the Save As dialog box showing the Format drop-down menu in Photoshop Elements*

ADJUST COLORCAST

Colorcast refers to a shift of color in your image, often appearing unnatural. Sometimes a colorcast is included in an image to create a certain mood or effect; for example, a blue colorcast evokes a cool, melancholy feeling, while a golden colorcast communicates warmth. But most of the time colorcast in an image is unintended and ends up looking like an unhappy accident.

Fortunately, PSE offers several ways to adjust the colorcast in your image: Auto Color Correction, Color Variations, Color Curves, and Adjust Color for Skin Tone. Because this book focuses on portraits of people, the Adjust Color for Skin Tone feature, as shown in 10-14, is explored here.

1. **Create a duplicate layer.** Choose Layer ⇨ Duplicate Layer, and click OK.

2. **Choose Enhance ⇨ Adjust Color ⇨ Adjust Color for Skin Tone.**

3. **Check to ensure the Preview check box is selected, and then place your cursor over an area of skin.** The cursor should turn into an eyedropper. Click and PSE adjusts the colorcast of the entire image with particular focus on your subject's skin.

4. **If you don't like the results, click a different area of skin or use the sliders to adjust the color change.**

5. **Click OK to close the dialog box and commit to the color changes.**

One of the many benefits of working with a duplicate layer is the ability to lessen the effect of any change just by adjusting the opacity of your duplicate layer, as shown in 10-15.

10-14

ABOUT THIS FIGURE *Using the Adjust Color for Skin Tone feature is an easy way to adjust the colorcast in your image.*

ADJUST CONTRAST

A good technique for improving many digital photographs is to look for ways to enhance the contrast in the images. By definition, *contrast* is the difference between the darkest and lightest areas in a photo — the greater the difference, the higher the contrast. Photos with low contrast can appear a bit muddy or blurred, lacking any clear distinctions between details in the images.

Photoshop Elements includes several useful tools for adjusting image contrast; one of the best is the Levels dialog box, shown in 10-16. To open the Levels dialog box, choose Enhance ⇨ Adjust Lighting ⇨ Levels.

The histogram represents the various levels of tonality in your image. It looks like a mountain range, but is really a graphical representation of how many pixels of each tone (shadows, midtones, and highlights) are present in an image. If your image is dark, the mountains are higher on the left side. If the image is very light, the mountains are taller on the right side of the histogram.

10-15

ABOUT THIS FIGURE *The duplicate layer has been adjusted to 72 percent opacity. This lessens the effect of the changes made on the image and provides an additional option for fine-tuning.*

Three sliders are located underneath the histogram. Each slider controls a section of tones within your image. The slider on the left controls the dark pixels in your image; the middle slider controls the midtone pixels in your image; and the slider on the right controls the light pixels in your image.

By making a few adjustments to the shadows, midtones, and highlights in a photo, you can quickly achieve contrast that was previously lacking. For example, in 10-17, the colors were a little too dark. So I moved the highlights slider (the right slider) slightly to the left and aligned it with the beginning of the most significant portion of information in the histogram. The need to optimize the tonality or dynamic range of your image is the first step in nearly all image-editing tasks. The results of the slight adjustment are shown in 10-18. What a difference a small adjustment can make!

10-16

ABOUT THIS FIGURE *An example of the Levels dialog box in Photoshop Elements*

EYE AND TEETH ENHANCEMENTS

From babies to seniors and everyone else in between, most images of people look better when the eyes and teeth are enhanced, as long as you keep things looking authentic and natural.

My simple technique draws attention to the eyes and makes the catch-lights sparkle. Blue, green, and gray eyes reveal the effects to a greater degree, but darker eyes can also benefit from this enhancement.

To enhance the eyes in a photograph, follow these steps:

1. **Make a duplicate of the Background layer.** Choose Layer ➪ Duplicate layer, and click OK.

2. **Use the Zoom tool to enlarge your image in the workspace.** This allows you to see what you're working on in great detail.

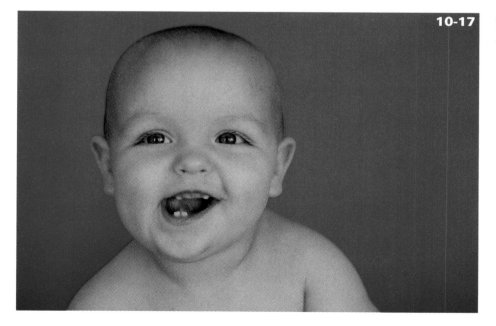

10-17

ABOUT THIS PHOTO
This image looks a little too dark and underexposed.

3. Click the Dodge tool, located near the bottom of the toolbar (as shown in 10-19).

4. Choose Midtones in the Range drop-down menu located on the Options bar.

5. Select an Exposure level of approximately 10 percent.

6. **Choose a Brush size that fits nicely into the whites and the iris of the eye.** To adjust the brush size, press the left bracket key on your keyboard ([) to reduce the brush size and press the right bracket key (]) to enlarge the brush size. My brush size is 95 px; your image may require a different brush size.

7. **Paint the whites of the eyes with the Brush tool, then paint the iris of the eye.** Just a few circular motions around the eye should do it.

8. Click the Burn tool, located underneath the Dodge tool in the same stacked set of tools.

9. Adjust the brush size to something smaller (mine is 40 px; yours may vary).

10. Choose Midtones in the Range drop-down menu located on the Options bar.

11. Select an Exposure level of approximately 10 percent.

12. **Carefully draw around the outside of the iris to darken and sharpen the edges.**

13. Use the Opacity slider in your duplicate layer to lessen the effect of the eye enhancement, if necessary.

ABOUT THIS PHOTO
I adjusted the contrast in this image using the Levels dialog box.

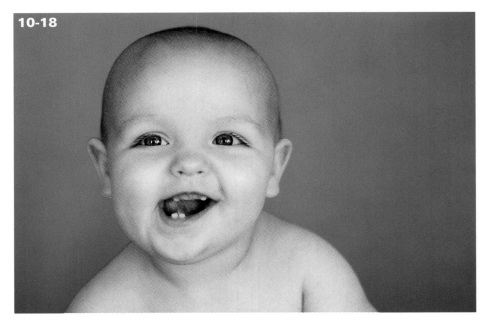
10-18

10-19

ABOUT THIS FIGURE *I'm preparing to lighten the whites and the iris of the eyes with the Dodge tool.*

You can see the results of using the Dodge and Burn tools to lighten and darken certain areas of the eyes in 10-20.

You can also quickly improve any portrait photo by lightening the teeth of a smiling subject. This technique involves using the Zoom tool to enlarge the image and the Dodge tool to slightly lighten your subject's teeth. Be careful not to make the teeth too white and the enhancement unrealistic.

In this example, Gianina's teeth are beautiful and need very little correction (as shown in 10-21), but there is always room for improvement (as shown in 10-22) as long as it doesn't look unnatural.

To whiten teeth, follow these steps:

1. **Make a duplicate of the Background layer.** Choose Layer ⇨ Duplicate layer. Click OK.

2. **Use the Zoom tool to enlarge your image in the workspace.** This allows you to see what you're working on in great detail.

10-20

ABOUT THIS FIGURE *After I lightened the whites and the iris of the eye, I used the Burn tool to darken the edges of the iris.*

3. Click the Dodge tool, which is located near the bottom of the toolbar beneath the Sponge tool.

4. Choose Midtones in the Range drop-down menu located on the Options bar.

5. Select an Exposure level of approximately 20 percent.

6. Choose a Brush size that is no larger than your subject's teeth.

7. **Move the Brush tool across the teeth one or two times.** Take care not to overbrush or your subject's teeth might look unnaturally white.

8. **Use the Opacity slider in your duplicate layer to lessen the effect of your teeth whitening, if needed.**

10-21

ABOUT THIS FIGURE *I used the Zoom tool to enlarge the image. The teeth look okay in this before shot, but I've whitened them slightly for a subtle enhancement in 10-22.*

tip Use the bracket keys on your keyboard to quickly change your brush sizes. The left bracket key ([) makes the brush size smaller; the right bracket key (]) makes it larger. These keys are located just to the right of the letter P on your keyboard.

note *Hue* is the actual color, such as red or green, and *saturation* is the intensity or purity of a color.

10-22

ABOUT THIS FIGURE *I used the Dodge tool to slightly lighten Gianina's teeth in this after image. The Dodge tool is represented by a wand-like icon on the toolbar and is located within the stacked set of tools that includes the Sponge tool and the Burn tool.*

REMOVE RED-EYE

If you have taken pictures of people in low-light situations with an on-camera flash, you've probably noticed that eerie red-eye effect in your images. Red-eye occurs when the on-camera flash reflects off the back of the inside of a subject's eye — it's not very attractive. Until recently, it was difficult to eliminate red-eye in your images, but with the image-editing software programs available today,

you can remove red-eye easily by simply clicking the Auto button in the Options toolbar. The software program searches for the red-eye in your image and eliminates it automatically. This is a good general fix, but you have more control over the red-eye removal if you use the Red Eye Removal tool and follow these steps:

1. **Select the Red Eye Removal tool.** Your pointer becomes a crosshair when moved over the image.

2. **In the Options bar, choose 50 percent in both the Pupil Size and Darken Amount fields.** You may have to adjust this number if your red-eye adjustments are not successful.

3. **Place the crosshair over the red-eye area and click.** Photoshop Elements samples the reddish pixels in the area and adjusts them based on a predefined darkness value, as shown in 10-23. The Red Eye Removal tool changes the hue of the affected eye, eliminating those glowing red eyes in your images, as shown in 10-24.

10-23

ABOUT THIS FIGURE *I selected the Red Eye Removal tool and positioned my pointer-turned-crosshair over each pupil and clicked.*

10-24

ABOUT THIS FIGURE *Here is the result of using the Red Eye Removal tool on my image — no more red-eye!*

REMOVE SKIN IMPERFECTIONS

Digital cameras seem to capture more detail than I like when it comes to wrinkles and skin imperfections, which is why I'm very thankful for all the retouching tools that PSE offers. Attending to the subtle details of an image can improve its overall appearance and produce rave reviews from your subjects and your viewers. The most commonly used tool for retouching in Photoshop Elements is the Healing Brush tool, which is sometimes referred to as the "zit zapper" by complexion-conscious models and actors. It makes removing imperfections in your images fast and easy. It's almost like a visit to the dermatologist!

There are two healing tools in the toolbar: the Spot Healing Brush and the Healing Brush. They both use other pixels on your image to blend and smooth over the spots you target. The Spot Healing Brush tool works instantly to clear up small spots. The Healing Brush tool requires a little more work but gives you more control. I use the Spot Healing Brush tool in this example.

My good-looking friend, Bo, was kind enough to let me use his face for this before and after retouching example. I used the Spot Healing Brush to remove a few imperfections, and I softened skin texture by using a Blur filter.

To remove spots with the Spot Healing Brush, follow these steps:

1. **Make a duplicate of the Background layer.** Choose Layer ⇨ Duplicate layer, and click OK. Once you begin working in multiple layers, it's a good idea to rename your layers according to what you're working on in that layer. In this example, I renamed the duplicate layer "spot healing."

2. **Use the Zoom tool to enlarge the area of your image you want to work on.** The closer you can get in and still see the overall area of the image, the easier your work is.

3. **Select the Spot Healing Brush tool.** If the Spot Healing Brush tool icon is not visible, click the small triangle in the corner of the Healing Brush tool icon and select the Spot Healing Brush tool from the fly-out menu (as shown in 10-25).

4. **Choose a brush size in the Options toolbar.** A brush size slightly larger than the spot you want to fix works best.

5. **Select a Type option in the Options toolbar.** Proximity Match is the default option; it uses the pixels around the edge of your image imperfection and blends them together for a smooth, natural-looking retouch. You can also try the Create Texture in the Type option and decide which effect looks more natural.

6. **Click just outside the spot on your image and drag over it with your pointer.** Poof! The spot instantly disappears. It looks like magic, but it's actually the software program automatically mixing together pixels surrounding your spot.

Now that the minor imperfections are eliminated, I polish up the skin texture by using the Gaussian Blur filter. Here's how you do it:

10-25

ABOUT THIS FIGURE *Here is the "before" image of Bo as I'm getting ready to retouch small spots on his face using the Spot Healing Brush tool.*

1. **Make a duplicate of the Background layer.**
 Choose Layer ➪ Duplicate layer, and click OK. In this example, I rename this duplicate layer "blur."

2. **Choose Filter ➪ Blur ➪ Gaussian Blur.**
 When the Gaussian Blur dialog box appears, use the slider to select a Radius of approximately 15 pixels, as shown in 10-26. The blur strength depends on your particular image, so adjust it to your liking.

10-26

ABOUT THIS FIGURE *Use the slider to adjust the blur amount in your image.*

3. **Press and hold Alt (Option on the Mac) and click once on the Add Layer Mask icon at the bottom of the Layers palette.** This new black layer mask removes all the blur from view.

4. **In the Layers palette, make sure the layer mask is active (you see a white frame around it), as shown in 10-27.** This is the layer you're going to "paint" on. Press D on your keyboard to set the Foreground color to

white. Use the Brush tool (or press B) and choose a medium-sized, soft-edged brush from the Brush Picker in the Options bar. Now you can begin painting over his skin. This painting reveals the blur located below your black layer mask. Be sure to avoid any detail areas such as eyes, eyebrows, lips, and hair. You should only be "painting" or blurring the skin on the face. Vary the size of the brush to get under the nose and around the eyes.

10-27

ABOUT THIS FIGURE *I used the Brush tool to paint the entire face (except the eyes, lips, hair) and you can see the blurred effect on his skin.*

5. **Click on Opacity slider in your Layers palette to tone down the intensity of the retouching you just performed.**

6. **Adjust the Opacity slider to approximately 40–60 percent.** The imperfections pull back ever so slightly, resulting in a natural yet enhanced image (see 10-28).

Removing every blemish, sunspot, and under-eye circle is tempting, especially if you are enhancing a picture of yourself, but the resulting look can be quite unnatural, and everyone knows the image has been retouched. A good rule of thumb for most retouching efforts is to adjust the Opacity slider to taste in that layer for an improved yet authentic-looking portrait photograph.

10-28

ABOUT THIS FIGURE *By using the Blur tool and the Opacity slider, I was able to create a more natural-looking enhanced image.*

tip

Sharpening filters can also help improve the appearance of contrast in your photos. The most popular filter for sharpening images in Photoshop Elements is Unsharp Mask. Using this filter takes a bit of experimentation using the three available controls. To apply the filter, choose Filter ⇨ Sharpen ⇨ Unsharp Mask on a Mac and Enhance ⇨ Unsharp Mask on a PC. This opens the Unsharp Mask dialog box in which you can make and preview adjustments.

CREATIVE CROPPING

The Crop tool enables you to crop out parts of your image. This is useful if you want to remove clutter in the background, focus on one area of your image, or create more visual impact with an existing image. For example, trimming areas from a photo can change the prominence of particular objects. Along with removing unnecessary image

content, cropping reduces the file size of the final image. This can be important if you are using the image on a website, where a smaller file size results in faster downloading.

You can also use the Crop tool to add extra space around your image to give it a distinctive framed appearance. To add extra space, you must first increase the area of the image window so that the Crop tool can extend beyond the boundaries of the image. Clicking and dragging the Crop tool outside the boundary and then applying the crop in this manner increases the canvas size.

Unlike other adjustments in Photoshop Elements, cropping an image affects all the layers in the image, including layers that are currently not selected or visible. The example in 10-29 shows the bounding box that's created when the Crop tool is used on an image.

To crop a photo, follow these steps:

1. **Click the Crop tool to select it.**

2. **Click and drag inside the photo to define the cropping boundary.**

10-29

ABOUT THIS FIGURE *The Crop tool enables you to trim your image and focus on a certain area, creating an image with greater impact.*

3. Click the Commit button to apply the change. The Commit button is denoted by a green check mark located in the Options toolbar above your image on a Mac or in the lower-right corner on a PC.

To add extra space around your photo, follow these steps:

1. Click and drag out the corner of the image window to add extra space around the photo.

2. Click the Crop tool to select it, and then click and drag to define the cropping area.

3. Click and drag the handles to extend the cropping area outside the boundary of the photo. The handles are the squares that appear along the crop boundary; they allow you to adjust the size of the crop selection area.

4. Click the Commit button to apply the change.

tip

When you select the Crop tool, you can use the dialog boxes in the Options toolbar to specify the dimensions and resolution of the resulting image. Type values in the Height, Width, and Resolution boxes. You can automatically add the dimensions and resolution of the current image by clicking the Front Image icon in the Options toolbar.

Keep in mind that cropping eliminates pixels, which affects the resolution of your image and therefore its quality. Viewing an image online requires less resolution (72 to 96 pixels per inch [ppi]) as opposed to printing an image, which requires a higher resolution (240 to 300 ppi) to maintain image sharpness.

note

The more pixels in your digital image, the higher your image resolution. Image resolution determines how much detail you see in your images and how large an image you can successfully print.

SHARE AND SAVE YOUR IMAGES

Storing images in shoeboxes on shelves or under the bed is a thing of the past. Now that you've captured all those special life moments with your digital camera or scanner and have enhanced them using an image-editing software program, it's time to share them with the world — or at a minimum, your immediate friends and family. From creating slide shows, to e-mailing images, to using photo-sharing websites, to printing photos, you have many ways to show off your images. All it takes is some inspiration, dedication, and a very small amount of perspiration.

SLIDE SHOWS

A fun way to share your photographs is to create and view them in a slide show on a computer screen, TV monitor, or projector. Many slide-show applications are in the marketplace, and some are more robust than others. Most image-editing and image-organizing software programs also include the ability to create slide shows in varying degrees of sophistication. This is all great if you plan on hauling your computer around with you to present your slide show, but what if this isn't possible or convenient?

If your goal is to create a slide show of images set to music and you plan to show it with a DVD player, your software requires that capability.

After you create your slide show, you need to export it in a format that can be easily viewed. I've found that many people, when given a CD or DVD with homemade image content, aren't clear on whether they can view the content on their TV monitors with a DVD player or whether they must view it on their computer screens. How many grandparents sit down in front of the TV to view the new images of their grandkids only to discover that their DVD players won't recognize the discs? Save yourself a lot of future frustration by finding out how people want to view your slide show and then explore the capabilities and limitations of your software.

There are many software programs on the market that you can use to create a slide show or that are dedicated to slide-show creation, including iPhoto, Picasa, Photoshop Elements, and one of my favorites, http://animoto.com. If you plan to create slide shows, try what you have available to you or can get free before investing in software. That way you know what features you want and need before stepping up to other options that likely have more features.

> **note** Digital photo frames are easy to use and provide a unique way to showcase your digital images from any room in the house. Most of these frames accept media cards, and some have the capability of connecting wirelessly to your router at home to receive images from online photo-sharing sites.

UNDERSTANDING IMAGE FILE FORMATS

Most digital cameras capture images as JPEGs, the standard algorithm for the compression of digital images. For simplicity, I concentrate on working with the JPEG format in this book. When you save your images, you may notice other mysterious file formats in the drop-down list in the Save As dialog box. The following list provides a short description of each file format to introduce you to the differences. This is a basic introduction, but as you continue to learn more about image-editing software programs, the purpose of these formats will begin to make more sense.

- **JPEG (Joint Photographic Experts Group).** The standard format for digital photos.
- **TIFF (Tagged Image Format File).** The industry-standard graphics file format.
- **PSD (Photoshop Document).** A native file format for Photoshop and Photoshop Elements.
- **BMP (Bitmap).** A Windows image format.
- **GIF (Graphics Interchange Format).** A format for web images with limited colors.
- **RAW (unprocessed camera sensor converted data).** A unique format that must be converted to a standard graphics format before the image can be used.

E-MAIL

If your digital camera is set to capture images at the highest resolution, your image files are going to be too large to send successfully via e-mail because most e-mail providers reject attachments greater than 5MB (megabytes) in size. Digital cameras measure their resolution in megapixels (MP) and produce image file sizes measured in megabytes. If you have a 4MP to 10MP camera set at the highest resolution, your images can be 12MB to 30MB in size and far too large to send via e-mail, even with JPEG file compression. If your large files do manage to squeeze through the e-mail provider barrier, your friends and family may become annoyed when they are forced to wait for your large attachment to download, and then the file fills up their hard drive space.

To make matters more difficult, if you plan on printing images larger than 4 × 6 inches, it's necessary to shoot your images at the highest resolution because printers require more pixels to produce quality prints. The more pixels an image has, the more detail that can be seen; this is expressed as *resolution*. Commercial and inkjet printers require a resolution of 200 to 300 pixels per inch (ppi) to successfully print your images.

The solution to the e-mailing and printing file size dilemma is to save your original, high-resolution image and then create a copy of that image and downsize it for e-mailing purposes. Fortunately, computer screens only require a resolution of 72 to 96 ppi to display a quality image. The high-resolution image file is your printing image, and your low-resolution image file is your e-mailing image.

tip

Everyone has a different file-naming approach, but a filename example for high-resolution and low-resolution versions of the same image might be flower_h.jpg for high resolution and flower_l.jpg for low resolution.

note

A pixel is one square of information in a digital photograph. Digital photos are comprised of millions of these tiny squares. A megapixel is one million pixels.

To reduce your image file size for e-mail purposes, Choose File ⇨ Attach to Email. Photoshop Elements automatically reduces your file to an agreeable size and attaches it to a new, outgoing message in your e-mail client. This option is also available in iPhoto and many other image-editing programs.

You don't have to worry about designating your file size with this feature; the software application does it for you. With this method, you can e-mail images quickly; your friends and family can download your images easily; and your image maintains quality for on-screen viewing.

You can also customize your image size in Photoshop Elements by following these steps:

1. **Choose Image ⇨ Image Size on a Mac or Image ⇨ Resize ⇨ Image Size on a PC.** The Image Size dialog box opens.

2. **With the Resample Image check box selected, type a new height or width for the image.** If you have the Constrain Proportions check box selected (which I highly recommend), the other dimensions automatically adjust to maintain the proportions of the image.

A good rule of thumb for e-mail attachments is to reduce your image size to less than 1MB prior to sending. For example, an image size of 640 × 480 pixels, set at a resolution of 72, gives you an 8.8-×-6.6-inch viewable screen image. This image file size is 900K (kilobytes), just under 1MB, so it's large enough to see and small enough to successfully send over e-mail.

You can also instantly resize your images for emailing purposes with iPhoto, Photoshop Elements, Picasa, and other photo services. If you would like to forgo reducing the size of your image and send the high-resolution file instead, you can use services such as www.dropbox.com.

Now your friends and family are going to be happy to receive quality images at a file size their e-mail provider does not block or reject, and you are going to be happy to show off your images.

PHOTO-SHARING WEBSITES

Photo-sharing websites are a handy place to upload your digital images and easily share them with family and friends. Most photo-sharing websites enable you to order prints, note cards, calendars, coffee cups, purses, jewelry, or just about anything else you want to customize with your images.

One of the major benefits of using a photo-sharing website is you're able to share your images with others without sending your images as e-mail attachments. Your viewers simply click a link to instantly see your images online. And after your friends and family view the images, they are able to order prints or any of the other customized gifts, pay for them online, and have them shipped directly to their homes or offices.

It would be impossible to list every website that offers photo-sharing services, but here are a few well-known entities:

- **Free photo-sharing sites.** These are permission based; that is, only your designated viewers have permission to see your image albums or order products. You can create image albums for online sharing with password-protected viewing, as well as ordering prints.

> www.shutterfly.com

> www.kodakgallery.com

> www.snapfish.com

- **Subscription photo-sharing sites.** These are also permission based and offer all the basic print-sharing and ordering features as the free sites, but with more features. These features include video, RSS feeds, slide shows set to music, mobile phone image uploads, long-term image storage, GPS image tracking, and more.

> www.phanfare.com

> www.smugmug.com

> www.smilebox.com

note RSS is an XML-based vocabulary that specifies a means of describing news or other web content that is available for feeding (distribution or syndication) from an online publisher to web users. RSS is an abbreviation for describing one of three different standards, which include RDF Site Summary (RSS .9 and 1.0), Rich Site Summary (RSS 0.91 and 1.0), and Really Simple Syndication (RSS 2.0).

- **Photo-sharing community sites.** These are websites, such as www.flickr.com, on which you can publicly showcase personal photographs that online members can view and discuss. You can also create private galleries with invitation codes so you can send people the link to view your gallery. Some people also use these community sites as a repository for photo blogs.

Photo-sharing websites are very popular and, due to constant technological improvements, can change very quickly. Conduct your own online search to explore different website offerings and find one that suits your needs.

PRINT

Even though the world has gone digital, and many images are showcased on a computer monitor, iPad, smartphone, projector, or TV screen, nothing can compare to holding a print in your hand or flipping through a beautifully printed photo album. The tactile sense of paper and ink and the ability to peruse images at leisure, from anywhere, is preferable for many picture viewers. Perhaps the future is filled with hologram image walls or digital screens in every nook and cranny, but for now, framed prints in various sizes still adorn most people's homes and offices.

Photo-sharing websites, retail photo kiosks, home inkjet and laser printers, and mini-travel printers are all capable of printing with inks and photo-quality papers that rival the local photo lab. You have so many options!

Photo-sharing websites allow you to upload your digital images, share them with friends and family, and order prints and professional-looking photo albums online. These prints are promptly shipped to your home or office, sometimes faster than the local photo lab.

Retail photo kiosks enable you to print your images without the aid of a computer. You simply remove the media card from your camera, insert it into the kiosk, and follow the on-screen prompts to order your prints. Print pickup is often immediate or a few hours later.

Home inkjet and laser printers are less expensive options for printing photographs and offer more features than ever. Whether connected to a computer or a digital camera, you can view and print images in a variety of sizes. After you stock up on paper and ink, you become your own photo lab and image/craft creator, all in the comfort of your own home. If long-term archival image quality is an issue, be sure to read the literature that comes with your printer inks and papers regarding longevity.

BACK UP YOUR DIGITAL IMAGES

Not archiving (copying) or backing up images in case of a corrupted image file, computer crash, or natural disaster can be a huge mistake. Play it safe and back up your image files. The older your hard drive is, the more likely it is to fail. To avoid losing all or part of your digital photo collection, you should keep your photos well organized with an image manager. Have a procedure in place for periodically archiving them to an external hard drive or to the "cloud." Saving your images to a cloud is essentially uploading your images to an online server that allows you to access, share, and save your images to remote servers for efficiency and safety. For example, I subscribe to an online storage service called Dropbox (www.dropbox.com), which enables me to perform automatic backups of my images for a small monthly fee. I can then access my images from any computer, and I know that whatever happens I have a backup of my data and images stored off-site.

I used to recommend saving your images to DVD, but with the advent of external hard drives becoming more affordable, and options like Dropbox, I don't think that saving to a DVD is efficient or reliable in the long term. If you have a lot of digital files saved on a DVD, be sure to back them up on new external drives and online at least once a month, and if you really want to ensure the safety of your images, set up a separate backup hard drive offsite. Thirty years from now when your family is trying to retrieve old image files from your DVDs, there may not be a way to read the DVDs and access the information.

 x-ref

Learn more about backing up your images in Chapter 2.

Assignment

Show Off Your Image-Editing Skills

Choose a portrait you've taken recently and use your new photo-enhancement skills to retouch the image and make it look as natural as possible. Remember to use the duplicate layer Opacity slider!

To complete the assignment, I captured the image shown here and then adjusted the contrast using Levels, removed small imperfections with the Spot Healing Brush tool, smoothed out his skin texture with a Blur filter, and enhanced the eyes by using the Burn and Dodge tools. Taken at ISO 500, f/1.8, 1/160 sec. with a Canon EF 85mm f/1.8 lens.

 Remember to visit www.pwassignments.com after you complete the assignment and share your favorite photo! It's a community of enthusiastic photographers and a great place to view what other readers have created. You can also post comments, read encouraging suggestions, and get feedback.

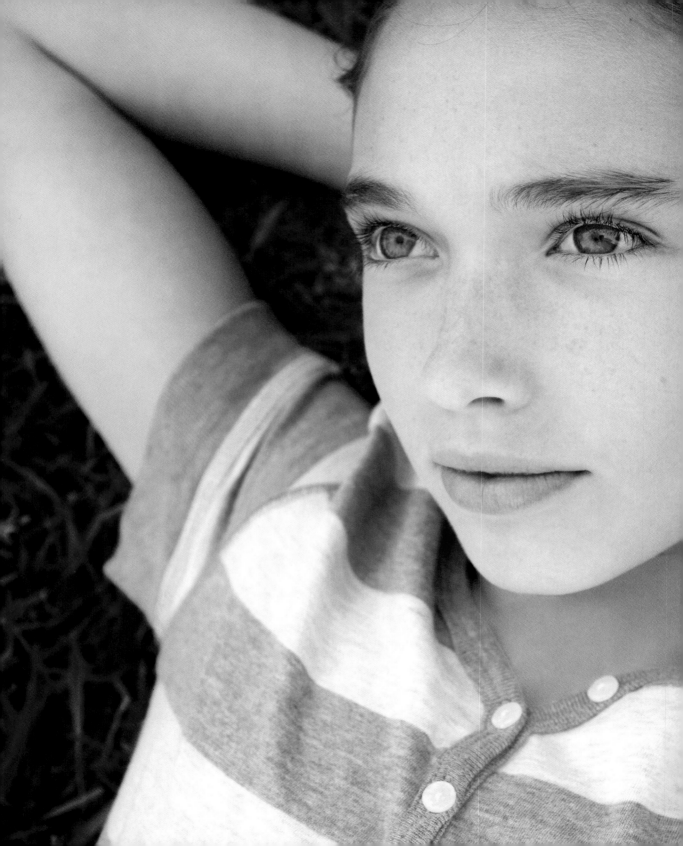

PERIODICALS

BOOKS

ORGANIZATIONS

PHOTOGRAPHY WORKSHOPS

PHOTOGRAPHIC EQUIPMENT AND REVIEW SITES

PHOTO- AND VIDEO-SHARING WEBSITES

IMAGE-ORGANIZING, ARCHIVING, AND SLIDE SHOW
 SOFTWARE

ONLINE PHOTOGRAPHY AND SOFTWARE CLASSES

WEBSITE DESIGN AND HOSTING

PERIODICALS

There are many magazines and other publications to choose from. Here are a few of my favorites that I hope you find useful.

DIGITAL PHOTO

www.dpmag.com

This magazine is devoted to digital photography and related techniques.

DIGITAL PHOTO PRO

www.digitalphotopro.com

A publication designed largely for working digital photo professionals. However, its in-depth reviews, how-to articles, and detailed explanations are useful to any photographer interested in expanding and improving his or her skills.

MAC LIFE

www.maclife.com

Written for both new and veteran users, Mac Life provides authoritative information and advice for readers who want to get the most out of their Macs, iPods, and third-party hardware, software, and services. The magazine has feature articles on the latest hardware and software, a how-to section, and reviews of the latest gear.

PHOTO DISTRICT NEWS

www.pdnonline.com

PDN provides useful photography news ranging from marketing and business advice to legal issues, photographic techniques, and new technologies.

POPULAR PHOTOGRAPHY

www.popphoto.com

This magazine offers illustrated, instructional articles and covers all facets of photography — amateur and professional as well as art and technique. You can also find helpful reviews of cameras and accessories.

BOOKS

If you are looking to expand your photography knowledge, these books are some of my longtime favorites.

DESIGN BASICS

Lauer, David, and Stephen Pentak. *Design Basics*. Wadsworth Publishing, 8th edition, 2011.

This book helps with getting great ideas. As the title implies, this book helps you understand visual theory simply, logically, and completely. I used this book in school years ago and I still refer to it often.

HENRI CARTIER-BRESSON: À PROPOS DE PARIS

Cartier-Bresson, Henri. *Henri Cartier-Bresson: À Propos de Paris*. Bullfinch, 1998.

This book offers an inspiring look at the photos from one of the masters of photography.

MATTERS OF LIGHT & DEPTH

Lowell, Ross. *Matters of Light & Depth*. Lower Light Management, 1999.

From the basics of lighting to advanced lighting techniques, this book is a great resource if you're interested in expanding your knowledge of lighting.

PHOTOSPEAK: A GUIDE TO THE IDEAS, MOVEMENTS, AND TECHNIQUES OF PHOTOGRAPHY, 1839 TO THE PRESENT

Mora, Gilles. *Photospeak: A Guide to the Ideas, Movements, and Techniques of Photography, 1839 to the Present.* Abbeville Press, 1st edition, 1998.

When you understand the bigger picture, it helps you take better photographs. This book is alphabetically arranged, providing a simple reference guide to the "ideas, movements, and techniques of photography." Impress your friends and family with your knowledge of the photographic timeline.

ORGANIZATIONS

While you may not be ready to dive into joining a professional organization just yet, there may come a time when you will benefit from what these organizations have to offer. This listing contains just a few of the more well-known groups — there are many others.

AMERICAN PHOTOGRAPHIC ARTISTS

www.apanational.com

American Photographic Artists (APA) establishes, endorses, and promotes professional practices, standards, and ethics in the photographic and advertising community.

AMERICAN SOCIETY OF MEDIA PHOTOGRAPHERS

www.asmp.org

The American Society of Media Photographers (ASMP) promotes photographers' rights, educates photographers in better business practices, produces business publications for photographers, and helps buyers find professional photographers.

NATIONAL ASSOCIATION OF PHOTOSHOP PROFESSIONALS

www.photoshopuser.com

The National Association of Photoshop Professionals (NAPP) is a trade association and a resource for Adobe Photoshop education, training, and news. It is led by a team of Photoshop experts, authors, consultants, trainers, and educators whose focus is to ensure that NAPP members stay up to date on Photoshop techniques.

NATIONAL PRESS PHOTOGRAPHERS ASSOCIATION

www.nppa.org

This is a national organization for photojournalism, including sports photographers.

PHOTOGRAPHIC SOCIETY OF AMERICA

www.psa-photo.org

This is a worldwide photography organization for all types of photographers.

PROFESSIONAL PHOTOGRAPHERS OF AMERICA

www.ppa.com

Professional Photographers of America (PPA) seeks to increase its members' business savvy as well as broaden their creative scope. It aims to advance their careers by providing them with tools for success.

THE PICTURE ARCHIVE COUNCIL OF AMERICA

www.pacaoffice.org

If you're researching stock photography agencies in North America, check to see if the agency is a member of this trade organization. Members are required to uphold certain standards of professionalism.

WOMEN IN PHOTOGRAPHY INTERNATIONAL

www.wipi.org

Women in Photography International (WIPI) promotes the visibility of women photographers and their work through a variety of programs, exhibitions, juried competitions, and publications. The group's aim is to serve the needs of photographers, photo educators, photography students, gallery owners, and photographic organizations around the world.

PHOTOGRAPHY WORKSHOPS

These workshops are a year-round source of experiential learning and creativity for image makers of all skill levels. I've only listed a couple here, but there are many more around the country. Search the web to find one that fits your interests and skill level.

MAINE MEDIA WORKSHOPS

www.mainemedia.edu

Maine Media Workshops is a year-round educational center that offers inspiring and informative classes, from photography to filmmaking and multimedia. Classes are taught by instructors prominent in their field.

SANTA FE PHOTOGRAPHIC WORKSHOPS

www.santafeworkshops.com

This is a year-round educational center with informative hands-on photography and media workshops. Taught by world-renowned instructors, the workshops cover both the technical and creative aspects of photography.

CREATIVE PHOTO WORKSHOPS

www.creativephotoworkshops.com.au

Creative Photo Workshops is a Melbourne-based business that runs a range of photo workshops in Australia and selected overseas destinations. Run by Glynn Lavender and Shelton Muller, these workshops are fun-filled, action-packed, and very informational.

PHOTOGRAPHIC EQUIPMENT AND REVIEW SITES

Even if you do not choose to purchase photographic equipment online, the Internet is a great source of information, including competitive pricing and equipment reviews. The sites listed here are just a smattering of what's out there, but I have found them to be very useful.

ADORAMA

www.adorama.com

This is a major photography retailer that provides high-end cameras, lighting and grip equipment, accessories, online learning, and rentals.

B&H PHOTO

www.bhphotovideo.com

This is a very good place to purchase cameras, equipment, and accessories. B&H stands behind its products, and many professional photographers purchase their cameras and equipment there.

HENRY'S: PHOTO, VIDEO, DIGITAL

www.henrys.com

If you're located in Canada, Henry's has many retail store locations to choose from, plus online ordering, and Henry's School of Imaging offers workshops for dSLR and compact camera owners.

CNET.COM

http://reviews.cnet.com

This website offers information and product comparisons, and allows you to shop for digital cameras, all in one place.

DIGITAL PHOTOGRAPHY REVIEW

www.dpreview.com

This website offers information on new products from a variety of major camera manufacturers, as well as thorough reviews on a wide range of cameras and equipment.

EPINIONS.COM

www.epinions.com/digital_cameras

This website reviews many different products, including reviews of digital cameras from other consumers.

PHOTO- AND VIDEO-SHARING WEBSITES

Whether you want to post just a few pictures for your family on the other side of the country or create an entire gallery to showcase your photography, there is a site for you on the web. These websites allow a secure and easy way to view, store, and share your photos with friends and family. Most also provide free and premium services for editing with creative tools. The subscription-based website charges a monthly or annual fee and allows you to upload, store, share, and order prints and other specialty photo products. Some sites are now offering video, music, and long-term image storage with no advertising. A few are more community-based, meaning they enable others to look at your posted photos and comment on them. These sites make it easy to link your images to websites and blogs for online photo sharing.

- Animoto: www.animoto.com
- Flickr: www.flickr.com
- Fotki: www.fotki.com
- Kodak Gallery: www.kodakgallery.com
- Phanfare: www.phanfare.com
- Photoshelter: www.photoshelter.com
- Photo Workshop: www.photoworkshop.com
- Pictage: www.pictage.com
- Picturetrail: www.picturetrail.com
- Shutterfly: www.shutterfly.com
- Smilebox: www.smilebox.com
- Smugmug: www.smugmug.com
- Snapfish: www.snapfish.com

IMAGE-ORGANIZING, ARCHIVING, AND SLIDE SHOW SOFTWARE

There are many ways to organize photos and many software products to choose from for organizing and creating slide shows. This list offers just a quick look at some of the more widely used solutions.

ADOBE PHOTOSHOP LIGHTROOM

www.adobe.com/ap/products/photoshoplightroom

You can organize thousands of images in Lightroom. You can also use this software to develop, protect, and showcase large volumes of your digital pictures while saving valuable time in your workflow.

This workflow tool is designed specifically for digital photographers, and makes organizing, enhancing, and sharing digital images quick and easy.

APERTURE

www.apple.com/aperture

Aperture is an all-in-one postproduction tool for serious photographers. Aperture makes it easy to import, manage, edit, catalog, organize, adjust, publish, export, and archive your images more efficiently.

BOINX FOTOMAGICO

www.boinx.com

Boinx FotoMagico allows you to easily add your photos into a dynamic slide show presentation with music and transition effects that rival professionally created slide shows. It's a universal application that works on both PCs and Intel-based Macs. It also has the capability to export to iPod, DVD, and HDTV formats.

IPHOTO

www.apple.com/ilife/iphoto

iPhoto (for Macs) includes a photo-organizing and photo-viewing software program. It comes bundled with every Apple computer. iPhoto allows you to import, organize, edit, and retouch your images with a user-friendly interface.

PICASA

http://picasa.google.com

Picasa is a free software download from Google for Windows PC users that helps you locate and organize all the photos on your computer. This software collects and organizes all the images on your computer, scanning the images and automatically sorting them by date while you watch. You can also edit and add effects to your photos with a few simple clicks and then share your photos with others through e-mail, prints, and online.

TREND MICRO SAFESYNC

www.safesync.com

Store photos, videos, documents, and passwords online to the SafeSync servers, and access them from anywhere in the world through web, computer, or a mobile device. This service provides unlimited online backup and automatic synchronization.

DROPBOX

www.dropbox.com

Dropbox is a free service that lets you save your photos, videos, and documents from the web, computer, or mobile device and easily share them. The Pro Plans offer more storage at an affordable price.

ONLINE PHOTOGRAPHY AND SOFTWARE CLASSES

There are some great tutorials on the web on a variety of photography subjects, and there are also many sites that offer useful educational materials. The following are two of my favorites.

RENEEPEARSON.COM

www.reneepearson.com

This is an online educational website for photography, scrapbooking, design, and artistry.

LYNDA.COM

www.lynda.com

This website provides educational materials and video training for creative designers, instructors, students, and hobbyists. You'll find digital photography, design and development, and motion tutorials.

MACPROVIDEO.COM

www.macprovideo.com

MacProVideo.com is an online education community featuring tutorial videos and training for popular audio and video applications.

WEBSITE DESIGN AND HOSTING

Whether you're looking to design a simple website to show your work, or create a more sophisticated online presence for selling your imagery, a website is a must in the world of photography.

ZENFOLIO

www.zenfolio.com

Zenfolio is a web-hosting company that provides photographers with online portfolios and money-making sales tools.

BLU DOMAIN

www.bludomain.com

Blu Domain is devoted to hosting web pages, as well as offering website creation services to creative professionals.

LIVEBOOKS

www.livebooks.com

LiveBooks is known for its simple-yet-sophisticated websites that help creative professionals manage their work and promote their businesses online.

GLOSSARY

ambient light The natural light in a scene.

analogous colors Colors next to each other on the color wheel. For example, green and blue, yellow and orange, and red and violet harmonize nicely. Use these color combinations in an image to convey peace and balance.

aperture An opening inside the lens that can be adjusted to control the amount of light reaching a camera's sensor prior to the image being taken. The aperture diameter is expressed in f-stops; the lower the number, the wider the aperture. The aperture and shutter speed work together to control the total amount of light reaching the sensor. See also *f-stop* and *shutter speed*.

Aperture Priority In Aperture Priority mode, you select the aperture desired, and the camera sets the shutter speed as needed. This setting works great for controlling the depth of field in portraits.

backlight The light coming from behind the photo subject. See also *directional light*.

ballhead A type of tripod head. This ball is mounted to the platform of a tripod, and when you attach it to your camera it allows you to adjust your camera in a fluid, multidirectional way, until you lock it in place to keep it from moving. Protruding from the top part of the ball is a shaft that holds the quick-release clamp or platform.

bounce card A white, gold, or silver card used to provide soft, indirect lighting by bouncing light off the card. It can also be used to gently brighten shadow areas. See also *reflector*.

bounce light The light bounced into a reflective surface (such as a wall, ceiling, or reflector card) to illuminate a subject with softer light, reducing harsh shadows. The color of the reflective surface determines the color of the light bounced into the subject.

brightness The brightness (light/dark) of an image, the intensity of a light source or color luminance.

card reader A device that allows you to transfer images from a memory card to your computer. Instead of connecting your camera to the computer to download your images, you simply plug a card reader into your computer's USB or FireWire port.

catch-light A reflection of light represented by a twinkle in the eye.

colorcast The predominance of a particular color that affects the entire image. A colorcast changes the hue of an image while keeping the saturation and brightness intact.

color temperature See *Kelvin* and *colorcast*.

color wheel A chart that illustrates color relationships. Harmonizing colors are located near each other on the color wheel; complementary colors are located opposite each other on the color wheel. See also *complementary colors* and *analogous colors*.

complementary colors Colors that lie opposite each other on an artist's color wheel. When they appear together, their intensity increases.

constant aperture lens With a constant aperture lens, the lens speed and aperture remain constant as you focus closer in or farther away.

continuous light A light source that is on all the time, allowing you to see how the light falls upon your subject in the scene.

Continuous shooting mode A camera mode that allows continuous shooting of sequential images in quick succession. This mode works well with sports and active children.

contrast The difference between the darkest and lightest areas in a photograph — the greater the difference, the higher the contrast. Photos

with low contrast can appear muddy or blurred, lacking clear distinctions between details in the images.

crop factor A cropped field of view results because some dSLR cameras have a sensor smaller than the 35mm photographic film frame. They only capture part of the information projected by a lens and make images appear as though you are shooting with a longer lens. To compute the focal length, you must know your dSLR crop factor or multiplier; this information is included with your camera. The three most common multipliers are 1.5, 1.6, and 2.0. For example, if you attach a 100mm lens to a dSLR with a 1.5 crop factor, it actually captures images as a 150mm lens (100mm × 1.5 = 150mm). See also *focal length multiplier* and *dSLR crop factor*.

diffuser A translucent material placed between the light source and your subject to soften the harsh light in your scene. See also *flash diffuser*.

digital zoom The method of making a subject appear closer by cropping away the edges of a scene within the camera.

directional light The direction the light comes from. See also *backlight*, *sidelight*, and *top light*.

dSLR Short for digital single lens reflex, a dSLR is a type of camera that possesses a higher-quality sensor than a standard point-and-shoot model. dSLRs allow for faster image capture and better-quality images; in addition, they enable you to use different lenses. See also *SLR*.

dSLR crop factor A digital camera without a full-size sensor can enhance the lens focal length, resulting in a "cropped," or reduced, field of view in your images. See also *crop factor* and *focal length multiplier*.

dynamic range The range between the darkest parts of an image and the lightest parts of an image.

external flash A flash unit that connects to the camera with a cable, or is triggered by the light from the camera's internal flash.

field of view In photography, the total angle of view that is visible through the camera lens.

filters Pieces of glass or optical resin that you place in front of the lens to affect the image in the camera.

flash An on-camera or off-camera device that emits a burst of light, artificially illuminating your scene.

flash diffuser A flash accessory that consists of a white, translucent plastic or fabric cover that slips over the head of your flash unit. The flashed light passes through the translucent cover and is diffused and softened by the time it reaches your subject.

flash sync speed The fastest shutter speed at which the flash can fire and still capture a complete image.

fluorescent light A type of photo light. Fluorescent photo lights operate at cooler temperatures than photo floods, are energy efficient, and are easy to use.

focal length Focal length is technically defined as the distance from the rear nodal point of the lens to the point where the light rays passing through the lens are focused onto the sensor. Practically speaking, focal length can be thought of as the amount of a lens's magnification. The longer the focal length, the more the lens magnifies the scene.

focal length multiplier Many dSLR cameras have a sensor smaller than the 35mm photographic film frame and only capture part of the information projected by a lens. This results in a cropped field of view, which makes images appear as though you are shooting with a longer lens. See also *crop factor* and *dSLR crop factor*.

format An action that prepares and optimizes a memory card for use with your specific camera. Formatting is also the best way to clear the images off your memory card after you transfer them to a hard drive or portable storage device, or burn them onto a CD/DVD.

f-stop The designation for each step in the aperture. The smaller the f-stop or f-number, the larger the actual opening of the aperture; the higher numbered f-stops designate smaller apertures, letting in less light. See also *aperture* and *shutter speed*.

golden hour A time that occurs in the early morning or near sunset when the angle of the sun is low in the sky and just above the horizon. Golden hour light is considered to be very beautiful, soft light.

graduated neutral density filter A filter that is immensely helpful in landscape photography, particularly during sunrise and sunset. The bottom of this filter is clear, the top is a neutral gray, and the middle is a smooth gradation between the two. The gray part, the neutral density, simply lets less light in. This filter is used to darken a bright sky, bringing the exposure closer to that of a shaded foreground.

high key When the dominant value relationships in an image are medium to light.

histogram A visual representation of the range of tones from dark to light in a photo, which often looks like a mountain range.

hue The actual color of an object.

image sensor A computer sensor that electronically captures the light rays coming through the lens of a digital camera and creates a digital image.

incandescent light Light from tungsten light bulbs is the most common source of light in most homes. This very warm light can be used in a lot of photographic situations, but incandescent lights are limiting because of their relative low light output.

ISO speed A rating of a digital camera sensor's sensitivity to light. Digital cameras use the same rating system for describing the sensitivity of the camera's imaging sensor as film manufacturers do for film. Your digital camera has a manual control for adjusting the ISO speed, or your camera can adjust the ISO automatically depending on the lighting conditions. Generally, as the ISO speed increases, the result is discolored pixels (noise) in the darker image areas.

JPEG A standard for compressing image data developed by the Joint Photographic Experts Group. When a JPG image is captured and stored on a memory card, the camera renders the image, discards information, and applies compression to an image. Due to this compression, JPEG format does not give you the same amount of editing capabilities as the RAW format does. See also *lossy compression*.

Kelvin The color of light is described as color temperature and measured in Kelvin (K), named after the nineteenth-century physicist William Thomson, 1st Baron Kelvin. Ranging from 1,000K to 10,000K, lower temperatures describe light that is warmer or redder in appearance; midrange temperatures refer to light that is white, or neutral; and the higher readings indicate that light has a cooler, or bluer, appearance. Average noon daylight has a color temperature of 5,500K. For example, a common tungsten light bulb has a color temperature of 2,800K.

LCD An acronym for liquid crystal display, an LCD is a low-power monitor that is often used on the back of a digital camera to display settings and for viewing images.

leading line A compositional element in an image that draws your eye into and through an image.

lens speed The maximum aperture diameter of a photographic lens. A lens with a wide maximum aperture (for example, f/2.8) is considered a "fast" lens because more light passes through the lens, enabling you to use a faster shutter speed. A lens with a smaller maximum aperture (for example, f/5.6) is "slow" because less light passes through the lens and therefore a slower shutter speed is required.

light quality Generally defined as how hard or soft the light is. Bright sunlight is hard light, but an overcast day typically has soft light.

lossy compression A type of compression used in the JPEG file format. Pixel values are averaged out in the process, and you may lose some detail and color in the image. See also *JPEG*.

low key When the dominant value relationships in an image are medium to dark.

luminosity The brightness of an area determined by the amount of light it reflects or emits.

macro lens Available in various focal lengths, a macro lens allows you to photograph your subject from a very close distance without distortion.

macro photography True macro photography happens when the image on the sensor is equal to or bigger than the subject that is being photographed. The ratio of 1:1 means the image size on the sensor is equal to the subject size. Getting closer would make the ratio of the image to the subject 2:1, meaning the image is twice as big as the subject.

megabyte (MB) A measurement of data storage equal to 1024 kilobytes (KB).

megapixel (MP) A digital camera's resolution is measured in megapixels. One megapixel is equal to one million pixels.

memory card A small, thin, reusable device that is inserted into a slot in a digital camera to electronically record and store digital images.

metadata Data stored within a digital image. Images typically contain several forms of metadata, including a record of the settings that were in effect when the digital image was created — pixel resolution, shutter speed, aperture, focal length, ISO, white balance, metering pattern, whether a flash was used, and so on. Images typically also contain metadata noting the date and time the image was captured. This metadata is saved in a standard format called Exchangeable Image File (EXIF). Often, you can search for your images using this metadata as your criteria.

metering modes Known as Matrix, Center-weighted, and Spot (the name depends on the camera manufacturer). These metering modes tell the camera's light meter to analyze the light in your scene in different ways.

monochromatic A color scheme that uses variations in lightness and saturation of a single color.

neutral density filter A dark filter that attaches to a lens to control the amount of light reaching the camera's sensor.

noise The degradation of a digital image, usually noted by random discolored pixels. Most noticeable in the even areas of color in an image, such as shadows and sky, noise results from shooting in low light with a high ISO.

normal lens Also known as a standard lens, the focal length representative of the field of view of human sight. In 35mm format, it is approximately 50mm.

optical zoom The amount of zoom that can be achieved through the optics of a lens.

panning An action-photography technique where the camera follows a moving subject. The subject remains sharp and clear, while the background is blurred, giving a sense of motion to the photo.

parametric image editing (PIE) A type of non-destructive image editing in which the editing software does not change original files, but instead records changes to images as sets of instructions or parameters.

photo floods Similar to household lights, photo floods provide a continuous light source with a generous amount of illumination, but the bulbs have a fairly short life span and generate a lot of heat.

pixel An abbreviation for picture element. Digital images are comprised of millions of these tiny, tile-like, colored squares. One million pixels are the equivalent of 1 megapixel.

polarizing filter A filter that modifies the light as it enters the lens, removing the glare and reflections from the surface of glass and water. It can also darken the sky and increase color saturation.

prime lens A lens that has a focal length that doesn't change. This is in contrast to a zoom lens.

RAW capture RAW image files contain all the uncompressed data of the image photographed. RAW files are not standard image file formats, and the file extensions for RAW files vary by camera manufacturer. To edit RAW image files, you must first convert the files in the computer. RAW works well for difficult exposures or when you want to maximize the information captured for the best possible image.

red-eye The red glow from a subject's eyes caused by an on-camera flash reflecting off the blood vessels behind the retina. Red-eye occurs in low-light situations due to the enlargement of the pupil.

red-eye reduction A camera feature that can reduce red-eye in low-light situations. The camera emits one to two preflashes before the picture is taken using the actual flash. This constricts your subject's pupil and can help reduce the amount of red-eye in your images.

reflector A tool for redirecting light; usually a white or metallic cloth disc, a reflective umbrella, or a light-reflecting board.

remote shutter release A remote shutter release enables you to engage the shutter without having to press the shutter button on the camera. It is handy for minimizing vibrations that could cause image blur and a must when photographing in low light or at night.

resolution The more pixels in your digital image, the higher your image resolution. Image resolution determines how much detail you see in your images and how large an image you can successfully print.

saturation The color intensity of an image. A color with high saturation appears brighter and more vibrant than the same color with low saturation.

second curtain sync The firing of the strobe at the end of the exposure instead of the beginning of it. The first blade of the shutter opens to begin the exposure, light builds on the sensor creating the exposure, and just before the second blade comes down to the end of the exposure, the strobe goes off. This does two things: it freezes the subject at the end of the subject's movement and gives the subject a trailing blur.

selective focus An effect that is achieved by using a wide aperture to produce shallow depth of field so that the subject is isolated from its out-of-focus surroundings.

setups Setting up the scene considering the light, location, and composition of the image.

Shutter Priority A camera exposure mode that allows you to select a shutter speed and the camera chooses the aperture to correctly expose the scene.

shutter speed A measurement of how long the shutter remains open when the picture is taken. The slower the shutter speed, the more light hits the sensor. When the shutter speed is set to 1/250 sec. (250), this means the shutter is open for 1/250 sec. The shutter speed and aperture work together to control the total amount of light reaching the sensor.

sidecar file Also known as XMP files, a sidecar file is created when you make changes or enhancements to a RAW file. The sidecar file sits alongside the original RAW file with an XMP file extension and contains all the information about your enhancements to the RAW file. Sidecar files are needed if you are making changes in one application, such as Lightroom, then opening up the same RAW file in Photoshop because your changes cannot be saved to a RAW file and won't be recognized by third-party software. See also *parametric image editing (PIE)*.

sidelight Light that emanates from and illuminates the side of the scene, emphasizing the shape and texture in a scene. See also *directional light*.

slave A light-sensitive trigger device used to sync strobes and flashes without an electronic sync cord.

SLR An acronym for single lens reflex, which means that the light from the image comes through the lens and bounces off a mirror in front of the shutter into the viewfinder until the shutter button is pressed. At that time, the mirror flips up; the shutter opens, exposing the digital sensor, and then closes; and the mirror flips back down.

spot meter Unlike an evaluative or center-weighted meter, which averages the scene to get the right exposure, a spot meter allows you to select a very small part of the scene and find the exposure for just that area. This is particularly useful when you need to find the exposure of your subject and he is surrounded by large amounts of light or dark.

standard lens Also known as a normal lens, the focal length representative of the field of view of human sight. In 35mm format, it is approximately 50mm.

strobe Also known as a stroboscopic lamp, a strobe is a repeating flash that can be set to flash at a selected rate.

tag Tags are descriptive keywords attached to images. For example, if an image portrays an individual, you might add a tag to it with his or her name. Or if the image was taken in a particular city, you might tag it with the name of that city. As a third example, you might tag all images that contain a dog with the tag "dog." Then you can sort your images by tag, displaying all images with the same tag together. If you're looking for an image with a particular tag, this can make it much easier to find.

telephoto lens A lens designed for photographing distant objects. Similar to a telescope, it magnifies your subject and narrows your field of view.

top light A subject lit from above is lit with top lighting. However, top or front lighting has a tendency to look flat and uninteresting. See also *directional light*.

total zoom The combination of the optical and digital zoom on a compact digital camera, which creates a number of magnification. Optical zoom is the amount of zoom within the capabilities of your lens. Digital zoom digitally zooms and crops inside your camera. When purchasing a camera,

keep in mind that the optical zoom is optimum, and that you can achieve the digital zoom with most image-editing software applications.

transmitter A dedicated electronic device attached to your camera that can control an unlimited number of flashes so they fire in succession.

TTL An acronym for Through-the-Lens, this type of metering is for both ambient and flash exposures. TTL metering uses a meter inside the camera to measure the light after it passes through the lens. It is very accurate metering and is on virtually every dSLR.

tungsten/incandescent light A metal filament used in most light bulbs that emits a reddish/yellow light, creating a colorcast in a photograph.

UV filter A filter used to reduce the amount of ultraviolet light entering your lens, which may cause an image to appear hazy. UV filters are also used to protect the surface of a camera lens.

variable aperture lens With a variable aperture lens, the lens speed and aperture change as you zoom closer in or farther away. Although variable aperture lenses, which are less expensive than their fixed-aperture counterparts, are capable of producing excellent images, they do have limitations. For example, you won't be able to shoot handheld with a variable aperture lens in most low-light situations; you can only capture action in bright light or by using a flash. Also, some variable aperture lenses, for example f/3.5–5.6, cannot render a very shallow depth of field.

vignetting A reduction of the image's brightness in the periphery.

white balance A camera function that compensates for different colors of light being emitted by different light sources. Auto white balance

(AWB) works well in most lighting situations, although it can vary depending on the camera and type of light in your scene. White balance presets offer a choice of white balance options designed for specific lighting conditions. Custom white balance is useful when your scene is illuminated by mixed light sources, such as daylight coming in through a window blended with a fluorescent or tungsten light.

wide-angle lens A camera lens that has a shorter focal length than a normal or standard lens and covers a wider angle of view. A wide-angle lens comes in handy when you can't move far enough away from a subject to get everything in the picture, as well as for grand scenic vistas. Wide-angle lenses also provide a deep depth of field, so that all the elements seen through the lens appear in sharp focus. Wide-angle lenses are great for special effects — when you are close to a subject with a wide-angle lens, the subject appears huge in comparison to the background. The disadvantage is these lenses may distort subjects at the far edges of the image by making them appear wider than they actually are, and when used at its widest setting, this lens may create dark edges in the corners of your images.

XMP file See *sidecar file* and *parametric image editing (PIE)*.

zoom lens A zoom lens offers a range of focal lengths — for example, 24–70mm. With zoom lenses, you can switch from one focal length to another, including more or less of your scene in your shot, simply by moving the lens barrel. While using a zoom lens enables you to lug fewer lenses around, zoom lenses do have their disadvantages. For one, they tend to be more expensive. For another, they are less sharp than lenses with a fixed focal length, which can be a problem if the image will be printed in a larger format.

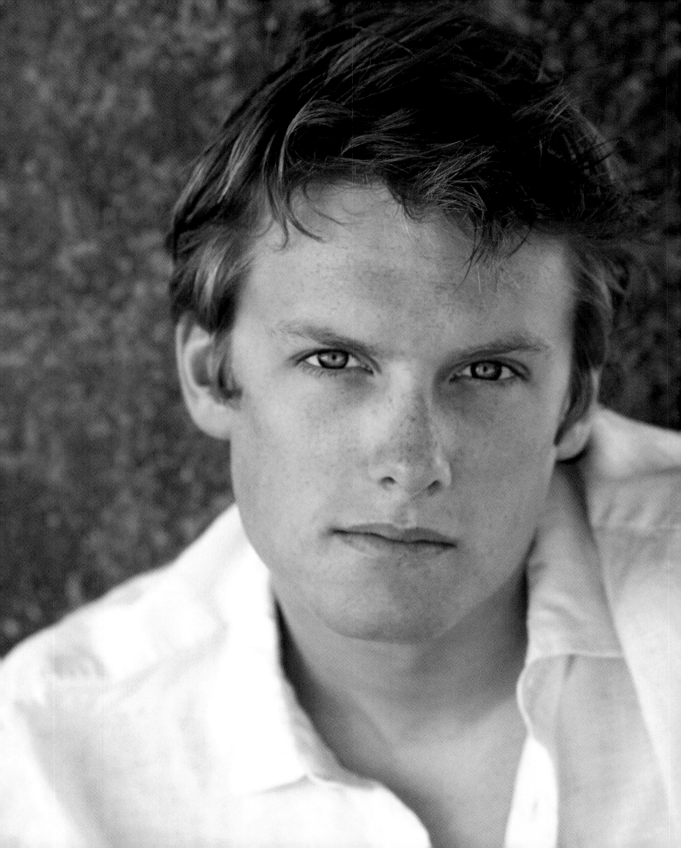

continued

Develop your talent.

Go behind the lens with Wiley's Photo Workshop series, and learn how to shoot great photos from the start! Each full-color book provides clear instructions, sample photos, and end-of-chapter assignments that you can upload to pwassignments.com for input from others.

978-0-470-42193-2

978-1-118-02454-6

978-0-470-53491-5

978-0-470-41299-2

978-1-118-01411-0

978-0-470-14785-6

978-1-118-02453-9

978-0-470-11876-4

978-0-470-11436-0

978-0-470-11433-9

978-0-470-40521-5

978-0-470-11955-6

For a complete list of Photo Workshop books, visit photoworkshop.com — the online resource committed to providing an education in photography, where the quest for knowledge is fueled by inspiration.

Available wherever books are sold.

WILEY
Now you know.